PAUL
OUTERBRIDGE
1896 - 1958

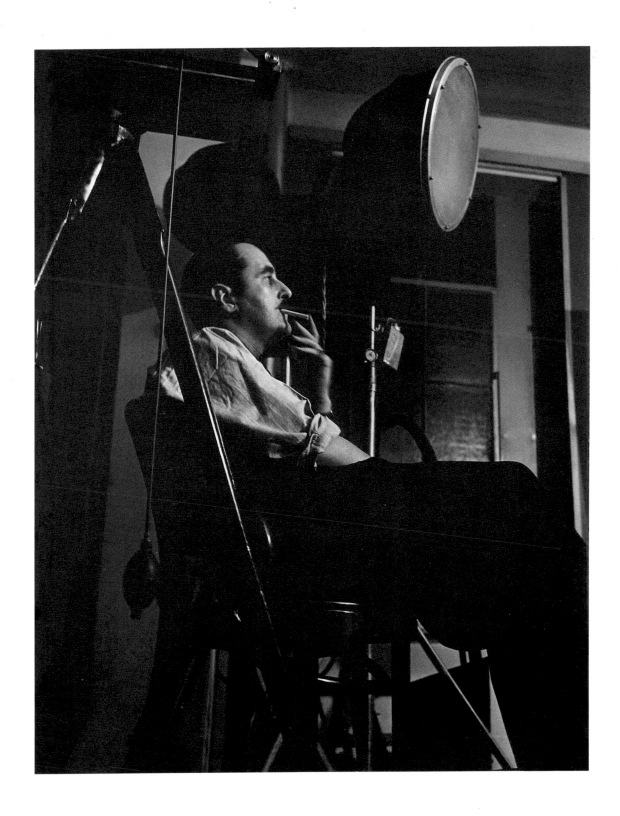

Self-Portrait | Selbstporträt | Autoportrait
c. 1937

PAUL

ESSAY BY **ELAINE DINES-COX**
WITH **CAROL McCUSKER**

OUTERBRIDGE

A PERSONAL PORTRAIT BY **M. F. AGHA**

1896-1958

EDITED BY **MANFRED HEITING**

TASCHEN

ACKNOWLEDGMENTS

Paul Outerbridge's life was adventurous and mysterious—as was the compilation of the material relating to him and the editing of this book. His known oeuvre may not exceed 560 images, made between 1920 and 1940, but the tracking down and selection of this material for the present book would have been impossible without the generous support of a team of friends and researchers. Invaluable in the completion of the project have been G. Ray Hawkins, who purchased the Paul Outerbridge estate in 1977, Elaine Dines-Cox, who, as co-author of an initial catalogue raisonné of Outerbridge's work and curator of his first major exhibition at the Laguna Art Museum in 1981, has written the essay for this volume in cooperation with Carol McCusker, who also has researched and located many of the original publications from the 1930s, in particular the text by M. F. Agha. A large collection of Outerbridge's work as well as his papers and documents reside at the J. Paul Getty Museum and The J. Paul Getty Research Institute in Los Angeles, and I am indebted to Weston Naef and his staff at the Museum and to Clare Kavanagh at the Institute for giving me unrestricted access to the Museum's holdings and in particular to the Outerbridge archives at the Research Institute in 1999 when publishing this volume for the first time.

During my research there as well as when reviewing the glass negatives still at the Paul Outerbridge estate, some striking new information and hitherto unpublished black-and-white and color images were discovered. The Carbro technique Outerbridge employed for his color photographs was based on three—sometimes four—glass negatives [one for each color] made in separate exposures. When taking images of people, he faced the problem of movement of the subject and was unable at the time to make Carbro prints of several of his most stunning negatives. I am grateful to Dieter Kirchner of DruckConcept in Berlin for his perseverance in realizing for the first time perfect color reproductions of such "moving" subjects, achieved with the aid of the computer and his digital process called NovaSpace®.

Many of Outerbridge's prints are unique and as such are widely treasured in both public and private collections. In being able to draw on numerous images from these collections for reproduction here, I am especially grateful to Michael Wilson of the Wilson Center for Photography, London, and his assistant Elizabeth Daniels; to Tom Hinson, Director of The Cleveland Museum of Art; to Roberto Prcela, Manager, Rights and Reproduction of that Museum; to Rick Wester of Christie's, New York; to Stephan Johnstone of Christie's Images, Long Island City; and to Graham Howe, Director, Curatorial Assistance, Passadena, and Hendrik Berinson, Berlin, who have made reproductions of their Outerbridge prints available for this publication. Finally, I would like to thank Christiane Rothe of DruckConcept, Berlin, and the team at TASCHEN, Cologne, especially Bettina Ruhrberg and Simone Philippi for their continuous commitment to this volume of Paul Outerbridge's photographs.

DANKSAGUNG

Der Entstehungsprozess dieser umfassenden Übersicht über das zwischen 1920 und 1940 entstandene Werk von Paul Outerbridge war nicht weniger abenteuerlich und mysteriös als das Leben dieses Fotografen. Auch wenn sein Œuvre aus diesen Jahren nicht mehr als 560 Bilder umfassen dürfte, wäre es ohne die großzügige Unterstützung zahlreicher Freunde und Forscher unmöglich gewesen, das Material für dieses Buch aufzuspüren und auszuwählen. Von unverzichtbarer Bedeutung für die Vollendung dieses Projekts waren insbesondere G. Ray Hawkins, der 1977 den Nachlass von Paul Outerbridge erwarb, und Elaine Dines-Cox, die einen ersten Catalogue Raisonné mitverfasste und 1981 im Laguna Art Museum, Laguna Beach, Kalifornien, die erste bedeutende Outerbridge-Ausstellung organisierte. Sie hat in Zusammenarbeit mit Carol McCusker, die viele Originalpublikationen aus den dreißiger Jahren – insbesondere den Text von M. F. Agha – ausfindig machen konnte, den Essay für dieses Buch verfasst. Ein großes Konvolut von Fotografien und Schriften von Paul Outerbridge sowie von Dokumenten über sein Leben wird im J. Paul Getty Museum und im J. Paul Getty Research Institute in Los Angeles aufbewahrt. Mein aufrichtiger Dank gilt Weston Naef und seinen Mitarbeitern im Museum sowie Clare Kavanagh vom Research Institute, die mir bei der Erstausgabe dieser Monografie 1999 den uneingeschränkten Zugang zu den Beständen im Museum und insbesondere zum Outerbridge-Archiv des Instituts gewährt haben.

Während meiner dortigen Nachforschungen und der Sichtung der noch im Paul-Outerbridge-Nachlass befindlichen Glasnegative konnte ich einige bislang unveröffentlichte Schwarzweiß- und auch Farbfotografien entdecken. Außerdem stieß ich auf neue, verblüffende Informationen. Die Carbro-Technik, die Outerbridge für seine Farbfotografien verwendete, beruhte auf drei, manchmal vier, Glasnegativen [je eines für jede Farbe] mit unterschiedlichen Belichtungszeiten. Wenn er Menschen fotografierte, war er mit dem Problem der menschlichen Bewegung konfrontiert, und es lag damals außerhalb seiner technischen Möglichkeiten, viele dieser fantastischen Negative in Carbro-Drucke umzusetzen. Den unermüdlichen

Bemühungen Dieter Kirchners von DruckConcept, Berlin, ist es zu verdanken, dass – mithilfe seines Computers und des von ihm entwickelten Digitalverfahrens NovaSpace® – zum ersten Mal perfekte Farbreproduktionen solcher „sich bewegender" Sujets erreicht werden konnten.

Bei vielen Outerbridge-Abzügen handelt es sich um kostbare Unikate, die sowohl in öffentlichen als auch privaten Sammlungen gehütet werden. Ich bekam die großzügige Erlaubnis, zahlreiche Bilder aus diesen Sammlungen hier zu reproduzieren. Insbesondere danke ich Michael Wilson vom Wilson Center for Photography, London, und seiner Assistentin Elizabeth Daniels, sowie dem Direktor des Cleveland Museum of Art, Tom Hinson und Roberto Prcela, dem dortigen Manager für Rechte und Reproduktionen; auch Rick Wester von Christie's, New York, Stephan Johnstone von Christie's Images, Long Island City und Graham Howe, Direktor, Curatorial Assistance, Passadena, haben ihre Outerbridge-Abzüge für Reproduktionen in diesem Buch zur Verfügung gestellt. Ihnen allen möchte ich meinen herzlichen Dank aussprechen. Und schließlich möchte ich Christiane Rothe von DruckConcept, Berlin und dem TASCHEN-Team in Köln, insbesondere Bettina Ruhrberg und Simone Philippi für ihren unermüdlichen Einsatz zum Gelingen dieses Buchprojekts danken.

REMERCIEMENTS

Ce livre offre une vaste vue d'ensemble de l'œuvre de Paul Outerbrige entre 1920 et 1940, et la manière dont il a vu le jour ne le cède en rien sur le plan de l'aventure et du mystère à la vie de ce photographe. Même si l'œuvre de celui-ci ne devait pas dépasser 560 photographies durant ces années, il aurait été impossible de découvrir et de sélectionner le matériel utilisé sans le soutien généreux de nombreux amis et chercheurs. Je nommerai ici quelques personnes dont le soutien a été essentiel pour la bonne conduite du projet : G. Ray Hawkins, qui acquit en 1977 la succession de Paul Outerbridge, et Elaine Dines-Cox qui collabora à la rédaction d'un premier catalogue raisonné et organisa en 1981 au Laguna Art Museum de Laguna Beach en Californie la première exposition importante des travaux de Outerbridge. En collaboration avec Carol McCusker qui sut retrouver de nombreuses publications originales des années 1930 – en particulier le texte de M. F. Agha –, elle a rédigé l'essai contenu dans le présent livre. Le J. Paul Getty Museum et le J. Paul Getty Research Institute de Los Angeles abritent de nombreuses photographies et écrits de Paul Outerbridge ainsi que des documents sur sa vie. Je remercie sincèrement Weston Naef et ses collaborateurs au Musée ainsi que Clare Kavanagh de l'Institut qui, pour la première édition de cette monographie en 1999, m'a accordé sans restrictions l'accès aux fonds du Musée et en particulier aux archives Outerbrige de l'Institut.

Au cours de mes recherches en ces lieux, j'examinai les négatifs de verre se trouvant (encore) dans la succession Outerbridge ce qui me permit de découvrir quelques photographies en noir et blanc et en couleur, inédites jusqu'ici. En outre, j'eus accès à de nouvelles informations stupéfiantes. Pour réaliser des photographies en couleur, Outerbridge utilisait une technique Carbro basée sur trois – parfois quatre – négatifs en verre [un par couleur] avec des temps de pose différents. Quand il photographiait des gens, il se trouvait confronté au problème du mouvement humain, et il lui était techniquement impossible à son époque de transposer ces négatifs fantastiques en impressions Carbro. S'il a été possible de réaliser pour la première fois des reproductions couleur parfaites de «sujets en mouvement», c'est aux efforts inlassables de Dieter Kirchner de DruckConcept à Berlin – avec l'aide de son ordinateur et du programme numérique créé par ses soins – que nous le devons.

De nombreuses épreuves de Outerbridge sont de précieuses pièces uniques, gardées dans des collections aussi bien publiques que privées. J'ai été généreusement autorisé à reproduire ici de nombreuses photos de ces collections. Je remercie en particulier Michael Wilson du Wilson Center for Photography, London, son assistante Elizabeth Daniels ainsi que le directeur du Cleveland Museum of Art, Tom Hinson et Roberto Prcela, Manager, Rights et Reproductions, Rick Wester de Christie's, New York, Stephan Johnstone de Christie's Images, Long Island City et Graham Howe, Director Curatorial Assistance, Passadena, Hendrik Berinson, Berlin, qui ont mis à notre disposition les épreuves de Outerbridge en leur possession afin qu'elles soient reproduites dans le présent ouvrage. Je les en remercie tous cordialement. Enfin, je souhaiterais remercier Christiane Rothe de DruckConcept [Berlin] et toute l'équipe de TASCHEN à Cologne, plus particulièrement Bettina Ruhrberg et Simone Philippi, pour leur engagement permanent dans la réalisation de ce livre de photographies de Paul Outerbridge.

Manfred Heiting

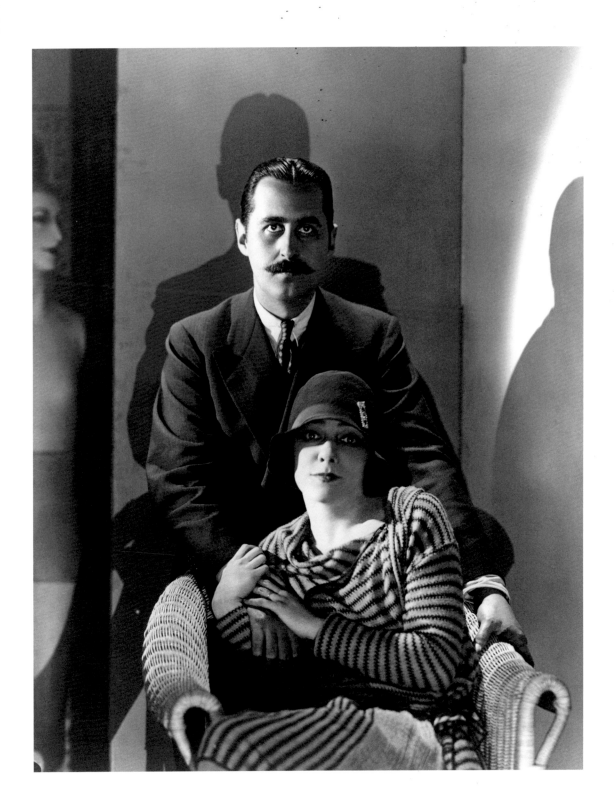

Self-Portrait with Paula | Selbstporträt mit Paula | Autoportrait avec Paula
c. 1927

Contents
Inhalt
Sommaire

M. F. AGHA

13] *Paul Outerbridge, Jr.*
88] Paul Outerbridge, Jr.
179] Paul Outerbridge, Jr.

ELAINE DINES-COX WITH CAROL McCUSKER

15] *Directorial Modernist*
 The Life and Art of Paul Outerbridge

90] *Ein richtungsweisender Modernist*
 Das Leben und Werk von Paul Outerbridge

181] *Un moderniste directif*
 La vie et l'art de Paul Outerbridge

PAUL OUTERBRIDGE

26] The Carbro Process
102] Das Carbro-Verfahren
192] Le procédé Carbro

APPENDIX ANHANG ANNEXES

248] *Biography*
 Biografie
 Biographie

252] *Selected Bibliography*
 Ausgewählte Bibliografie
 Bibliographie

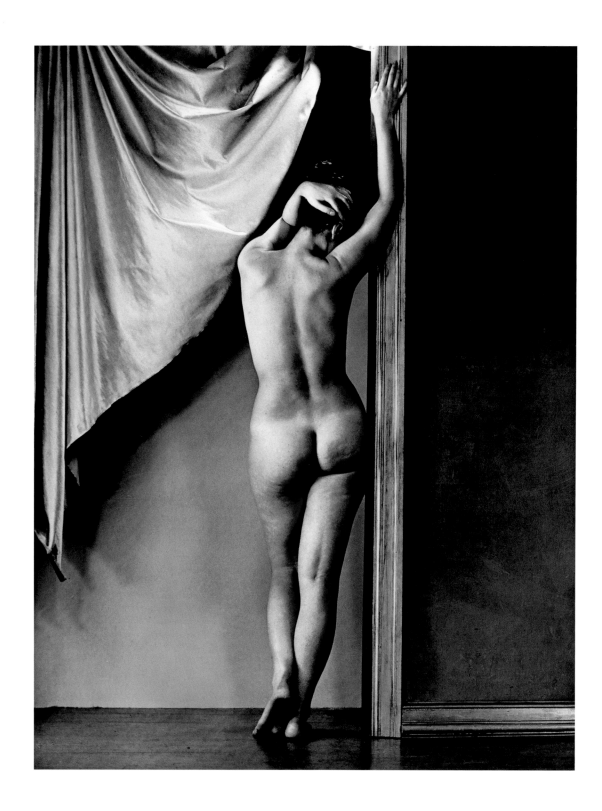

Nude with Frame, back view | Akt mit Rahmen, Rückenansicht | Nu avec cadre, vue de dos
1938

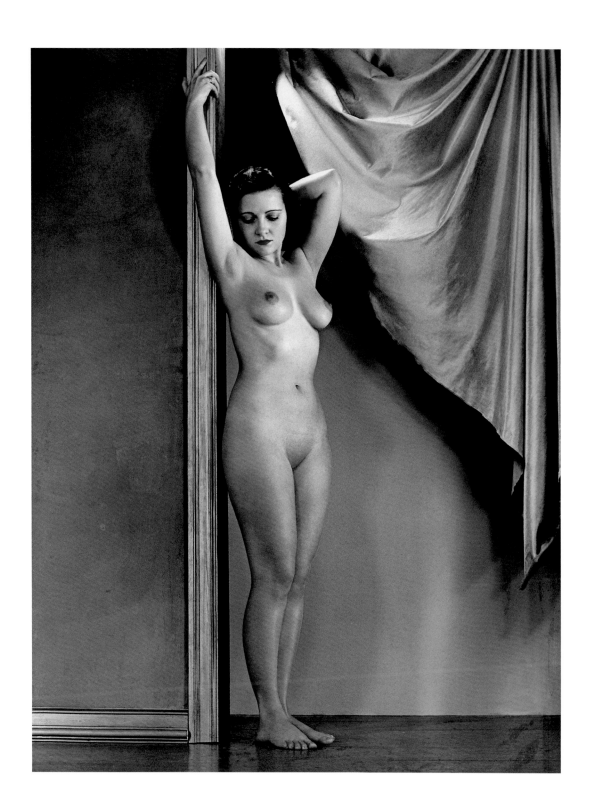

Nude with Frame, front view | Akt mit Rahmen, Vorderansicht | Nu avec cadre, vue de face
1938

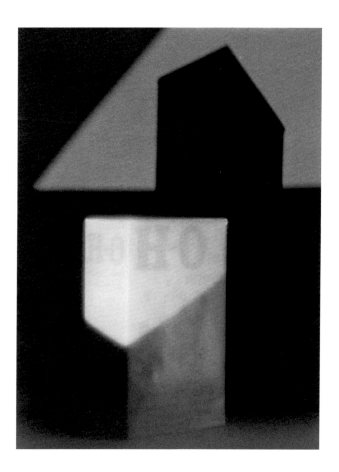

H.O. Box | H.O.-Schachtel | H.O. Box
1922

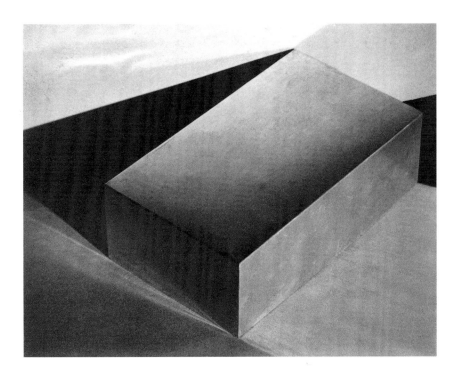

Saltine Box | Salzcracker-Schachtel | Boîte de gâteaux salés
1922

Avocados | Avocats
1936

Paul Outerbridge, Jr.

M. F. Agha

One of my Parisian friends told me a delicious story about Paul Outerbridge:

It seems that a year or so ago, all the Paris "that counts" was set aflutter by startling news: the photography, which was newly glorified as a full-fledged fine art, was about to know an era of splendor: the famous American photographer, Outerbridge, was building the world's greatest photographic studio in Paris. The world's greatest manufacturer of wax figures was financing the affair—some 1,500,000 francs were involved. "C'est phantastique."

The news became more and more fantastic during the next months: the new studio was to have an equipment which would be the latest word in mechanics at the service of esthetics: the electric suspended bridges would carry an unheard of amount of powerful lights and travel automatically at the slightest movement of Outerbridge's finger; no longer would there be any material obstacles between the artist's conception and its embodiment!

The excitement reached its climax when it was announced that, after long months of planning and building, the studio was completed, and the great moment approached: Outerbridge himself was going to take a photograph. And, finally, at the widely broadcasted date, Outerbridge arrived in the studio—and the sitting began: bridges moved, assistants rushed about the place, lights flashed. The great work of art was born; few breathless minutes passed and Outerbridge brought out of his world's greatest dark room and presented to the adoring audience—the picture of an egg!

Evidently, the fellow who told me the story was a philistine, unable to grasp the significance of an egg and its role in modern art—but the story depicts Outerbridge very graphically. There are other stories—covering continents, reaching over the seas. They will tell you in Berlin that Outerbridge destroys his plates after a few prints are made and thus gives to his photographs commercially the same high value as they have artistically—as is done with etchings by great masters. In Paris, you will hear about Outerbridge who made 4,000 plates [or was it 10,000?] before he discovered how an egg really should be photographed.

In New York, the colleagues of Outerbridge will tell you that the profession is heavily indebted to him, for he was one of the first to succeed by the sheer force of willpower and imagination in transforming prices paid for commercial work from two numerals to three or even four.

The superficial esthetician will compare his work with Brancusi [if he is in a complimentary mood], or with class exercises in the Clarence White School of Photography [if he is of a belittling kind]. But only the historian of arts will place Outerbridge in the right perspective. His

is the place of a pioneer, of that school of modern photography which is so close to the modern movement in painting as to be taken by some purists for imitation. There is, indeed, a great similarity between the symbolic guitar of Pablo Picasso repeated in the countless canvasses of the followers—and the symbolic eggs of Outerbridge, equally popular with photographers who decide to "go modern." The craving for the creation of "significant form" and the sublime detachment from everything that is "storytelling" are the real basis of Outerbridge's art. The romance and legends are only a pioneer means of self-defense, a way of piercing the indifference of philistine-minded multitudes.

The modern movement in photography seems to be ripe for a post mortem. The critics begin to discuss the question of origins and responsibilities.

The conservative German writers deny emphatically that modern photography was born in Germany. They point out the *Camera Work*, the *Broom*, the photos of Paul Strand, the American commercial photography, as the strongest influences which corrupted German youth and made it depart from the sacred dogma of pictorialism. Outerbridge is one of the heaviest and earliest offenders and, as such, deserves our deep respect.

Dr. M. F. Agha, [Director of Vogue *and* Vanity Fair *from 1928 to 1942], Paul Outerbridge Jr., in:* Advertising Arts, *New York, May 1931*

Directorial Modernist

The Life and Art of Paul Outerbridge

The period between the two world wars, considered by many scholars to be among the most creative, prolific and exceptional of the 20th century, were also the years of the artistic output of Paul Outerbridge [1896–1958], whose work represents a significant contribution to the history of photography. Retrospective analysis of his oeuvre reveals the extent to which he succeeded in translating the general aesthetic concerns of the avant-garde during those decades into the particular language of photography. It also reveals his singular achievement in using this language to create images which are only now becoming comprehensible in the explicit artistic context envisioned by Outerbridge.

The explosive, inventive years between the two world wars form the context of his art and ideas. He numbered among his friends and associates some of the most important artists of the avant-garde: Marcel Duchamp, Man Ray, Pablo Picasso, Francis Picabia, Constantin Brancusi, Alexander Archipenko, and Max Ernst. These artists influenced him above all during his Paris years of 1925–28. Outerbridge became their spiritual peer and fellow innovator, and was generally recognized as such during the course of his successful career. He was commercially successful in his lifetime with a distinctively fresh, modernist vision that significantly changed advertising design. By the 1920s he had already gained a reputation as an effective publicity photographer and graphic designer for chic fashion magazines, while in the 1930s he devoted himself to an intensive study and the refinement of his color technique. Through his development of the tricolor Carbro process, he gave transcendent expression to his unique and brilliant color prints, according them a stature as photographic paradigms that they have never lost.

Paul Outerbridge's contribution to the history of photography is his incomparable technical virtuosity, which he applied with a creative sense for abstract and geometric design. In addition, his innovations in color printing, which he presented to the public in a number of essays and in his book *Photographing in Color* [1940], demonstrate how photography could best render commercial interests and personal passions. He was capable of transforming everyday objects into virtual abstractions in which harmonious patterns of mass and line, light and shade superseded our conventional perceptions of such objects. However, his concern was not just with commercially viable subject matter, but also with investigating the female body in respect to what he called "feminine beauty": woman as idealized form, as fetish, as theater. Unlike many of his contemporaries, such as Walker Evans, whose camera became his conscience, Outerbridge's gaze was inwardly directed, introspective. Like László Moholy-Nagy and Man

Ray, he demythologized the camera. It was the eye and the mind, not the instrument, that created art. Imagination, not events, made the picture. Like Kandinsky, he discovered transcendent meaning in the pure form of objects. His choice of subject matter in conjunction with lighting made the ordinary extraordinary. Outerbridge internalized many of Germany's post-World War I aesthetic concerns, such as the purity of form found in the Neue Sachlichkeit [New Objectivity], as well as the popular trends found in German Expressionist cinema and cabaret, with their predilection for exploring the sexual and psychological. Translating these modernist impulses onto sensitized photographic paper, he brought photography further into the realm of the aesthetic and the deeply personal. For this reason, his work remains unique not only for his time but also for ours today.

A photograph of Paul Outerbridge at the age of twenty-five [in 1921, ill. p. 248] tells us much about the set of themes and aesthetic concerns that would preoccupy this burgeoning young photographer for the next 20 years. Transposed onto the presentation of himself is a sophisticated and reductivist sense of line and form, a fastidious appreciation of fashion, taste, and the abstract surface of the human form. In the photograph, these interests are manifest in a slicked-back, continental hairstyle, suave pose, and mannered gesture, white tuxedo tie and collar, a fitted, dark vest and jacket with velvet lapels, and patent leather shoes. On a New York rooftop [insinuating a lofty, remote observation point relative to the city below] Outerbridge is the quintessential aesthete, a post-World War I cosmopolitan one might have seen frequenting the theater and swank nightclubs of Manhattan. In keeping with his fascination with Hollywood filmmaking, he possessed an uncanny resemblance to Tyrone Power, or an extra in a Fred Astaire/Ginger Rogers film [although, it would be another decade before these stars graced the silver screen]. Outerbridge would, therefore, have been their prototype in the actual world. Ironically, this man of means and sophistication came early in his adult life to eschew the encumbrances and constraints of the elite social realm to which he had been born, and sought instead to explore the more expressive and unconventional life of the bohemian artist in Europe.

In 1925, Outerbridge and his young wife Paula Smith, whom he had married in 1921, moved to Paris. As a fledgling member of the avant-garde, and drawn to the conflicting worlds of restrained high style and bohemian indulgence, Outerbridge understood the importance of the radical, cutting-edge invention produced expressly by his generation, which had just emerged—psychically wounded and hungry for living—from one of history's worst conflagrations, the First World War. He was of his time, and incorporated into his own lifestyle the defining aesthetic of the avant-garde, which revolved around a distinctively urban, Euro-New York café society that possessed both a pre-war propriety and an impetuous post-war curiosity.

To understand the formal orientation and psychological complexity of Outerbridge's imagery, a discussion of his life and influences within the broader context of history is fundamental. These include a privileged but troubled family life; coming of age during the First World War; study at the Clarence White School of Photography; exposure to New York's practitioners of modernism—Alfred Stieglitz, Paul Strand, and Edward Steichen; life in Paris and Berlin as both these cities were experiencing a radical, prolific creativity; and friendships or associations with avant-garde luminaries. Assimilating their influence, Outerbridge produced photographs

with a highly personalized vision. His imagery is informed by a consistent, maturing aesthetic which achieved transcendent expression in his black-and-white photographs, and, later, in his unique and brilliant tri-color Carbro prints.

The second World War transformed world culture as did WWI. After 1941, Outerbridge's star began to descend. He was unable and unwilling to compromise with changes in fashion and taste, outliving the immediate popularity of the style he had perfected, dying in obscurity in 1958.

Throughout his career Paul Outerbridge subscribed to the belief that "art is life seen through man's craving for perfection and beauty—his escape from the sordid realities of life into a world of his imagination."[1] This conception of the function of art became his "true north."

The young photographer's personal aesthetics emerged through his assimilation of international styles like Precisionism [a straight, sharp-focused technique antithetical to the romantic soft-focus of Pictorialism], which he embraced for its clean, abstract, geometric design, of which Charles Sheeler and Paul Strand were the exemplary practitioners; and Surrealism, the fantastical, psychological complex within artmaking to which Man Ray introduced Outerbridge—which is manifest in Outerbridge's Carbro-color images of the female subject. Initially just another vehicle for investigating abstract form, his approach toward the female changed in the 1930s, with his color images becoming more theatrical and obsessive. Liberated from pre-World War I decorum, Outerbridge spent over a decade in the 1930s photographing female models in masks, garters, silk stockings, lace, high-heeled shoes, rubber caps, and metal-clawed gloves, producing images that both interrupted and interpreted ideas surrounding the classical nude.[2]

Outerbridge understood how desire for beauty in art, as in life, could translate into modernist, elegant, and alluring everyday forms, things of beauty that promised pleasure, whether they be the look of food, the interior of a home, or the human body. This understanding of bodily pleasures and tasteful fashion made his career in advertising the success that it was. Through carefully conceived and constructed sets isolated from their natural environment, Outerbridge would observe and then arrange a box, a piece of fruit, a female nude, or himself with meticulous exactness and extravagant precision, which included a unique sensuality. That sensuality informed his development of the Carbro-color process because color added a tangible richness to the surfaces and content of his photographs in the 1930s.[3]

In 1917, during America's involvement in the First World War, Outerbridge volunteered for service with the Royal Flying Corps, in which he experienced physical overexertion that jeopardized his flying career, and made him re-evaluate what he wanted to do for a career. In 1918, after 15 months in the service, he traveled down the coast of California with the purpose of finding some kind of work that would engage his talents and imagination. He arrived in Hollywood in early 1919 hoping to break into motion pictures. However, he ran out of money before he could make the necessary industry contacts, and returned to New York. Contrary to his family's wishes that he attend Harvard or establish himself in business, Outerbridge decided, at the age of 19, after a three-month apprenticeship in a Wall Street brokerage firm, on a career in the arts. In 1915 he enrolled at the Art Students' League in New York, where he studied anatomy and aesthetics. Around the same time, he designed posters for the theater. Soon after, in 1921, he enrolled in Clarence White's School of Photography. His decision flew in the face of what was conventional-

ly expected of the son of a renowned New York surgeon and eminent old family. But he persist-
ed. By 1921, after only a few months at the Clarence White School, his talent thrived not only
through a medium that fascinated and fulfilled his aesthetic aspirations, but also through close
associations with people and ideas integral to the art world of Europe. That same year he mar-
ried Paula Smith, a woman he met on his frequent trips to Bermuda, where his father had been
born and relatives maintained business interests. She would accompany him to Europe and occa-
sionally model for him.

These years were among Outerbridge's most important in the development of what was
to become his distinctive style. At the White School, he was challenged by the teaching of Max
Weber, who taught Arthur Wesley Dow's theories of composition and by his own publication
Essays on Art [1916], which advocated a consideration of two-dimensional Cubist abstract theory
in relation to photographing three-dimensional objects.[4] This was accomplished by fracturing
the planes surrounding an object through innovative uses of light, vantage point, and framing.

"Feeling that most of the best art in painting and sculpture had been done and that this
newer form of expression was more related to the progress and tempo of modern science and the
age,"[5] Outerbridge devoted himself entirely to photography. "I worked very hard, feeling for the
first time I had a real incentive in life, and made rapid progress."[6] Daily, in a room in his fam-
ily's house set aside as a studio, he made repeated exposures [with a 4 x 5-inch camera, carefully
noting his materials, equipment, and processes] of familiar objects such as a milk bottle, a bowl
of eggs, a light bulb, or a wooden box, lighting and arranging them into simple yet graceful com-
positions. By 1922, he was published in *Vogue*. Throughout that year and into 1923, he devel-
oped a friendly rivalry with fellow student Ralph Steiner, and he began a dialogue with Alfred
Stieglitz while also studying with Archipenko. By 1924, he was flush with commercial accounts.

Outerbridge rarely photographed from nature directly in the sense apparent in the work
of Ansel Adams. He was not seduced by the obvious beauty of surface appearances; rather he
was concerned with investigating the underlying formal principles of beauty within a composi-
tion. To understand this, he made many preliminary drawings [monochromatic studies] in an
attempt "to interpret the beauty existing in the simplest and humblest objects." Related to his
black-and-white photographs, his drawings investigated the relationship of linear rhythms and
black-and-white planes.

In order to achieve this end in photographs, he meticulously arranged and rearranged
objects until he arrived at a design corresponding to the intentions in his drawings. This design,
evident in the "distribution of dark against light, light against dark, and a general balancing of
areas and tones," represented a synthetic analogue of nature in the form of an abstract image of
harmony. Using "the camera lens to paint with light itself, just as an artist would employ paint
and brush," he snatched meaning from form with the deft artistry of a jewel thief. Describing
one of his most successful images of this period, H.O. Box [1922, ill. p. 10], Outerbridge ex-
plained the print as an attempt

> *[To] fill the rectangle... with a harmonious and pleasing distribution of light and dark areas.*
> *It will be seen what use has been made of the shadow of the saw against the ground and the*
> *background for this purpose, as well as the shadow of a board [out of the picture] against*

which the saw is resting. The teeth of the saw have been purposely obliterated by being thrown out of focus in order to avoid being a disturbing element and bring the object in harmony with the other straight lines of the composition... Attention is especially called to the fine gradations in the saw, going from extreme dark to extreme light.

Justifying his artistic manipulations, the photographer concluded that he "was not taking a portrait of these objects but merely using them to form a purely abstract composition."[7]

In images like Ide Collar [1922, ill. p. 49] and Two Eggs in a Pie Tin [1923, ill. p. 42] the balanced perfection of Outerbridge's composition corresponds to the Renaissance theoretician Leon Battista Alberti's definition of formal beauty: no element may be added or subtracted without disturbing the harmonious congruity of the whole.[8] More than merely a successful advertisement and clever solution to a design problem, Ide Collar was appreciated by Marcel Duchamp as a "ready-made." Outerbridge's Ide Collar advertisement attracted the attention of Duchamp, who tore the image from the November issue of *Vanity Fair* magazine of the same year, and tacked it to his studio wall. Perceiving it as a found object transformed into art through the imagination of the artist, Duchamp identified Outerbridge's photograph of a manufactured collar on a checkerboard as additional evidence for the redefinition of art objects.

As in photographs by Charles Sheeler and Paul Strand, the formal armature of Outerbridge's carefully constructed images frequently demonstrated a photographic parallel to abstraction in painting. In Saltine Box [1922, ill. p. 11], described by Outerbridge as an "abstraction created for aesthetic appreciation of line against line and tone against tone without any sentimental associations,"[9] he created an elegant Cubist composition entirely through the manipulation of light.

Even though platinum was scant in the years immediately following the First World War, Outerbridge insisted on using platinum paper for his photography because of the rich tonal quality it gave his negatives. A diary entry during this time indicates his pursuit of a copy of the final issue of *Camera Work* from 1917 that contained 11 photographs and a text by Paul Strand, who was integral to the "new vision." Strand advocated a non-Pictorialist, straight photography that made of functional, commonplace objects dynamic images of beauty. Important for Outerbridge, Strand emphasized in his *Camera Work* essay that

[It] is in the organization of objectivity that the photographer's point of view toward life enters in, and a formal conception born of the emotions, the intellect, or of both, is inevitably necessary for him, before an exposure is made, as for a painter before he puts brush to canvas. The objects must be organized to express the causes of which they are the effects, or they may be abstract forms that create an emotion unrelated to objectivity as such.[10]

Outerbridge enthusiastically embraced the formal components of this emerging new aesthetic. Voicing similar contemporary concerns over formal abstraction, he exclaimed, "the problem attempted here is to make pure black and white sparkle like fireworks...!"[11]

Exhibiting a natural talent for photography, success came rapidly to Outerbridge and by 1925 he was eager and ready for more rigorous, aesthetic challenges.

When he moved to Paris that same year, after accruing a considerable body of photographic work, he worked for Paris *Vogue*, making photographs of fashion accessories, where he

met Edward Steichen [who would remain a life-long rival], as well as Man Ray and Berenice Abbott. The latter two introduced him to Duchamp, Brancusi, Picasso, Stravinsky, and Picabia, among many others. Immersion in this world of modernism, energetic ideas, stimulating conversation, technical mastery, financial success, and artistic recognition provided a powerful antidote to the career indecisions and doubts of his earlier years. He remained in Europe until 1929, spending three years in Paris and two in Berlin. In competition with Steichen, he left *Vogue* and began working for other magazines, stating in his autobiography:

> I held the Vogue *job for perhaps three months and quit due to the following causes: interior politics, misunderstanding and disagreement with the owner due to over self-confidence on my part and utter lack of business knowledge and headstrongness, etc. There was never any criticism of my work, which was much liked and well thought of.*[12]*

During this period of freelancing, Outerbridge teamed up with Mason Siegel, the world's leading mannequin manufacturer, to build a reported 1,500,000-franc photographic studio, which closed after less than a year. Before its total demise, however, the photographer made several images of the wax dummies in strange positions with unusual props. These static, remote mannequins provided a subject matter that would resurface in his emotionally distant, yet erotically charged photographs of female nudes a few years later.

After his separation from his wife Paula in 1927, Outerbridge relocated in 1928 to Berlin, where he became involved with German cinema, which he greatly admired. He seems to have studied with Georg Wilhelm Pabst, who was prominent among directors cultivating the new realism. Uninterested in creating "pictorial" compositions, as German director Friedrich Wilhelm Murnau did, Pabst arranged real-life material to attain veracity paralleled in photography by August Sander.[13] Shortly thereafter, Outerbridge found it more congenial to work in England with Ewald André Dupont who, collaborating with cameraman Karl Freund, had directed the very successful film *Variety* in 1925. Dupont had transformed the conventional realism of feature film by using unusual camera angles and multiple exposures, which Outerbridge believed resembled his own work of three years earlier. Significantly, *Variety* is a seamy music-hall story in which the sensual beauty of a trapeze artist drives her partner to jealous rage and murder. A habitué of the nightclubs of Paris and cabarets of Berlin, Outerbridge increasingly wove symbols associated with this life into his images, adding a note of bizarre fetishism particularly prominent in his later Carbro-color nude studies.

Disappointed by his failed attempt to make career headway into the movie industry, by his unsuccessful venture with Siegel, and by a failed marriage, he returned home to New York in 1929. That he succeeded in breaking into the exclusive ranks of the international avant-garde at this time is evidenced by two important exhibitions. The Stuttgart *Film und Foto* exhibition of 1929 remains among the most important and comprehensive photographic exhibitions ever held. International in its scope, the show included Outerbridge among the Americans.[14] And, later, Beaumont Newhall included Outerbridge in his mammoth 1937 Museum of Modern Art exhibition, *The History of Photography*, as well as in his *Pageant of Photography* in San Francisco in 1940. His work reportedly made an emphatic impression, which enhanced his reputation in Europe as well as the United States. The Julien Levy Gallery also showed Outerbridge's work in

1932, further testifying to his stature as an artist, regardless of medium. Not only a pioneer in the advocacy of photography as art, the Levi Gallery was for two decades one of the most important galleries in New York, and this association placed Outerbridge alongside Moholy-Nagy, the Surrealists, and other avant-garde contemporaries.

In 1930, Outerbridge assessed that his black-and-white photography had developed as far as it could. Undaunted by the financial conditions of the time, he realized that color would soon become a major component in the marketplaces of both fine art and commercial photography, so he set about immersing himself in the most innovative [and expensive] research on color to date. His painstaking studies would lead to the development of the Carbro-color print, which he compiled into *Photography in Color*, a book published by Random House in 1940 which met with critical praise. Several laborious hours of concentrated effort and financial investment went into making a single Carbro-color print. It is unique among photographic processes because the pigments used are the same as those in oil paint. Not only are the pigments unusually permanent, but they exhibit an extra-dimensional quality, the shadows perceptibly deeper in their glossy appearance and the highlights finely graded in their matte surface. Enhancing the tactile sense of the objects photographed, the relief effect augments the illusion of depth and defines the compositional elements more sharply than alternative techniques allowed. That Outerbridge consistently employed this process to produce his images testifies to an intensity of vision matched only by infinite patience and obsessive precision. Important to him was how the physical qualities inherent in this color technique gave his prints an intensely lifelike effect.

He accurately assessed the quality of his work and consistently demanded – and received – very high prices, as much as $750 for one color print. Early dummies for *Life* magazine for example were put together and circulated by Henry Luce to attract backers and advertisers for the magazine, a photo-illustrated weekly that would transform and unite American culture beginning in 1936 and continuing for decades to come. One such prototype constructed by Luce contained a cover by Outerbridge and five of his color photographs within, examples of "the beauty and art that could be encompassed with camera and color." Although initially reluctant to pay Outerbridge his customary high price, Luce eventually conceded.

In 1930 Outerbridge set up a color studio at his country home in Monsey, New York. For the next several years he would support himself with successful color and black-and-white commercial work for *Vanity Fair*, *McCall's*, *Harper's Bazaar*, *Advertising Arts*, and *House Beautiful* to name a few. Many of the color prints he made during this time are, in essence, extensions of his black-and-white experiments in abstract composition. In the earlier platinum work, the objects from which the images were composed tended to be drained of symbolic content. In color, however, these elements are endowed with an overpowering presence. Their symbolic character is made more seductive by the heightened tangibility of the color process so that the images retain a suggestiveness and overt sensuality not present in the monochromatic pictures.

For instance, Outerbridge's black-and-white Fan and Pearl Necklace [1924, ill. p. 55] functions primarily as an exercise in abstract composition, whereas the Carbro-color print Party Mask with Shells [1936, ill. p. 201] is not only a superb composition, but it is also an image that evokes the tawdry finery and decadence of a Berlin cabaret. If Outerbridge's platinum prints

made in the 1920s can be related to the mainstream in progressive art during the years of their creation, his color work of the 1930s is wholly unique, extraordinary, and evocative. According to one reporter at the 1937 third U.S. Camera Salon, the crowd stopped in front of Outerbridge's exhibit of Carbro-color prints, "apparently stunned by the perfection of the man's work. Without doubt it was the artistic and technical sensation of the salon."[15] The difficulty of the Carbro-color print process, and its unexplored sensual and expressive potential, offered Outerbridge the exacting challenge he had been looking for.

One particular color masterpiece created during these years was Images de Deauville [c. 1936, ill. p. 197]. The effect of disorientation produced by reflecting surfaces in the image is the result of the dislocation of reality arising by the games Outerbridge played with perspective and the peculiar assortment of objects represented. Perhaps alluding to André Breton's dictum that a Surrealist painting should be a window through which one looks onto an inner landscape, Outerbridge located an oversized playing die, a silver sphere, a yellow pyramid, a clam shell, and a seascape within constructed frames. Taking advantage of pictorial conventions established in the Renaissance, he made the corners of each frame form perspectival orthogonals which produce an illusion of deep spatial recession, enhancing the impression of monumentality created by the overall scale of the photograph. By manipulating conventions to reveal new meanings in the startling juxtaposition of familiar objects, Outerbridge extended to photography attitudes he acquired through his association with the Surrealists.

His most substantial work among the Carbro-color prints, however, deals with the female form as subject. With regard to the nude, Outerbridge believed it to be a legitimate subject of artistic expression, as have artists for centuries. Yet, resistant 19th-century social mores persisted against his definitively uninhibited, post-World War I, creative exploration of this subject. Following difficulties with the Eastman Kodak Company, when they refused to process some of his film [which was returned after the "offending" images had been mutilated], Outerbridge wryly observed that a perfectly simple, innocent nude study had been given pornographic connotations." Although he complained that "the business of the state trying to legislate modesty is relatively both an infantile and ridiculous procedure," he was not vocal in this regard. An urban gentleman not wishing to draw attention to himself, he was content to avoid confrontations with censorious authorities such as Hollywood's recently empowered Hays Office. Outerbridge himself sometimes altered his prints when public display warranted delicate editing because "the law specifically appears to ban nipples and pubic hair, and although they are unable to prevent nature from growing these physical attributes, they can at least prevent people from photographing them."

The principles underlying his practice in photographing the female form included considerations such as the following:

Cause a cute nude model to look directly at the lens with a provocative smile or inviting glint in her eye, and the photographer has usually crossed the border between the nude and a particular girl without her clothes on. He might be said to have left the world of art and entered the world of pornography.

In addition, he appreciated juxtapositions such as "bringing soft, warm flesh against cold hard stone"; furthermore contrasts that "enhance the nude form's inherent characteristics" are neces-

sary components in creating an effective composition. "The fundamental law of opposites in nature," he continued, "hot and cold, hard and soft, positive and negative, dark and light may be advantageously made use of to enhance the dramatic effect."

Working for himself alone, he created nudes that reflect formal aesthetic principles, a powerful erotic content, and a unique, unprecedented vision. Like the Carbro process itself, the nude represented a considerable challenge to him. "The nude," he maintained, "is by far the most difficult of all subjects."[16] He noted the problems of color reflections, which are increased by the fact that the contours of the body are constantly changing. He found that "the outline of the figure changes momentarily with the slightest movement. The human body is a remarkable plastic thing." Female nudes, such as Model [1923, ill. p. 129] or *Odalisque* [1936] make Outerbridge's ideal of feminine beauty particularly clear. The composition of these pictures refers back to famous paintings like *The Valpiçon Bather* [1808], *Grande Odalisque* [1814], and *The Turkish Bath* [1863] by the French classical painter Jean-Auguste-Dominique Ingres. As formal solutions to compositional problems and as exemplifications of color technique, photographs such as Odalisque and the two versions of Nude with Frame [1938, ill. pp. 8-9] demonstrate Outerbridge's consummate expertise in rendering form, texture, and color as an expression of intention and desire.[17]

These nudes were created within the context of the Surrealist rediscovery of woman as a myth and object of obsession. They relate thematically to the efforts of Surrealist photographers like Henry List and Clarence John Laughlin, who attempted to show desires, fears, and frustrations through the representation of the symbolic contents of the subconscious.[18] Yet, even in this context, many of Outerbridge's nudes, which were also among his most personal works, remain unique. Recognizing that the elegantly postured figures are adorned with the accoutrements of his obsessions, we find it preferable to leave discussion of their content to others, and accept in this regard Outerbridge's own words:

> [A] fine complete work of art...should carry its own message inherent within itself. Book illustrations visualize the text, and the text explains the pictures, but the higher forms of art exist for themselves alone, and being quite complete within themselves, do not need another art form [literature] to enhance their significance.[19]

Outerbridge's Carbro-color print studies are comparable to and probably more fascinating than his other work because of their unconventional imagery. The treatment of the figure as a compositional element represents an extension of his earlier experiments in the manipulation of form. Like the subtle modulations of tone captured in the black-and-white prints, the exquisite rendering of texture, light, and color testifies to an unparalleled command of his medium. The culmination of his creative career, the Carbro-color print defines the limits of the camera as a medium of artistic expression. From the 1940s through to the 1950s, Outerbridge was successful in selling his commercial work and several photo-essays about his travels throughout the United States, Mexico, and South America. He moved to Hollywood in 1943, and then to Laguna Beach, where he set up a small portrait studio. In 1945, he was married a second time, to Lois Weir, a successful fashion designer, with whom he went into business, merging his own skills with hers to create "Lois-Paul Originals." In 1958, he died of lung

cancer in Laguna Beach, California. In 1959, the Smithsonian Institution held a solo exhibition of his work.

Prominent among photographers working to develop an independent aesthetic for photography, Outerbridge, alone among his colleagues, possessed the artistic vision and technical finesse to explore the entirely new medium of color through the application of his experience in refining black-and-white composition. He was among the few but talented visionaries of modernist photography who established the medium as an artistic language. Outerbridge applied his intuition, dedication, and technical knowledge to the creation of powerful, oftentimes beautiful, always memorable images which fulfilled his definition of art as a victory for the imagination over the imperfections of reality.

1] Paul Outerbridge, "Patternists and Light Butchers," in: American Photography, 46, no. 8 (August 1952), p. 54.

2] During this time, Outerbridge also wrote a lengthy treatise titled "What is Feminine Beauty," published in Physical Culture [January, 1933], 37-39, 74-77, no doubt influenced by the books he studied while in Paris on sexuality and the erotic.

3] To make a single Carbro print, three separate exposures through three different colors were required, and as in silk-screening, these needed exact registration onto the paper. It took up to ten hours to develop a single print, and cost a minimum of $100 per image, which during the Depression [and even today] was a considerable investment.

4] Weber recalled, "... to my mind, to this day, my teaching at the White School was the first authentic, geometric approach to the basic construction of photographs as art." From John Pultz and Catherine Scallen, Cubism and American Photography, 1910–1930 [Williamstown: Clark Art Institute, 1981], p. 42.

5] Maurice Burcel, "Paul Outerbridge, Jr.," Creative Art, 12, no. 2 [February 1933], pp. 110-12 passim.

6] Unpublished autobiography, J. Paul Getty Center Archive, Los Angeles.

7] Paul Outerbridge, "Visualizing Design in the Common Place," in: Arts and Decoration, 17, no. 5 [September, 1922], pp. 320ff.

8] Leon Battista Alberti, Ten Books on Architecture, ed. J. Rykwert, trans. J. Leoni [New York: Transatlantic Arts, 1966], VI, II, p. 113. "...I shall define Beauty to be a Harmony of all the Parts, in whatsoever Subject it appears, fitted together with such Proportion and Connection, that nothing could be added, diminished or altered, but for the Worse". See also IX, V (esp. pages 194 195).

9] Graham Howe and G. Ray Hawkins, eds., Paul Outerbridge, Jr.: Photographs [New York: Rizzoli, 1980], p. 11.

10] Paul Strand, "Photography," in: Camera Work, nos. 48-50 [June 1917], p. 112.

11] Robert Marks, "Portrait of Paul Outerbridge," in: Coronet 7, no. 5 (March 1940), p. 27.

12] Unpublished autobiography.

13] Siegfried Kracauer, From Caligari to Hitler [Princeton: Princeton University Press, 1947], p. 168.

14] In celebration of the 50th anniversary of this famous exhibition a number of reprints of the catalogue were published in Germany and the U.S. The Periodical Camera, no. 10 [October 1979] devotes the whole issue to the exhibition. See also Film und Foto [New York: Arno Press, 1979].

15] U.S. Camera, Annual, 1937, p. 30

16] He wrote extensively about it in an essay "What is Feminine Beauty" [published in Physical Culture, 1933] and in an unpublished essay titled "The Nude," both of which helped him clarify his intentions for this new subject matter.

17] All quotations from an unpublished, undated manuscript by Outerbridge titled "The Nude," pp. 1-6 passim [Outerbridge Archive, Special Collections, The Getty Center for the History of Art and the Humanities, Los Angeles].

18] Nancy Hall-Duncan, Photographic Surrealism [Cleveland: New Gallery of Contemporary Arts, 1979], p. 10.

19] Paul Outerbridge, "Clarence Laughlin and His Many Mansions: A Portfolio," unpublished typescript dated 12.5.52, located in The J. Paul Getty Center Archive, Los Angeles

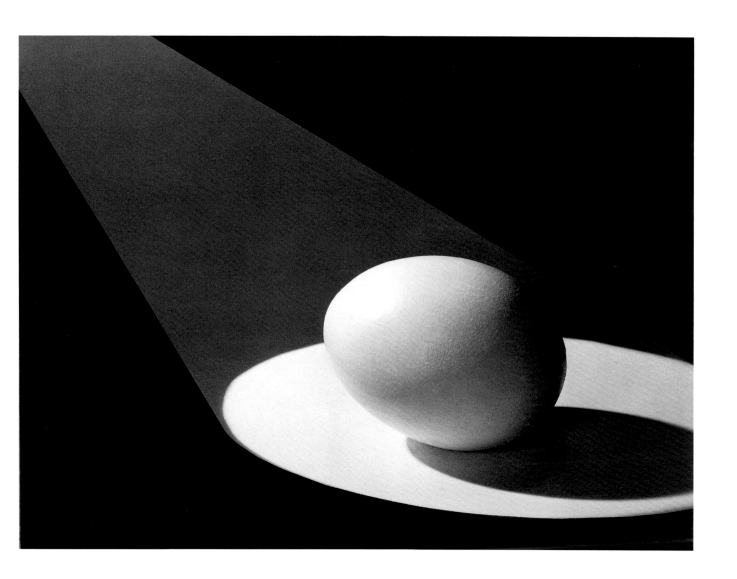

Egg in Spotlight | Ei im Rampenlicht | Œuf sous le feu du projecteur
c. 1928

The Carbro Process

Excerpts from *Photographing in Color*
by Paul Outerbridge

In the opinion of the majority of color workers, Carbro is by far the finest of all the color print processes. It is not so new, but until present-day advertising created a sufficient demand for color prints, really intelligent efforts were not made to bring it out of the laboratory and into some sort of general practical use. [...]

The chief causes for failure in the Carbro process up to recent times were lack of standardization of all operations and lack of densitometric control of negatives, lack of voltage control on the enlarger, and unbalanced color tissues having insufficient adhesive element to insure their remaining on the celluloids during development. [...] With the proper equipment and knowledge, a Carbro print is becoming increasingly simple to make. Undoubtedly Carbro yields the most beautiful prints of all the available printing processes. [...]

Carbro is a process that necessitates precise timing of all operations, and temperature and humidity control. It is subject to quite a few variables, depending upon the chemical content of the water available, climate, weather, storage, age of materials, and many other things. If you are willing to spend the amount of money required and apply plenty of concentrated, intelligent effort, you can learn to make good Carbro prints and even arrive at fairly consistent results, but don't think it will be easy. [...]

PREPARING NEW CELLULOIDS FOR WORK

There are two theories about preparing new celluloids for use in Carbro printing. One is that they should be washed first in slightly abrasive soap [or Gold Dust, for example]. But never use anything gritty that will actually scratch them. The other theory is that merely by waxing them once, polishing them off, and letting the wax dry thoroughly and then rewaxing them and repolishing, they are satisfactory for use. When they get too scratched or worn they should be discarded. They will give a cleaner image when they are at their newest, but they will work a little more satisfactorily when they have been broken in a bit. Never attempt to clean them off in very hot water, as too much heat will make them buckle; if they become badly buckled, they will not lie flat when you attempt to squeegee your color tissue on them or when you wish to superimpose all three in register to examine the color balance of your print. [...]

WAXING THE CELLULOIDS

[...] Sprinkle a few drops of the waxing solution near the four corners and in the center of each celluloid. Take a buffer that you have previously made as follows: make a block of wood about two inches square by one inch high; fasten to the bottom of this, with hot glue, a piece of springy felt [like piano felt] about a quarter of an inch thick. Make another one of these, but larger – about two by four inches. You now have the necessary tools for waxing and cleaning off celluloids and also for cleaning off the residue of wax left on your temporary support paper. [...]

BROMIDE PRINT PAPER

The basis of Carbro printing is the bromide prints. Ilingworth Normal Contrast Bromide Paper [...] is the best for this purpose. It is the paper used by most of the best Carbro workers, and comes in rolls ten yards long by 40 inches wide, and also in ten-foot rolls of the same width. Packages of a dozen cut sheets may be had in 11 x 14 or 8 x 10 inch sizes. If one is doing much work, the larger rolls are more economical, for they go soon enough; furthermore it is better to buy bromide paper for Carbro in roll form. Defender Velour Black may also be used with the two-bath bleach, but deeper printing will be necessary to produce the same results. [...]

FIXING AND WASHING

The bromides should be fixed for 15 minutes, but no longer, in a fresh hypo solution and washed for from one hour to an hour and a half. As the fixing bath ages, the prints may be left in for a longer time without harm, but in the long run it is always better to use it fresh. Hypo must be entirely eliminated or troubles will ensue, so it is best to test for complete elimination with a permanganate solution. [...]

REDEVELOPING AND SAVING BROMIDES

A certain amount of critical faculty, which comes only with experience and knowledge, is essential in examining and compar-

ing for balance a set or sets of bromides. For this reason, I think in Carbro it is well to redevelop and save the bromides in order to use them later for purposes of comparison by way of printing depth and for checking the tonal value of certain colors in new sets against similar or nearly similar colors in past pictures. A good reference library of this sort, together with your notebook, is of great value under certain conditions. Nearly exact duplicates of color prints may be made from a set of redeveloped bromides. I have found this the best way to come closest to the original print. For this purpose, the bromides should be redeveloped for five minutes, preferably in plain metol developer. After this second development, about a half-hour of washing is sufficient. If any trouble is experienced, washing should be more thorough. [...]

SOAKING PIGMENT PAPER

[...] After one minute has elapsed, immerse the red pigment paper in the same tray, above the blue, following the same procedure. At the end of the next or second minute put in the yellow. When the clock rings, at the end of the third minute, reset it and lift out the blue tissue and hang to drain with clips in the two upper corners. At the end of another minute, take out the red tissue and hang to drain. At the end of the next—the third minute—lift out the yellow to drain. It will be seen that it is necessary that each color tissue, or pigment paper, soak and drain for exactly the same length of time, and each must receive identical handling.

SENSITIZING AND BLEACHING PIGMENT PAPER

When the clock rings again, at the end of the third minute [a total of six minutes has elapsed], pour the b and c solutions into the sensitizing bath and rock the tray well to thoroughly mix. Start the second timer and immerse the blue pigment paper in the sensitizing solution at exactly 12:00, zero, rocking constantly in both directions. When the second hand comes up to 12:00 again, at the end of 60 seconds, immerse the red pigment paper, and in another 60 seconds, the yellow. 30 seconds after the yellow is put in, remove the blue tissue from the bottom of the tray and bring it to the top. The tray should be carefully rocked throughout this entire procedure to ensure even sensitizing and bleaching.

SQUEEGEEING THROUGH THE WRINGER

Now you will have to step lively. 15 seconds before the three minutes have elapsed, lift the blue printer bromide from the soaking tray and hold it up to drain until it reaches the dripping stage; then place it on the marks of the top or right celluloid in the wringer. Immediately remove the blue pigment paper from the sensitizing bath and, without draining, place it on the marks of the bottom or left celluloid. Release the top celluloid from its hook and, holding it with the left hand, keep the bromide and color tissue apart until they enter the wringer; with the right hand, operate the wringer as quickly as possible,

and then set the "sandwich" which has come through to one side. Set a ten-minute clock on it. In the tight contact between bromide and Carbro color paper produced by the wringer, the image on the bromide is transferred to or hardened in the Carbro pigmented gelatin, and whatever has not been hardened will wash away in the hot water bath, leaving an exact reproduction of the black-and-white bromide print image in colored gelatin. [...]

SEPARATING SANDWICH AND THE ALCOHOL BATH

Prepare a fresh tray of cold water—the colder the better, certainly below 60°F—and place this next to the slab of thick plate glass on the work bench. When the ten-minute bell rings, remove the combined blue bromide and pigment paper sandwich from the celluloid blanket and place it in this tray of cold water. Then carefully peel the bromide apart from the pigmented paper under water and set the bromide to wash immediately, face down. Where air bubbles persist, it is possible to eliminate them by means of a 25 percent alcohol bath of low temperature used in place of cold water. This alcohol bath relieves surface tension and should be mixed and cooled before using, as mixing generates heat. In warm weather, this tray should be well iced and the celluloids well chilled to prevent slipping of the pigmented paper when squeegeeing. The pigmented paper should not remain in this bath for more than 30 seconds after the bromide has been removed. [...]

SQUEEGEEING

Now remove the tissue from the water or alcohol bath, and without draining, let the lower end of it come in contact with the left side of the celluloid, which is firmly anchored on the sheet of glass. Press this end down firmly, hinging down the rest in a manner calculated to exclude air. All squeegeeing operations in the Carbro processes involve the complete exclusion of air from between the two surfaces in contact. The film of water squeezed out should always carry all air with it. Hold the left side of the color tissue down firmly with the left hand, preventing any possibility of movement, and with either a flat rubber squeegee or one of the window-cleaning variety, which I use, draw the squeegee across the pigment paper from about one-third of the distance from the left end of the celluloid, from left to right, slowly and evenly, to exclude all moisture and air. [...]

DEVELOPING CELLULOIDS

Fill two trays with hot water, from 110° to 115°F and a third with cold water. Slide the celluloid bearing the blue pigment paper into the first tray, and set a two-minute clock on it. When the bell rings, you will see the excess gelatin, which has not been hardened by chemical reaction, beginning to ooze out from beneath the edges of the paper. Place the thumbs on diagonally opposite corners of the color tissue, underwater, and gently slide the tissue sideways. Then peel back the tissue slowly from the gelatin and throw it away, keeping the celluloid against the

side of the tray to loosen the excess pigment, and rinse under water until the water becomes cloudy with the dissolved gelatin. Now rinse by running it through the hot water with a pendulum movement, lifting it out of the water with both hands, from side to side, with a motion calculated to wash off as much excess gelatin as possible. The image transferred from the bromide will now be clearly apparent in blue pigment. Place the celluloid face up in the second tray of hot water and allow it to remain while the red tissue celluloid is slid in to soak in the first tray. [...]

TRANSFERRING THE IMAGES

The Carbro images appear in the final print assembled in the following order: yellow at the bottom on the paper base, next red, and then blue on top. The reason for this order is that the yellow is an opaque pigment while the red and blue are transparent. If the yellow were on the top, the other colors could not be seen properly through it. Therefore if the three images were transferred straight off onto final support paper, the yellow would have to be put down first; as it is somewhat difficult to see the outlines of a yellow image against white, registration of another color over it would be quite difficult. [...]

REMOVING WAX FROM THE TEMPORARY

The coating of wax which left the celluloid must now be removed from the temporary support paper, or the next [red] image will not adhere. Tack the temporary down in the four corners with push pins on a drawing board kept for this purpose. Saturate a wad of cotton with rectified spirits of turpentine, and wipe off the print. Then go over the surface with fresh cotton; then with a square of cotton flannel wrapped around the larger of the two buffers used for polishing the celluloids. Polish off as much wax as possible. [...]

SOAKING TEMPORARY FOR SECOND TRANSFER

Take the temporary support and again submerge it in the same water. After the back is wet and it has become slightly limp, lift it out of the water with both hands at the corners and lower it down into the surface of the water slowly to remove all air bubbles. The celluloid bearing the red image, face up, should have been previously slid under it just as was formerly done, and naturally, with the composition facing in the same direction as on the celluloid. Put a five-minute clock on it. At the expiration of this time, draw out the two together as before and, by holding them up to the light, slide them into the best rough quick register possible. The heat from the thumbs on the edges of the paper, if held in one place for a few moments, will serve to tack or anchor lightly its position. [...]

REGISTERING THE RED AND BLUE IMAGES

Lay the celluloid down on the glass plate and squeegee the temporary very lightly to remove the excess moisture and air. The celluloid is then picked up, and by transmitted light the image on the paper is moved about, holding the temporary only by the borders until it registers as well as possible over the red image. Then give the temporary another light squeegee, and turning the celluloid over upon a fresh photographic blotter, squeegee the water off the back. Squeegee the moisture off the glass plate. Lay a fresh dry blotter down on the glass plate and lay the celluloid, with the temporary underneath, next to the blotter. If any air bubbles are visible, they must be removed with a small squeegee before commencing local registration. [...]

After this area is registered, by the time you get down into the center of the print you may find it has dried sufficiently to obviate further squeegeeing. If it moves into register too easily, it will pull out again just as easily. It should stick tightly enough to stay in place once you have pushed it there. If, on the other hand, it takes a great deal of pushing to register, you had better resubmerge the celluloid in the water, and under the surface, gently peel the temporary off the celluloid where you are having the trouble. If the difficulty has occurred in the lower portion of the print, you need not, of course, separate the images farther than where the trouble lies; then, after lifting the celluloid out of the water with a quick upward movement, you may very lightly squeegee the separated images back together again. [...]

REGISTERING THE YELLOW IMAGE

After registration of the blue and red images is completed, pin the celluloid up to dry in front of a fan as before. When the temporary has dried and fallen from the celluloid, you will have a purple image in, we hope, perfect register. Clean this image with turpentine as you did with the blue, and following the same routine, soak the combined blue and red on the temporary with the yellow on the celluloid for five minutes. At the end of that time, remove them and register, as you did the other two images, remembering that it is always the image on the celluloid that you are moving. [...]

TRANSFER TO THE FINAL SUPPORT

After the temporary support bearing the complete transfer has come off the celluloid, it should be cleaned off with turpentine in the manner previously described, making sure that the cleaning has been thorough. Then trim off the outer edge containing the push pin or thumb tack holes, and perhaps a few small tears, to within a half-inch of the picture area. Immerse it in the large tray of cold water in which the final support paper is floating, face up. Pull the final support paper through and under the water to ensure completely covering its surface, and then let it stand face up—but completely submerged—for one minute. Then remove it from the water and lower it down in the manner previously described for avoiding air bubbles. Let it rest face down in the water for another minute, at which time slide it over the final support paper which is now grasped with both hands, the thumbs holding the temporary to its sur-

face in the two upper corners, and lift it straight up out of the water to ensure quick drainage with exclusion of air from between these two surfaces. Lay the final support paper down on a sheet of glass, face up, with the temporary on top. Squeegee the two surfaces together, as previously described, in all directions and until as much moisture as possible has been squeezed out of this sandwich. The drier you can get it, and the tighter the contact, the better. By a corner, lift it up off the sheet of glass; squeegee all the water off the glass; lay a new blotter on the glass, then the final support on this, and another new blotter over it. Roll with the roller lengthwise and crosswise, and with greater pressure than previously employed. Lay on top of the whole a thick sheet of plate glass, and on top of this place bottles of photographic solutions to a total weight of about ten pounds, and set a half-hour clock on it.

DEVELOPMENT OF THE FINAL SUPPORT

Just before the expiration of the half-hour, run a tray of 110°F water, and when the bell rings, lay the combined final and temporary, with the temporary underneath, on the surface of the water. The temporary is placed underneath so that the hot water will start melting its soluble gelatin as soon as possible. With a cupped hand, spread water over the back of the final support to keep it flat. Put a two-minute clock on it. This operation is very similar to developing the pigment tissues on the celluloids. […]

DRAINING AND DRYING

Hang this final print from a shelf edge with a couple of push pins for a minute or two, during which time you can cut off the required length of some pieces of ordinary commercial gummed tape, and get ready a smooth board like a drawing board on which to fasten the print. Lay the print down on the board, centering it carefully, before it touches—as it should not be moved once it has been placed. Wet the tape with a wad of cotton and tape the edges of the print to the board, pressing it down with the fingertips from the center outward along its length. Be sure that this tape is rubbed down tight, even using a small towel when rubbing. If the edges of the gelatin image show any tendency toward frilling, they may be stuck down with a soft camel's hair brush dipped in alcohol, or a solution of half alcohol and half water.

[New York: Random House, 1940]

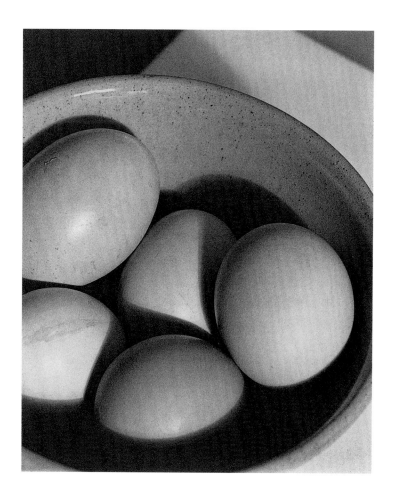

Eggs and Bowl | Eier und Schüssel | Œufs et saladier
1922

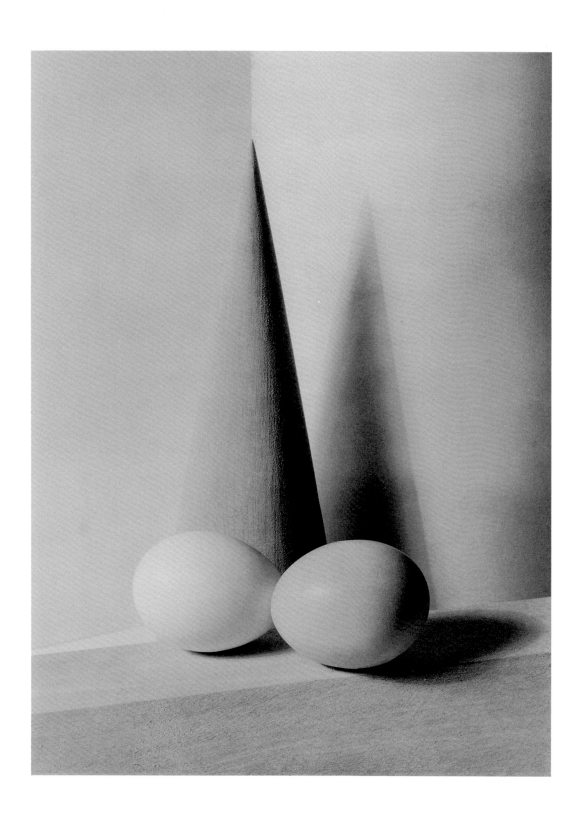

Consciousness | Bewusstsein | Conscience
c. 1931

Art is life seen through man's craving for perfection and beauty—his escape
from the sordid realities of life into the world of the imagination.

*Die Kunst ist das Leben, gefiltert durch das Verlangen des Menschen nach
Perfektion und Schönheit – seine Flucht vor der erbärmlichen Realität des
Lebens in eine Welt der Fantasie.*

L'art est la vie vue à travers le désir de perfection et de beauté de l'homme –
une fuite loin des réalités sordides de la vie dans un monde créé par son imagination.

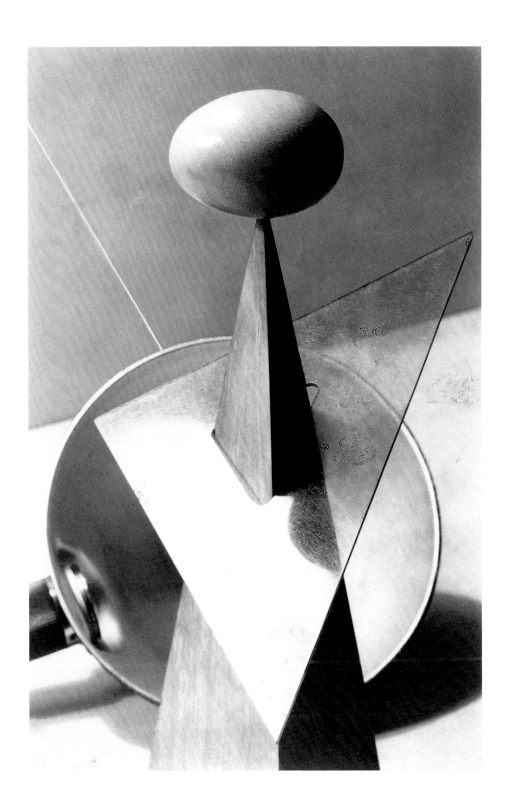

The Triumph of the Egg | Der Triumph des Eis | Le triomphe de l'œuf
1932

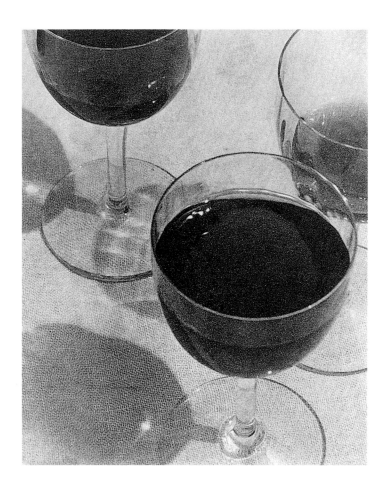

Wine Glasses | Weingläser | Verres de vin
c. 1923

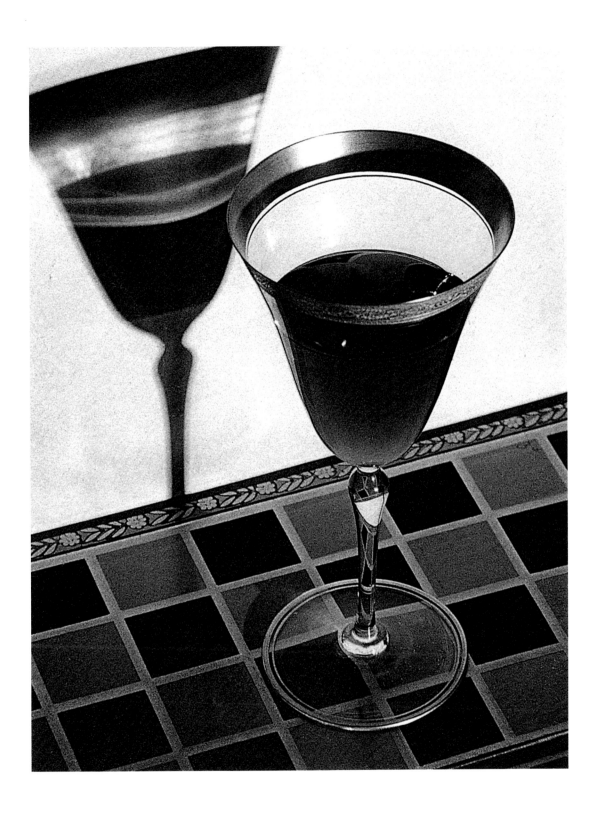

Wine Glass on Checkerboard | Weinglas auf einem Schachbrett | Verre de vin sur un échiquier
1922

Fruit in Bowl | Obst in einer Schale | Fruits dans un compotier
1921

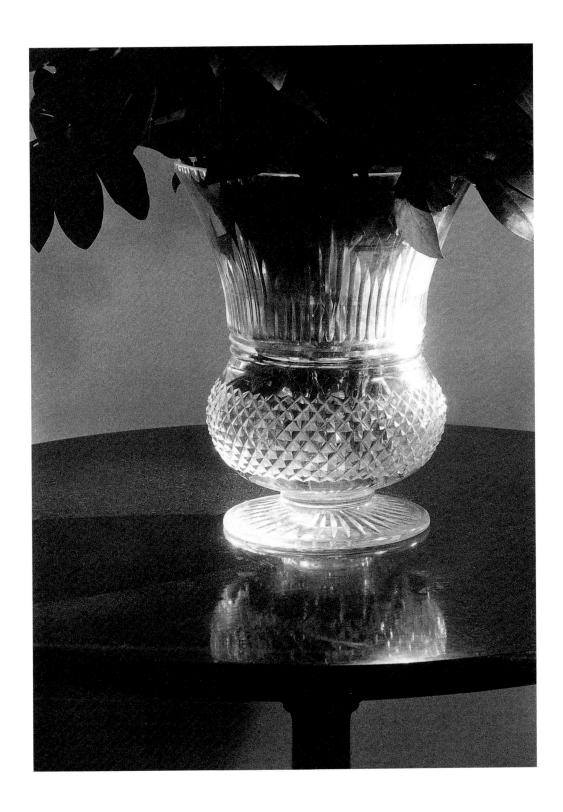

Waterford Glass Vase | Waterford-Glasvase | Vase en verre Waterford
1924

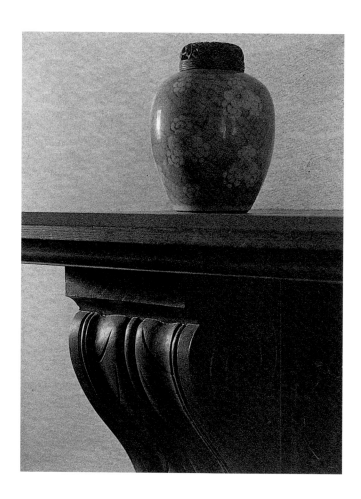

Vase on Mantel | Vase auf einem Sims | Vase sur un manteau de cheminée
c. 1922

Riding Crop with Spurs and Jacket | Reitgerte mit Sporen und Jacke | Cravache avec éperons et veste
1924

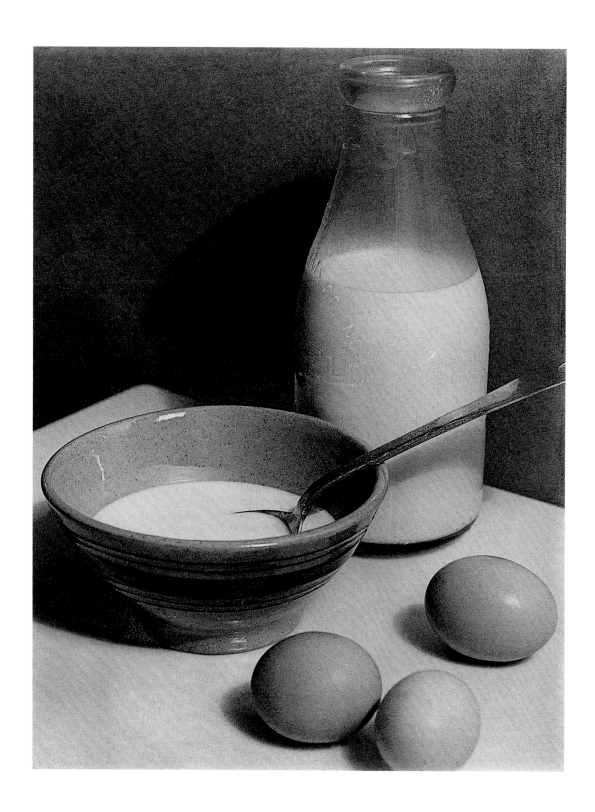

Kitchen Table | Küchentisch | Table de cuisine
1921

Rhythmic Curves | Rhythmische Kurven | Courbes rythmiques
1923

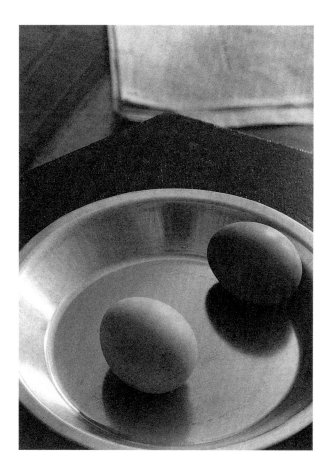

Two Eggs in a Pie Tin | Zwei Eier in einer Pastetenform |
Deux œufs dans un moule à tarte
1923

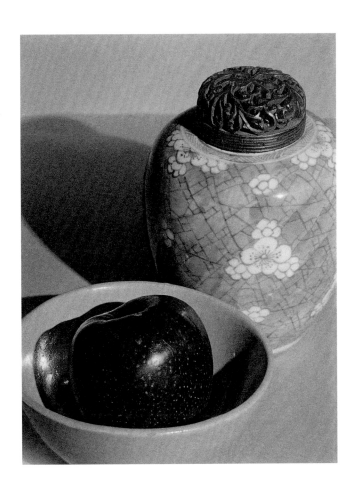

Study of an Apple with Ginger Jar | Apfelstudie mit Ingwerdose |
Étude d'une pomme avec un pot de gingembre
c. 1922

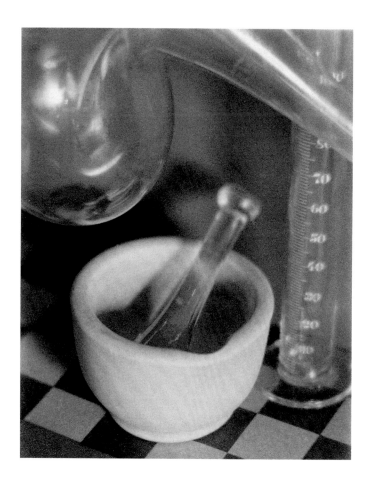

Chemistry | Chemie | Chimie
1923

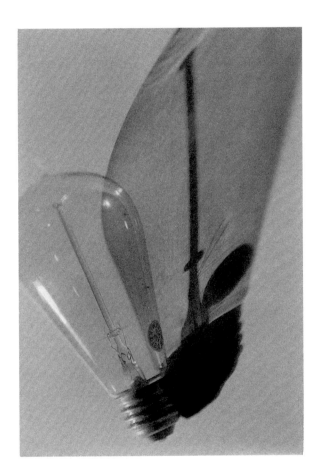

The Dragonfly's Wing | Der Flügel der Libelle | L'aile de la libellule
1922

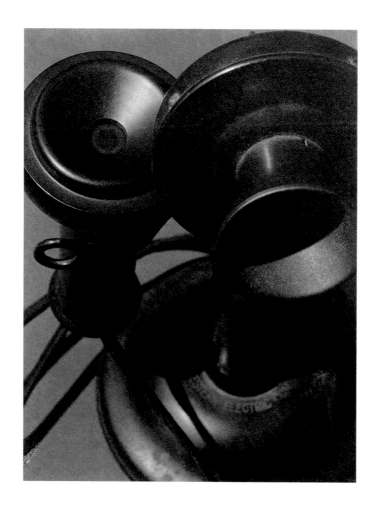

Telephone | Telefon | Téléphone
c. 1922

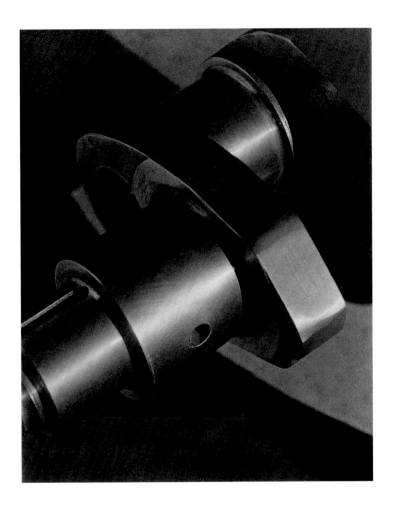

Marmon Crankshaft | Marmon-Kurbelwelle | Vilebrequin marmon
1923

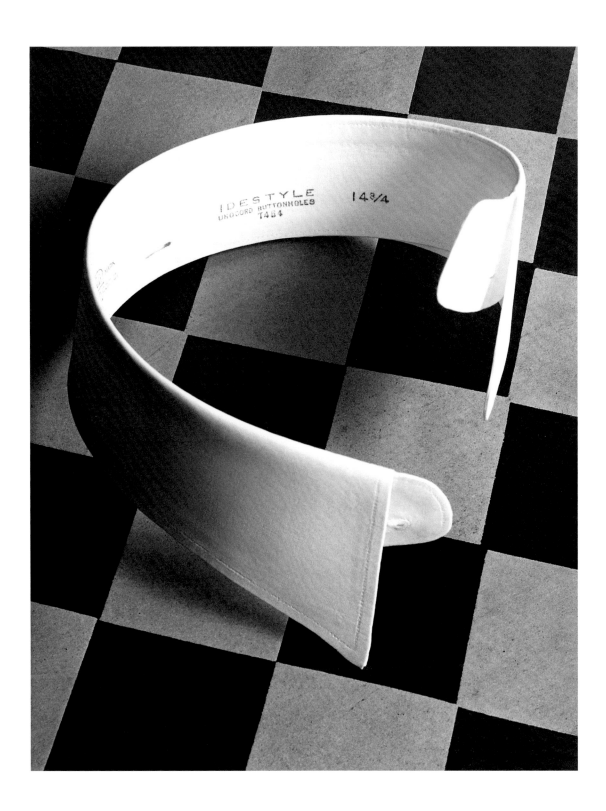

Ide Collar | Ide-Kragen | Le Col d'Ide
1922

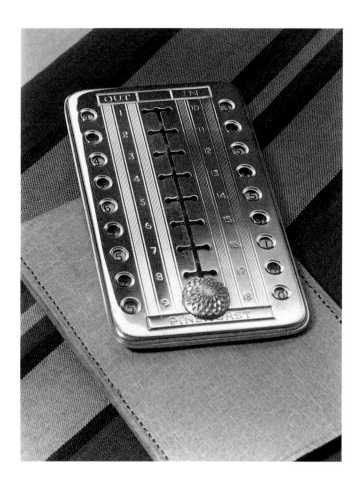

Golf-Score Keeper | Golf-Punktezähler | Marqueur de points [au golf]
c. 1924

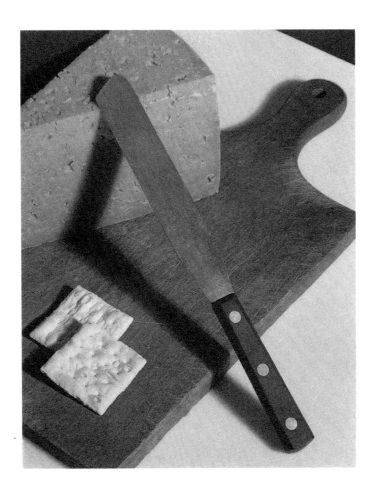

Cheese and Crackers | Käse und Cracker | Fromage et crackers
1922

Men's Scarves | Herrenschals | Foulards pour hommes
1924

Fantasy | Fantasie | Fantaisie
1926

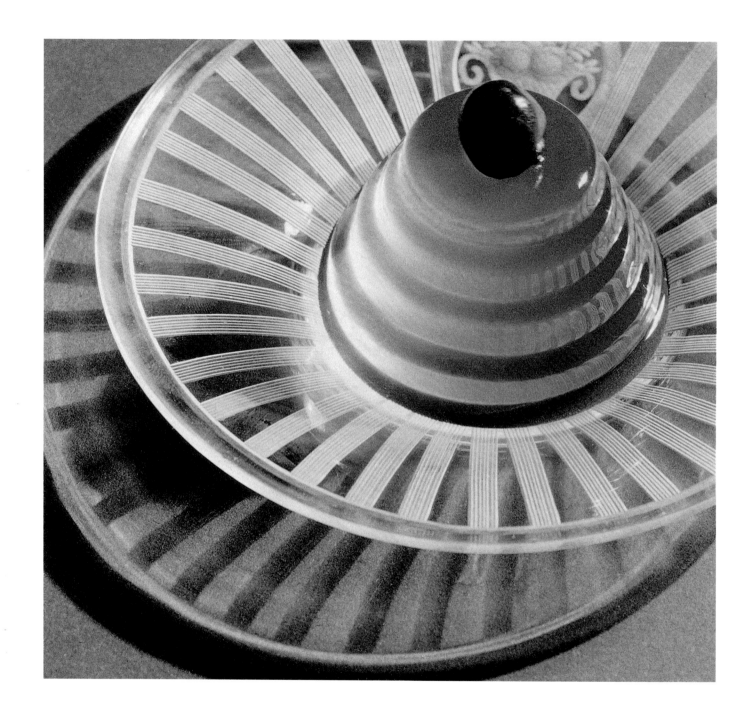

Jello | Götterspeise | Gelée
1923

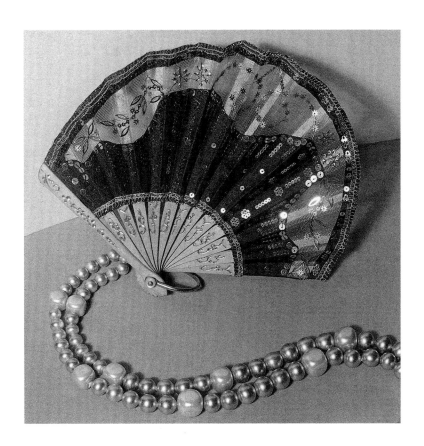

Fan and Pearl Necklace | Fächer und Perlenkette | Éventail et collier de perles
1924

The light and shadows, angles, and ellipses of a bowl, a bottle of milk, a collar, an electric light bulb, a breadboard, knife and cheese can be arranged into a design pleasing from an art sense and practical from an advertising one.

Die Gestaltung von Licht und Schatten, Ecken und Kurven einer Schüssel, einer Milchflasche, eines Kragens, einer elektrischen Glühbirne, eines Brettchens mit Messer und Käse kann so ausgeführt werden, dass sie vom Standpunkt der Kunst her gefällig und im Sinne der Werbung praktisch ist.

La lumière et les ombres, les angles ou les courbes d'un saladier, d'une bouteille de lait, d'un col, d'une ampoule électrique, d'une planche à pain, d'un couteau et d'un morceau de fromage peuvent être disposés de manière agréable pour les sens et efficace d'un point de vue publicitaire.

Men's Accessories | Herrenaccessoires | Accessoires pour hommes
1924

Pail on Ladder | Eimer auf einer Leiter | Seau sur une échelle
1922

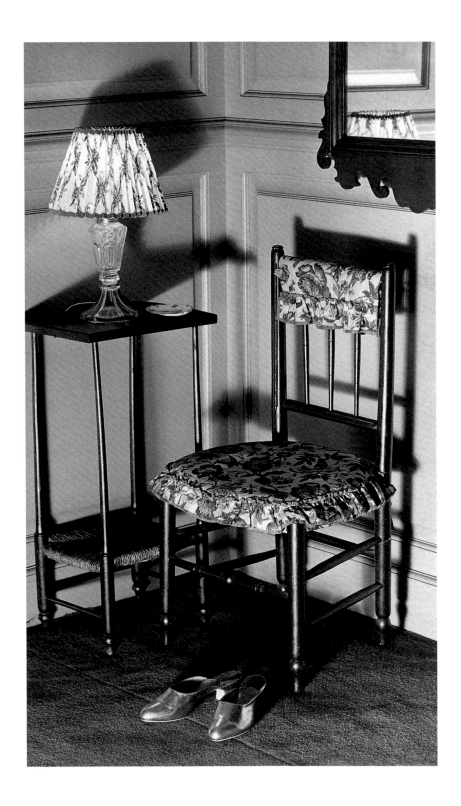

Table, Chair, Lamp, and Shoes | Tisch, Stuhl, Lampe und Schuhe | Table, chaise, lampe et chaussures
1924

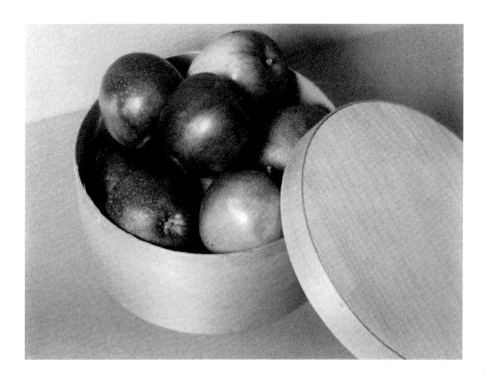

Apples in Container | Äpfel in einem Behältnis | Pommes dans un récipient
1922

61

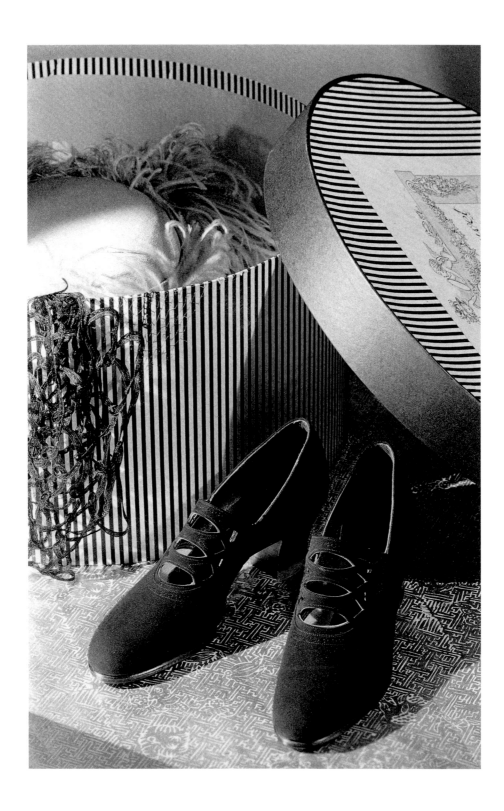

Hatbox and Shoes | Hutschachtel und Schuhe | Boîte à chapeau et chaussures
c. 1924

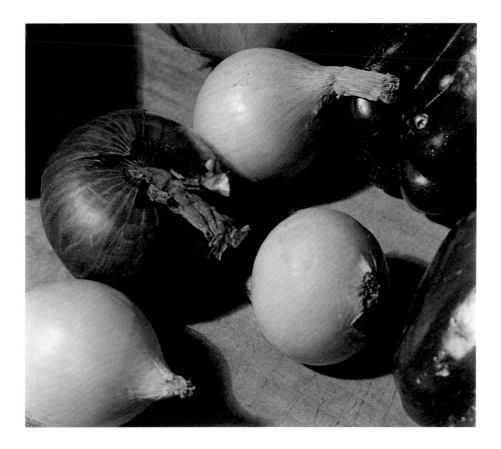

Vegetables | Gemüse | Légumes
1923

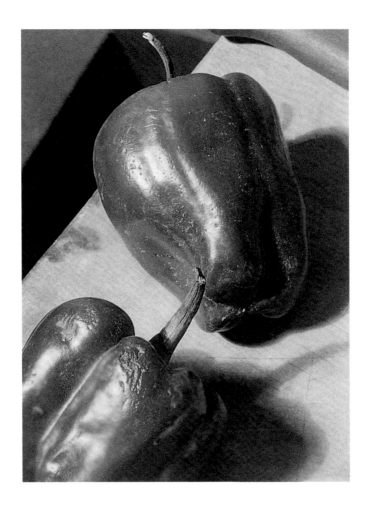

Green Pepper | Grüne Paprika | Poivron vert
1923

From all my activities and observations, what I have to sell is a certain amount of dependably good taste, which is quite a rare thing.

Nach allen meinen Beschäftigungen und Beobachtungen ist das, was ich anzubieten habe, ein relativ verlässlich guter Geschmack, der nicht oft zu finden ist.

Parmi toutes mes activités et mes observations, ce que je possède le plus est une certaine quantité de goût sûr, chose assez rare.

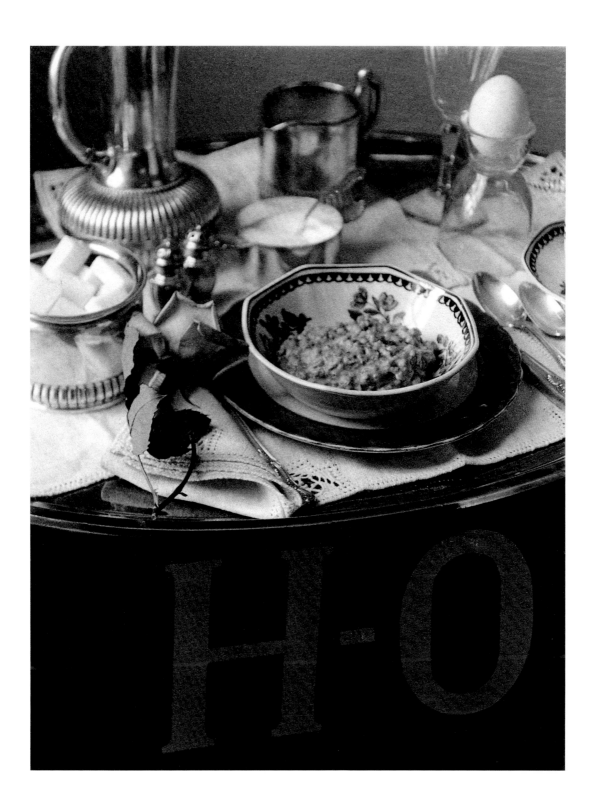

H.O. Breakfast | H.O.-Frühstück | Petit déjeuner H.O.
c. 1922

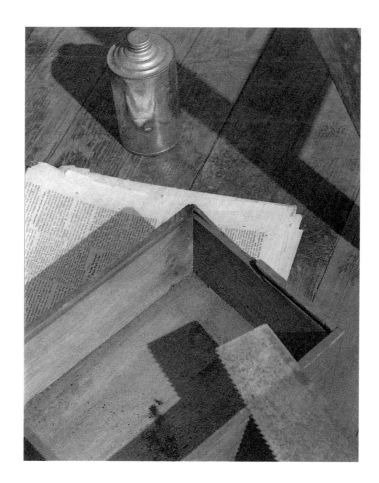

Wooden Box with Saw | Holzkasten mit Säge | Boîte en bois avec scie
c. 1923

Wine Glasses and Book on Table | Weingläser und Buch auf einem Beistelltisch |
Verres à vin et livre sur une table
1924

Walking Canes | Spazierstöcke | Cannes
c. 1924

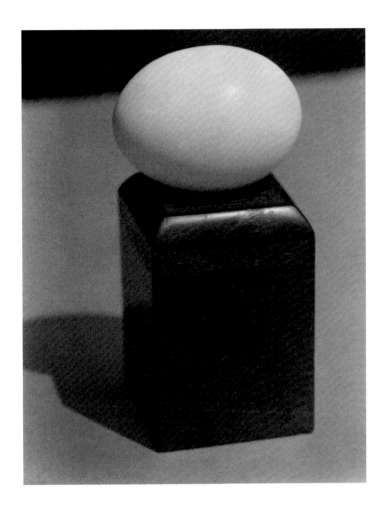

Egg on Block | Ei auf einem Klotz | Œuf sur un bloc
1923

Ashtray, Cigarette Box and Case | Aschenbecher, Zigarettenkiste und -etui | Cendrier, boîte à cigarettes et étui
c. 1924

Pattern No. 342 | Muster Nr. 342 | Motif n° 342

c. 1931

Coins, Pencil, and Paper | Münzen, Bleistift und Papier | Pièces de monnaie, crayon et papier
1924

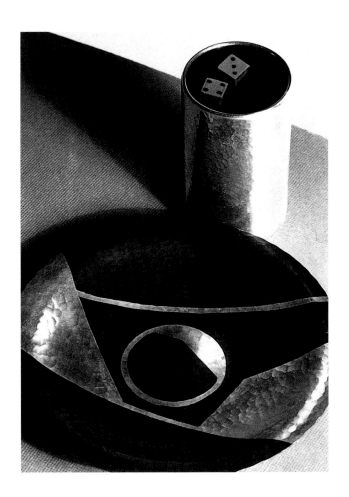

Dice-Cup and Dish | Würfelbecher und Teller | Gobelet à dés et plat
1922

In the various fields of art [modern scenic designing, lighting, magazine layout, sculpture, women's fashions, photography, and the mechanical and artistic possibilities of the motion picture camera] I have been a pioneer. For example, the camera angles which made such a stir in motion pictures when they first appeared had been thoroughly exploited by me in my own photographic work three years before.

Ich bin ein Wegbereiter für die unterschiedlichsten Kunstrichtungen: modernes Bühnenbild, Beleuchtung, Zeitschriften-Layout, Bildhauerei, Damenmoden, Fotografie sowie die mechanischen und künstlerischen Möglichkeiten der Filmkamera. Die Blickwinkel der Kamera z. B., die in der Filmindustrie so großes Aufsehen erregten, als sie zuerst aufkamen, habe ich in meiner eigenen fotografischen Arbeit schon drei Jahre zuvor vollständig ausgenutzt.

Dans les domaines variés de l'art [décors de scène modernes, éclairage, mise en page de magazines, sculpture, mode féminine, photographie et les multiples possibilités mécaniques et artistiques de l'appareil photo], j'ai été un véritable pionnier. Par exemple, les fameux réglages à l'angle voulu qui firent sensation au cinéma lorsqu'ils apparurent, je les avais déjà exploités entièrement dans mon atelier photographique trois ans plus tôt.

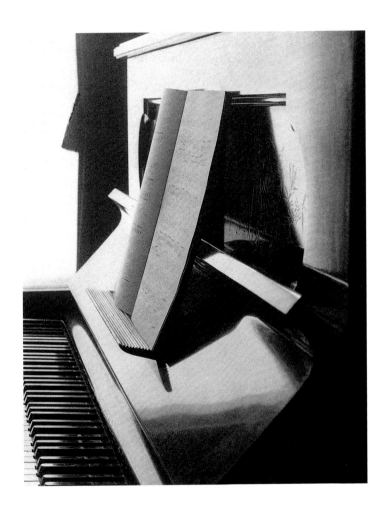

Piano
1926

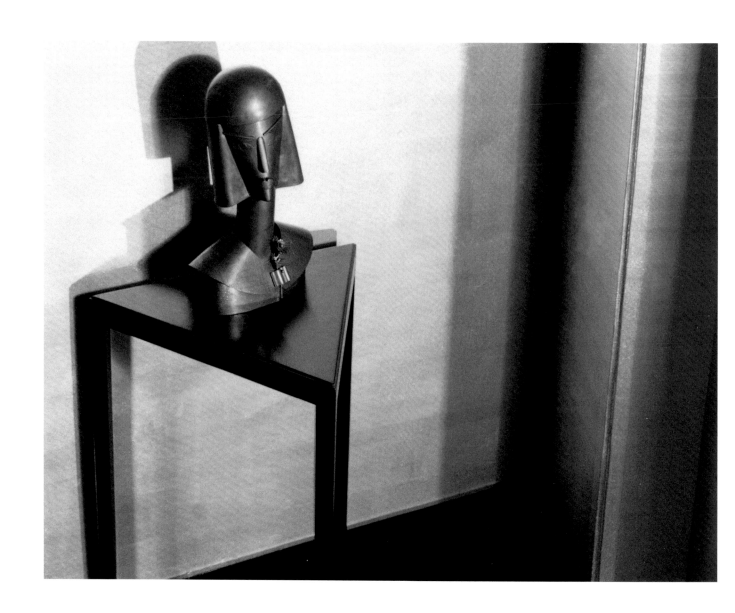

Statue on Table | Statue auf einem Tisch | Statue sur une table
1924

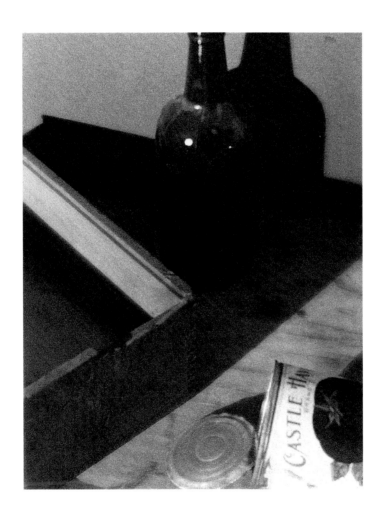

Box, Bottle, Can | Kasten, Flasche, Büchse | Boîte, bouteille, conserve
c. 1923

Collar, Tie, and Pin | Kragen, Krawatte und Nadel | Col, cravate et épingle
1922

Top Hat and Mufflers | Zylinder und Schals | Haut-de-forme et écharpe
c. 1926

Wrist Golf-Score Keeper | Armband-Zähler für den Spielstand beim Golf | Indicateur de score pour le golf
1922

Socks and Garter | Strümpfe und Strumpfband | Chaussettes et jarretière
1921

Composition is the organization of forms, and pictorial composition is the organization of forms with definite limits or boundaries.

Die Komposition liegt in der Anordnung von Formen, und die Komposition eines Bildes ist die Anordnung von Formen innerhalb bestehender, festgesetzter Grenzen.

La composition est l'organisation des formes, et la composition picturale est l'organisation des formes avec des limites ou des frontières bien définies.

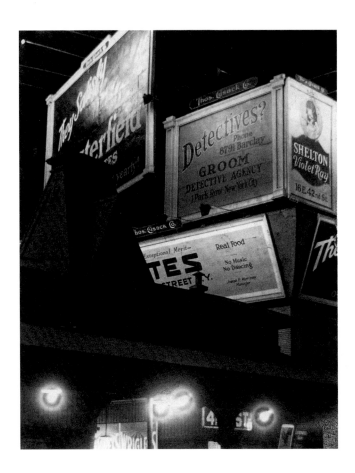

42nd Street Elevated | Hochbahn, 42. Straße | Métro aérien 42ᵉ Rue
1923

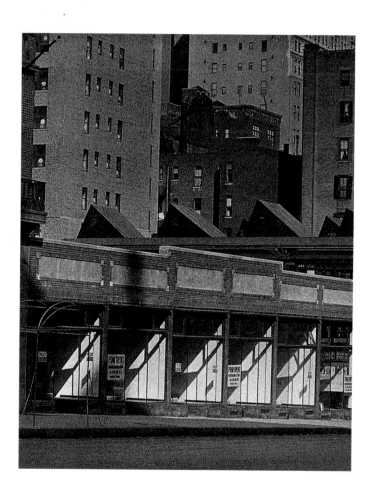

Stores for Rent | Läden zu vermieten | Magasins à louer
c. 1923

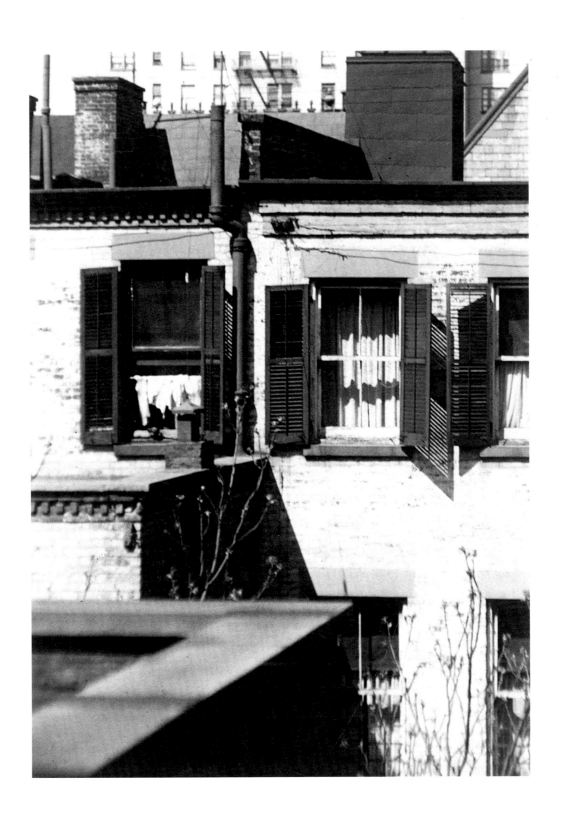

Tenement View | Blick auf Mietshäuser | Vue d'un logement
c. 1923

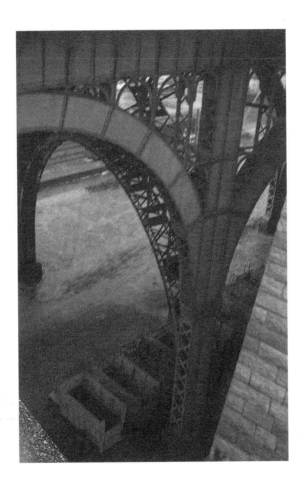

Arches | Brückenbogen | Arches
c. 1923

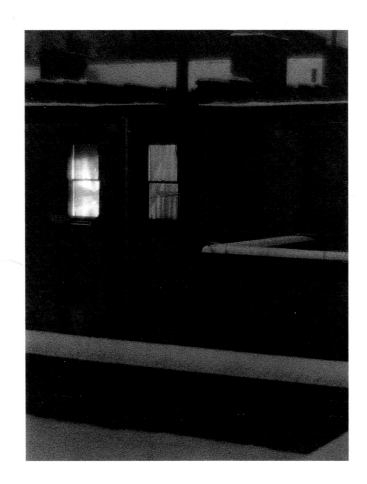

Night Window | Fenster in der Nacht | Fenêtre de nuit
1923

Paul Outerbridge, Jr.

M. F. Agha

Ein Pariser Freund erzählte mir folgende köstliche Geschichte über Paul Outerbridge:

Angeblich waren die Kreise von Paris, „die zählen", vor ungefähr einem Jahr ganz aufgelöst von einer überraschenden Neuigkeit: dass die Fotografie, neuerdings zur selbstständigen Kunstrichtung avanciert, einer glanzvollen Ära entgegensehe, denn der berühmte amerikanische Fotograf Paul Outerbridge baue in Paris am größten Fotoatelier der Welt! Der international führende Hersteller von Schaufensterpuppen unterstütze das Vorhaben – und zwar mit 1.500.000 Franc. „C'est fantastique!"

Die Nachrichten wurden über die nächsten Monate immer fantastischer; das Studio solle eine Ausstattung erhalten, die der letzte Hit der Technik im Dienste der Ästhetik sei: Die elektrischen Beleuchterbrücken sollen eine unglaubliche Menge strahlender Lichter bereithalten und seien mithilfe der leisesten Bewegung von Outerbridges Finger automatisch in Gang zu setzen. Zwischen dem Konzept des Künstlers und seiner Umsetzung solle es nie mehr irgendwelche Hindernisse geben!

Die Begeisterung erreichte ihren Höhepunkt, als es hieß, dass das Studio nach langen Monaten der Planung und des Aufbaus endlich fertig und der große Augenblick gekommen sei: Outerbridge höchstpersönlich würde ein Foto machen! Und schließlich kam Outerbridge am weithin angekündigten Termin im Atelier an – und die Sitzung sollte losgehen: Brücken bewegten sich, Assistenten rannten hin und her, es hagelte Blitzlichter. Das große Kunstwerk war geboren; einige Minuten lang stockte der Atem – dann brachte Outerbridge aus der besten Dunkelkammer der Welt, was er dem schmachtenden Publikum vorzuführen hatte: ein Foto von einem Ei!

Ganz offensichtlich war der Kerl, der mir diese Geschichte erzählt hat, ein Banause, der nicht in der Lage war, die Bedeutung von Hühnereiern und ihrer Rolle in der modernen Kunst zu begreifen. Aber die Geschichte führt uns Outerbridge doch recht anschaulich vor. Es gibt viele solche Anekdoten, über die Kontinente und Ozeane hinweg. In Berlin kann man erfahren, dass Outerbridge seine Platten nach ein paar Abzügen zerstöre, wodurch seine Fotos den gleichen hohen kommerziellen Wert erlangen, der ihnen auch künstlerisch gebührt, genauso wie es bei den Radierungen großer Meister üblich ist. In Paris bekommt man zu hören, Outerbridge mache 4.000 fotografische Platten [oder waren es gar 10.000?], bevor er herausfinde, wie ein Ei eigentlich fotografiert sein wolle. In New York sagen seine Kollegen, dass die Branche tief in seiner Schuld stehe, da er einer der ersten war, denen es durch reine Willenskraft und Fantasie

gelang, die Preise kommerzieller Arbeiten von zweistelligen auf drei- oder sogar vierstellige Zahlen zu steigern. Der oberflächliche Ästhetiker mag Outerbridges Werk mit dem von Brancusi vergleichen [falls ihm gerade nach Komplimenten zumute ist], oder aber mit Schulübungen an der Clarence White School of Photography [wenn er gern spottet]. Doch erst die Kunstgeschichte wird Outerbridge dereinst ins rechte Licht rücken. Ihm gebührt der Platz des Pioniers derjenigen Schule innerhalb der modernen Fotografie, die der Bewegung in der modernen Malerei so nahesteht, dass sie von einigen Puristen glatt für deren Imitation gehalten wird. Und in der Tat herrscht eine große Ähnlichkeit zwischen der symbolischen Gitarre eines Picasso, die in so vielen Bildern seiner Nachfolger wiederzufinden ist, und den symbolischen Eiern eines Outerbridge, die unter den Fotografen, die „auf modern machen" wollen, von ebenso großer Beliebtheit sind. Die eigentlichen Grundlagen von Outerbridges Kunst sind das Verlangen nach der Hervorbringung einer „bedeutenden Form" und die erhabene Distanz zu allem, was eine Geschichte erzählt. Die romantischen Legenden sind nur Mittel zur Selbstverteidigung, die dem Pionier die Gelegenheit bieten, die Gleichgültigkeit der unkultivierten Massen zu durchbrechen.

Die moderne Bewegung der Fotografie ist offenbar reif für eine Analyse. Die Kritik hat bereits begonnen, die Frage nach den Anfängen zu stellen und Verantwortliche zu suchen. Konservative deutsche Autoren bestreiten vehement, dass die moderne Fotografie in Deutschland erfunden worden sei. Sie bezichtigen insbesondere *Camera Work* und Broom, die Fotos von Paul Strand sowie die amerikanische kommerzielle Fotografie, die deutsche Jugend verdorben und sie dazu veranlasst zu haben, vom heiligen Pfad des Piktorialismus abzuweichen. Outerbridge ist einer der ersten und schwersten Verbrecher und verdient als solcher unseren aufrichtigen Respekt.

Dr. M. F. Agha, [Art Director von Vogue *und* Vanity Fair *von 1928 bis 1942], in:* Advertising Arts, *New York, Mai 1931.*

Ein richtungsweisender Modernist

Das Leben und Werk
von Paul Outerbridge

Die zwei Jahrzehnte zwischen den beiden Weltkriegen – viele Experten zählen sie zu den krea-
tivsten, produktivsten und außergewöhnlichsten des 20. Jahrhunderts – sind auch die Jahre, in
denen sich das künstlerische Schaffen von Paul Outerbridge [1896-1958] verdichtet. Mit seinem
Werk hat er einen wesentlichen Beitrag zur Geschichte der Fotografie geleistet. In der
Retrospektive zeigt die Analyse seines Schaffens, wieweit es ihm gelang, die grundlegenden
ästhetischen Fragestellungen der Avantgarde während dieses Zeitraums in die besondere
Sprache der Fotografie umzusetzen. Sie verdeutlicht aber auch seine einzigartige Leistung, in
dieser Sprache Bilder zu schaffen, die erst heute in den künstlerischen Zusammenhang gestellt
werden können, der Outerbridge damals vorschwebte.

Die explosiven, erfinderischen Jahre zwischen den beiden Weltkriegen gaben seiner
Kunst und seinen Ideen ihren Kontext. Zu seinen Freunden und Partnern zählten einige der
wichtigsten Künstler der Avantgarde: Marcel Duchamp, Man Ray, Pablo Picasso, Francis
Picabia, Constantin Brancusi, Alexander Archipenko und Max Ernst. Diese Künstler beeinfluss-
ten ihn vor allem während seiner Pariser Jahre von 1925 bis 1928. Outerbridge wurde zu einem
geistigen Mitstreiter und Innovator, als der er im Laufe seiner erfolgreichen Karriere allgemein
anerkannt wurde. Mit einer spezifisch neuen, modernistischen Art zu sehen, war er nicht nur
wirtschaftlich sehr erfolgreich, sondern veränderte auch das Werbedesign nachhaltig. Bereits in
den 20er-Jahren war er in den Vereinigten Staaten als guter Werbefotograf und Grafikdesigner
für mondäne Modemagazine bekannt geworden. In den 30er-Jahren widmete er sich dann dem
intensiven Studium und der Verfeinerung seiner Farbtechnik. Durch seine Entwicklung des
dreifarbigen Carbro-Verfahrens gab er seinen einzigartigen, brillanten Farbaufnahmen einen
transzendenten Ausdruck und verlieh ihnen eine Sonderstellung innerhalb der Fotografie.

Paul Outerbridges Beitrag zur Geschichte der Fotografie liegt in seiner unvergleichlichen
technischen Virtuosität, die er mit schöpferischem Gespür für abstraktes und geometrisches
Design anzuwenden wusste. Mit seinen Erfindungen im Farbdruck, die er der Öffentlichkeit in
mehreren Aufsätzen und seinem Buch *Photographing in Color* [1940] vorstellte, zeigte er, wie die
Fotografie kommerzielle Interessen und persönliche Leidenschaften am besten zum Ausdruck
bringen kann. Er war in der Lage, alltägliche Gegenstände quasi in Abstraktionen zu verwan-
deln, bei denen der harmonische Wechsel von Masse und Linie, Licht und Schatten unsere her-
kömmliche Wahrnehmung der Objekte infrage stellt. Es ging ihm aber nicht nur um Bildinhalte,
die sich kommerziell vermarkten ließen, sondern auch um die Erforschung des weiblichen

Körpers im Hinblick darauf, was er „weibliche Schönheit" nannte: die Frau als idealisierte Form, als Fetisch, als Schaustück. Im Gegensatz zu vielen seiner Zeitgenossen, etwa Walker Evans, dessen Kamera sein Gewissen war, arbeitete Outerbridge eher introspektiv. Wie László Moholy-Nagy und Man Ray entmythologisierte er die Kamera. Auge und Geist – nicht das Instrument – schufen Kunst; Fantasie – nicht das Ereignis – machte das Bild aus. Wie Wassily Kandinsky entdeckte er eine transzendente Bedeutung in der reinen Form der Gegenstände. Die Wahl der Objekte und ihrer Beleuchtung ließen aus dem Alltäglichen Außergewöhnliches entstehen. Outerbridge nahm viele der im Deutschland der Weimarer Repuplik vorherrschenden ästhetischen Fragestellungen in seine Arbeit auf, etwa die der Reinheit der Form in der Neuen Sachlichkeit und die allgemein beliebten Trends des expressionistischen Films und Kabaretts mit ihrer Vorliebe für das Sexuell-Erotische und das Psychologisieren. Durch die Übertragung dieser Impulse auf lichtempfindliches Fotopapier rückte er die Fotografie ein Stück weiter in den Bereich des Ästhetischen und zutiefst Persönlichen. Aus diesem Grund bleibt sein Werk einzigartig, nicht nur zu seiner Zeit, sondern auch noch heute.

Eine Aufnahme des 25-jährigen Paul Outerbridge von 1921 [Abb. S. 248] verweist schon auf die Themen und ästhetischen Probleme, die den munteren jungen Fotografen über die nächsten 20 Jahre beschäftigen sollten. Ein subtiles Verständnis von Linie und Form, eine Beschränkung auf das Wesentliche, ein untadeliger Sinn für Mode, Geschmack und die abstrakte Oberfläche der menschlichen Gestalt sind in diesem Selbstporträt erkennbar. Auf dem Foto zeigen sich diese Interessen in dem streng zurückgekämmten, europäischen Haarschnitt, der eleganten Pose und manierierten Geste, der weißen Smokingschleife mit Kragen sowie in der dunklen, taillierten Weste, der Jacke mit den Samtrevers und den Lackschuhen. Auf einem New Yorker Dach [das auf eine erhöhte, distanzierte Beobachterposition über der Stadt anspielt] ist Outerbridge der typische Ästhet, ein Kosmopolit der 20er-Jahre, den man bei häufigen Theaterbesuchen oder in luxuriösen Nachtclubs in Manhattan hätte antreffen können. Ganz im Sinne seiner Faszination für Hollywoodfilme besaß er eine verblüffende Ähnlichkeit mit dem Schauspieler Tyrone Power oder einem Statisten in einem Film mit Fred Astaire und Ginger Rogers [obgleich es noch ein Jahrzehnt dauern sollte, bis diese Stars zur Leinwand fanden]. Im wirklichen Leben wäre Outerbridge eher ihr Prototyp gewesen. Ironischerweise ließ dieser vermögende, kultivierte Mann schon sehr früh die mit den gesellschaftlichen Verpflichtungen und sozialen Zwängen verbundenen Belastungen der Elite, in die er hineingeboren war, hinter sich, und suchte stattdessen das unkonventionellere Dasein als Bohemien in Europa, in dem er sich als Künstler entfalten konnte.

1925 zogen Outerbridge und seine Frau Paula Smith, die er 1921 geheiratet hatte, nach Paris. Als Nachwuchstalent der Avantgarde – zwischen stilvoller Zurückhaltung und der ausschweifenden Existenz eines Bohemiens hin- und hergerissen –, verstand Outerbridge die außerordentliche Bedeutung der radikalen, neuartigen Erfindungen seiner Generation. Sie hatte gerade eine der schlimmsten Katastrophen der Geschichte überlebt, den Ersten Weltkrieg, und war zwar psychisch verwundet, aber lebenshungrig. Outerbridge war Kind seiner Zeit, sein Lebensstil entsprach der vorherrschenden Ästhetik der Avantgarde, bei der sich alles um eine unverwechselbar großstädtische Kaffeehausgesellschaft drehte – sei es in New York oder in einer

der europäischen Metropolen. In ihr verband sich Vorkriegsbiederkeit mit der impulsiven Suche nach Innovation, die nach dem Krieg einsetzte.

Will man die formale Orientierung und die psychologische Komplexität von Outerbridges Bildwelt verstehen, muss man sein Leben und die ihn künstlerisch prägenden Einflüsse in einem größeren historischen Zusammenhang diskutieren. Seine Biografie umfasst ein privilegiertes, aber gestörtes Familienleben, sein Erwachsenwerden während des Ersten Weltkrieges, sein Studium an der Clarence White School of Photography, seinen Kontakt zu den New Yorker Verfechtern des Modernismus: Alfred Stieglitz, Paul Strand und Edward Steichen; seinen Aufenthalt in Paris und Berlin zu einer Zeit radikaler, überschäumender Kreativität, und seine Freundschaften und Bekanntschaften mit den Großen der internationalen Avantgarde. Outerbridge nahm diese Einflüsse in sich auf und schuf Fotografien mit einer höchst eigenständigen Vision. Seine Bilder sind von einer konsequenten, gereiften Ästhetik geprägt, die schon in seinen Schwarzweißfotografien der 20er-Jahre einen transzendenten Ausdruck erhält und sich später in seinen einzigartigen, brillanten dreifarbigen Carbro-Drucken wiederfindet. Mit dem Zweiten Weltkrieg hatte sich die Weltkultur erneut grundlegend verändert. Nach 1941 nahm Outerbridges Bekanntheitsgrad ab. Er überlebte die enorme Popularität des Stils, den er selbst zur Perfektion entwickelt hatte. Outerbridge starb 1958 als unbekannter Künstler.

Während seiner gesamten Karriere hielt Outerbridge an seinem Glauben fest: „Kunst ist das Leben, gefiltert durch das Verlangen des Menschen nach Perfektion und Schönheit – seine Flucht vor der unerfreulichen Realität des Lebens in eine Welt der Fantasie." [1] Dieses Konzept von der Funktion der Kunst wurde zu seinem Leitmotiv. Die persönliche Ästhetik des jungen Künstlers entwickelte sich gerade durch seine Offenheit für die internationalen Stilrichtungen, z. B. des Präzisionismus – eine Technik mit Scharfeinstellung, die dem romantischen, unscharfen Stil des Piktorialismus diametral gegenübersteht. Typische Vertreter waren Charles Sheeler und Paul Strand. Outerbridge schätzte diesen Stil wegen seiner Klarheit, Abstraktion und Geometrie. Hinzu kam der Surrealismus – das Phantastische, psychologisch Komplexe, an das ihn Man Ray heranführte. Dessen Einfluss spiegelt sich in Outerbridges Carbro-Color-Bildern von Frauen wider. Was anfangs nur als ein weiteres Mittel zur Behandlung abstrakter Form erschien – seine Annäherung an das Weibliche –, veränderte sich in den 30er-Jahren, als seine Farbbilder stärker inszeniert und besessener wirkten. Befreit von den Zwängen der Schicklichkeitsvorstellungen der Zeit vor dem Ersten Weltkrieg, verbrachte Outerbridge die 30er-Jahre mit dem Fotografieren von Frauen in Masken, mit Strapsen und Seidenstrümpfen, in Spitze sowie hochhackigen Schuhen, Gummimützen und Handschuhen mit Metallkrallen – Bilder, die die Vorstellungen vom klassischen Akt zerstörten und gleichzeitig weiterführten. [2]

Outerbridge wusste, wie die Suche nach Schönheit auf elegante, alltägliche Dinge übertragen werden konnte: durch anziehende, Genuss versprechende Formen, egal, ob es sich um Lebensmittel, die Inneneinrichtung eines Hauses oder den menschlichen Körper handelte. Dieses Verständnis für leibliche Freuden und für geschmackvolle Mode führte seine Werbekarriere zu großem Erfolg. Outerbridge beobachtete seine Objekte – einen Kasten, eine Frucht, einen weiblichen Akt oder auch sich selbst – losgelöst aus ihrem natürlichen Umfeld und entwarf dann sorgfältig zusammengestellte Arrangements, die von einer akribischen Genauigkeit

und Präzision zeugen und die dennoch eine unverkennbare Sinnlichkeit ausstrahlen. Diese Sinnlichkeit war es auch, die seine Entwicklung des Carbro-Color-Verfahrens vorantrieb, da die Farbe den Oberflächen und Inhalten seiner Fotos aus den 30er-Jahren eine geradezu haptische Qualität verlieh.[3]

Im Jahr 1917, als die USA in den Ersten Weltkrieg eintraten, stellte sich Outerbridge für den Dienst beim Royal Flying Corps zur Verfügung. Dort überanstrengte er sich körperlich derart, dass seine Fliegerkarriere gefährdet und er gezwungen war, seine Berufsvorstellungen neu zu durchdenken. Nach 15 Monaten im Fliegerdienst nahm er seinen Abschied und bereiste 1918 die kalifornische Küste auf der Suche nach einer Arbeit, die seinem Talent und seiner Fantasie entsprach. Anfang 1919 kam er nach Hollywood, wo er sich einen Durchbruch in der Filmindustrie erträumte. Leider ging ihm jedoch schon bald das Geld aus, und er kehrte nach New York zurück. Entgegen den Wünschen seiner Familie hatte sich Outerbridge schon als 19-jähriger, nach einer dreimonatigen Lehre an der New Yorker Wall Street, für eine Künstler-karriere entschieden. 1915 schrieb er sich bei der Art Students' League in New York ein, um Anatomie und Ästhetik zu studieren. Zur gleichen Zeit entwarf er Poster für das Theater. 1921 setzte er sein Studium an der Clarence White School of Photography fort. Diese Entscheidung widersprach allem, was sich für den Sohn eines bekannten New Yorker Chirurgen und einer hochangesehenen Familie gehörte. Doch entgegen der Bedenken seiner Familie blühte nach nur wenigen Monaten an der Clarence White School sein Talent auf; nicht nur wegen des Mediums, das ihn faszinierte und in dem er seinen ästhetischen Bestrebungen nachgehen konnte, sondern auch wegen des engen Kontakts zu Menschen und Ideen, die in der europäischen Kunstwelt verankert waren. Im gleichen Jahr heiratete er Paula Smith, die er bei seinen häufigen Reisen nach Bermuda kennengelernt hatte, wo sein Vater geboren war und seine Verwandten Geschäftsinteressen pflegten. Sie sollte ihn nach Europa begleiten und ihm gelegentlich Modell stehen. Für die Entwicklung seines charakteristischen Stils zählten diese Jahre zu seinen wichtigsten. An der White School bot der Unterricht des deutsch-polnischen Malers Max Weber über Arthur Wesley Dows Kompositionstheorien eine Herausforderung. Hinzu kam Webers eigene Schrift *Essays on Art* [1916], in der er für die Anwendung der kubistisch-abstrak-ten Theorie der Zweidimensionalität beim Fotografieren dreidimensionaler, plastischer Objekte eintrat.[4]

Outerbridge widmete sich ganz der Fotografie, denn er „spürte, dass die besten Arbeiten in Malerei und Skulptur schon geschaffen" seien und „dieses neuere Ausdrucksmittel enger mit dem Fortschritt und dem Tempo der modernen Wissenschaft und Zeit verbunden sei."[5] „Ich habe sehr hart gearbeitet und hatte zum ersten Mal in meinem Leben ein wirkliches Ziel und machte daher gute Fortschritte."[6] In einem Zimmer des Familienwohnsitzes, das als Fotostudio eingerichtet war, machte er mit einer großformatigen [10 x 12 cm] Kamera immer wieder Aufnahmen von alltäglichen Gegenständen wie einer Milchflasche, einer Schüssel Eier, einer Glühbirne oder einer Holzkiste, die er beleuchtete und zu einfachen und doch eleganten Kompositionen zusammenstellte. Dabei notierte er sorgfältig seine Materialien, Ausrüstung und Verfahren. Im Jahr 1922 wurden seine Arbeiten erstmalig in *Vogue* publiziert. Bis 1923 stand er in einem freundschaftlichen Wettstreit mit seinem Kommilitonen Ralph Steiner, nahm

den Dialog mit Alfred Stieglitz auf und studierte außerdem bei dem Bildhauer Alexander Archipenko. Schon ein Jahr darauf war er mit kommerziellen Stammkunden gut versorgt.

Outerbridge fotografierte selten direkt nach der Natur wie Ansel Adams. Die offensichtliche Schönheit der Oberflächen von Erscheinungen reizte ihn nicht. Sein Interesse galt der Untersuchung der formalen Prinzipien, die der Schönheit einer Komposition zugrunde liegen. Zu seinem eigenen besseren Verständnis fertigte er viele Studien an, und versuchte, „die Schönheit in den einfachsten und unbedeutendsten Gegenständen zu interpretieren." In seinen Zeichnungen, die auf seine Schwarzweißfotografien bezogen sind, untersuchte er die Beziehung zwischen linearer Rhythmik und schwarz-weißen Flächen. Um seine Ziele zu erreichen, ordnete er die Gegenstände pedantisch immer wieder aufs Neue, bis er schließlich bei einer Komposition angekommen war, die seinen Vorstellungen für die Zeichnungen entsprach. Diese Komposition, die auf „der Verteilung von dunkel auf hell, hell auf dunkel, und einer allgemeinen Ausgewogenheit der Flächen und Tonwerte" beruhte, stand für eine künstliche Analogie zur Natur: eine abstrakte Darstellung von Harmonie. Durch Anwendung „der Fotolinse zum Malen mit Licht, genau wie ein Maler Farbe und Pinsel verwendet", löste er mit der Sicherheit eines Juwelendiebes aus den Formen ihre Bedeutung heraus. Outerbridge erklärte eines der erfolgreichsten Bilder aus dieser Zeit, H.O. Box [1922, Abb. S. 10], als den Versuch,

> „ein Rechteck [...] mit einer harmonischen und gefälligen Verteilung von hellen und dunklen Flächen zu füllen. Man wird sehen, wie der Schatten der Säge auf Boden und Hintergrund zu diesem Zweck genutzt wurde, wie auch der Schatten eines Bretts [außerhalb des Bildes], gegen das die Säge gelehnt ist. Die Zähne der Säge sind absichtlich verschleiert, indem sie unscharf gehalten sind, damit sie kein störendes Element darstellen und den Gegenstand mit den anderen geraden Linien der Komposition in Einklang bringen [...]. Besondere Aufmerksamkeit gebührt den feinen Gradierungen in der Säge, die von extrem dunkel bis extrem hell reichen."

Um seine künstlerischen Manipulationen zu rechtfertigen, kam der Fotograf zu dem Schluss, dass er „nicht ein Bildnis dieser Gegenstände" schaffe, sondern sie „zur Gestaltung einer rein abstrakten Komposition" verwende.[7] Die perfekte Ausgewogenheit von Outerbridges Kompositionen in Bildern wie *Ide-Kragen* [1922, Abb. S. 49] und *Zwei Eier in einer Pastetenform* [1923, Abb. S. 42] entspricht der Definition formaler Schönheit des Renaissancetheoretikers Leon Battista Alberti: „Kein Element kann hinzugefügt oder weggenommen werden, ohne das harmonische Gleichgewicht des Ganzen zu stören."[8] Mehr als nur ein erfolgreiches Werbemittel und eine raffinierte Lösung eines Designproblems sah Marcel Duchamp in *Ide Collar*: Für ihn war es ein „Ready-Made". Outerbridges *Ide Collar* weckte Duchamps Aufmerksamkeit. Er riss das Bild aus der Novemberausgabe der Zeitschrift *Vanity Fair* und hängte es an die Wand seines Ateliers. Duchamp hielt Outerbridges Foto eines maschinell hergestellten Kragens auf einem Schachbrett für ein weiteres Indiz für die Neudefinition von Kunstgegenständen, für ein „objet trouvé", das durch die Fantasie des Künstlers in Kunst verwandelt wurde.

Wie bei Aufnahmen von Charles Sheeler und Paul Strand kann der formale Aufbau von Outerbridges sorgfältig konstruierten Bildern als fotografische Parallele zur Abstraktion in der Malerei gesehen werden. *Salzcracker-Schachtel* [1922, Abb. S. 11], eine elegante, kubistische Komposition – allein durch die Manipulation des Lichts entstanden –, beschrieb Outerbridge

als „Abstraktion, die zum ästhetischen Verständnis von Linie zu Linie und Farbton zu Farbton ohne sentimentale Assoziationen gemacht war."[9] Obgleich Platin in den Jahren nach dem Ersten Weltkrieg knapp war, bestand Outerbridge auf Verwendung von Platinpapier für seine Fotografien, was seinen Negativen einen großen Tonwertreichtum verlieh. Ein Tagebucheintrag aus dieser Zeit belegt seine Suche nach der letzten Ausgabe der Zeitschrift *Camera Work* aus dem Jahr 1917, die elf Fotos und einen Text von Paul Strand enthielt. Strand war für das „Neue Sehen" maßgeblich. Er sprach sich für eine „straight photography" aus, die nicht piktorialistischer Natur war und aus funktionalen, alltäglichen Gebrauchsgegenständen dynamische Bilder von großer Schönheit entstehen ließ. Outerbridge hielt es für bedeutsam, dass Strand in seinem Essay in *Camera Work* unterstrich:

> *„In der Organisation der Objektivität kommt die Lebenssicht des Fotografen ins Spiel, und eine formale Konzeption, die aus dem Gefühl, dem Intellekt oder beidem entsteht, ist für ihn unverzichtbar, bevor die Belichtung gemacht wird, genauso wie für einen Maler, bevor er den Pinsel auf die Leinwand aufsetzt. Die Gegenstände müssen so angeordnet werden, dass sie die Ursachen, deren Folgen sie sind, zum Ausdruck bringen, oder sie können abstrakte Formen sein, die ein Gefühl hervorrufen, das nichts mit Objektivität als solcher zu tun hat."[10]*

Outerbridge nahm die formalen Komponenten dieser neuen Ästhetik voller Enthusiasmus auf. Er brachte ähnliche Gedanken über die formale Abstraktion zum Ausdruck, als er ausrief: „Bei diesem Problem gilt es, reines Schwarz und reines Weiß in ein glitzerndes Feuerwerk zu verwandeln [...]!"[11]

Outerbridge erwies sich als begnadeter Fotograf, und der Erfolg ließ nicht lange auf sich warten. Schon 1925 war er zu extremeren ästhetischen Herausforderungen bereit, ja er suchte sie. In diesem Jahr zog er mit einem erstaunlichen Portfolio seiner fotografischen Arbeiten nach Paris und wurde von der der Pariser *Vogue* für Aufnahmen von Modeaccessoirs engagiert. Hier lernte er Edward Steichen [der ein lebenslanger Rivale bleiben sollte], Man Ray und Berenice Abbott kennen. Die beiden letzteren machten ihn mit Marcel Duchamp, Constantin Brancusi, Pablo Picasso, Igor Strawinsky, Francis Picabia und vielen anderen bekannt. Das Eintauchen in diese Welt der modernen Kunst, des lebhaften Ideenaustauschs, der stimulierenden Konversation, der technischen Raffinesse, des finanziellen Erfolgs und der künstlerischen Anerkennung waren ein überwältigendes Gegenmittel gegen die Unentschlossenheit und Zweifel der vorangegangenen Jahre.

Bis 1929 blieb Outerbridge in Europa, er verbrachte drei Jahre in Paris und zwei in Berlin. Wegen seiner Konkurrenz zu Steichen verließ er *Vogue* und arbeitete für andere Zeitschriften. In seiner Autobiografie schrieb er:

> *„Ich hatte den Job bei der Vogue etwa drei Monate lang, dann habe ich aus folgenden Gründen aufgehört: innere Politik, Missverständnisse und Meinungsverschiedenheiten mit dem Besitzer aufgrund meines zu großen Selbstbewusstseins, eines völligen Mangels an Geschäftserfahrung, Eigensinnigkeit, usw. Meine Arbeiten erhielten keine negativen Kritiken, sondern wurden geschätzt und fanden Beachtung."[12]*

Während seiner Zeit als freier Fotograf tat sich Outerbridge mit Mason Siegel, dem führenden Schaufensterpuppenhersteller der Welt zusammen. Angeblich bauten sie für 1.500.000 Franc ein

Fotostudio auf, das schon nach weniger als einem Jahr schließen musste. Vor der endgültigen Auflösung des Ateliers gelangen dem Fotografen jedoch mehrere Bilder von Modepuppen in eigenartigen Posen und mit ungewöhnlichen Requisiten. In diesen statischen, unnahbaren Figuren fand er die Thematik, die wenige Jahre später in seinen gefühlsmäßig distanzierten, doch erotisch aufgeladenen weiblichen Akten wiederkehren sollte.

Nach der Trennung von seiner Frau Paula im Jahre 1927, zog Outerbridge 1928 nach Berlin und befasste sich intensiv mit dem deutschen Film, den er sehr bewunderte. Hier hat er sich wahrscheinlich Georg Wilhelm Pabst angeschlossen, einem der führenden Regisseure des neuen Realismus. Anders als Pabst hatte der andere große Regisseur des deutschen Films, Friedrich Wilhelm Murnau, kein Interesse an „piktorialistischen" Kompositionen. Pabst arrangierte Material aus dem realen Leben und erzielte so eine Wahrheitstreue, die der des Fotografen August Sander nicht unähnlich war.[13] Kurze Zeit später entschied sich Outerbridge, in England mit dem Regisseur Ewald André Dupont zusammenzuarbeiten, der 1925 in Kooperation mit dem Kameramann Karl Freund den sehr erfolgreichen Film „Variety" gedreht hatte. Dupont hatte den konventionellen Realismus des Spielfilms durch ungewöhnliche Kamerawinkel und Mehrfachbelichtungen transformiert, und Outerbridge sah darin eine Ähnlichkeit mit seinen eigenen, vor drei Jahren entstandenen Werken. Interessanterweise handelt es sich bei „Variety" um die Geschichte einer heruntergekommenen Musikhalle, in der die sinnliche Schönheit einer Trapezkünstlerin ihren Partner zu einem Eifersuchtsausbruch und schließlich zum Mord treibt. Als Stammgast der Pariser Nachtclubs und Berliner Kabaretts begann Outerbridge zunehmend, Symbole dieses Lebensstils in seine Bilder aufzunehmen und fügte ihnen dadurch den Hauch eines grotesken Fetischismus hinzu, der besonders deutlich in seinen späteren Aktstudien im Carbro-Verfahren zutage tritt.

Enttäuscht von seinem erfolglosen Versuch, in die Filmindustrie einzusteigen, dem missglückten Unternehmen mit Mason Siegel und seiner gescheiterten Ehe mit Paula Smith, kehrte er 1929 nach New York zurück. Seine Teilnahme an zwei wichtigen Ausstellungen zeigt jedoch, dass es ihm trotz dieser Fehlschläge gelang, in die Spitzenklasse der internationalen Avantgarde vorzustoßen. Die Stuttgarter Ausstellung *Film und Foto* von 1929 bleibt eine der wichtigsten und umfassendsten Ausstellungen in der Geschichte der Fotografie. Outerbridge nahm als einer der wenigen Amerikaner daran teil.[14] Beaumont Newhall nahm Outerbridge später, 1937, in seine gigantische Ausstellung *The History of Photography* im Museum of Modern Art und 1940 in seine *Pageant of Photography*-Show in San Francisco auf. Outerbridges Arbeiten hinterließen einen bleibenden Eindruck, der seinen Bekanntheitsgrad sowohl in Europa als auch in den Vereinigten Staaten erhöhte. 1932 zeigte die Julien Levy Gallery in New York seine Fotografien und bestätigte damit seine Bedeutung als Künstler und Fotograf. Diese Galerie leistete mit ihrem Engagement für die Fotografie als Kunst in den 30er-Jahren Pionierarbeit. Darüber hinaus war sie zwei Jahrzehnte lang die wichtigste New Yorker Kunstgalerie. Outerbridge stellte dort zusammen mit László Moholy-Nagy, den Surrealisten und der zeitgenössischen Avantgarde aus.

1930 wurde Outerbridge klar, dass er die Möglichkeiten der Schwarzweißfotografie ausgereizt hatte. Uneingeschüchtert von den finanziellen Umständen dieser Zeit erkannte er, dass die Farbe – sowohl in der bildenden Kunst als auch in der kommerziellen Fotografie – bald eine

vorrangige Rolle spielen sollte. So begann er, sich ganz in die fortschrittlichsten [und teuersten] Untersuchungen zur Farbfotografie zu vertiefen. Die Entwicklung des Carbro-Color-Verfahrens beruht auf gewissenhaften Recherchen, die er in seinem 1940 von Random House veröffentlichten Buch *Photography in Color* zusammenfassend darstellte [s. S. 102-105]. Viele Stunden konzentrierter Arbeit und ein beträchtlicher finanzieller Aufwand waren für jeden einzelnen Carbro-Color-Druck notwendig. Das Verfahren ist einzigartig in der Fotografie. Die benutzten Pigmente sind dieselben wie in der Ölmalerei; sie sind nicht nur ungewöhnlich beständig, sondern entfalten auch eine außergewöhnliche Tiefendimension: Glänzende Oberflächen lassen Schatten auffällig tiefer wirken, während matte Stellen die Helligkeit feiner abstufen. Der Reliefeffekt verstärkt den Eindruck der Tiefe und betont die Umrisse der kompositorischen Elemente schärfer als es andere Techniken zuließen, was die haptische Qualität der dargestellten Objekte unterstreicht.

Die Tatsache, dass Outerbridge dieses Verfahren durchgängig für seine Bilder anwandte, zeigt die Intensität seiner Vision, die nur noch durch seine schier unendliche Geduld und zwanghafte Präzision überboten wurde. Es war ihm wichtig, dass die physikalischen Eigenschaften seiner Farbtechnik den Bildern einen äußerst realitätsnahen Eindruck verliehen. Outerbridge konnte die hohe Qualität seiner Arbeit gut einschätzen, und er verlangte – und erzielte – durchgehend stattliche Preise, bis zu 750 Dollar für einen Farbabzug. Henry Luce stellte beispielsweise Nullnummern für die illustrierte Zeitschrift *Life Magazine* zusammen und verteilte sie, um Sponsoren und Werbemittel aufzutreiben. Eine dieser erstellten Vorabnummern hatte ein Cover von Outerbridge und enthielt fünf seiner Farbfotografien, Beispiele für „die Schönheit und Kunst, die mit Kamera und Farbe hervorgebracht werden konnte" [s. S. 254]. Obwohl er anfangs zögerte, Outerbridge seinen üblichen hohen Preis zu bezahlen, willigte Luce schließlich ein.

1930 richtete sich Outerbridge in seinem Landhaus in Monsey, New York, ein Studio für Farbfotografie ein. In den folgenden Jahren verdiente er sein Geld mit erfolgreichen Werbefotografien in Farbe und Schwarzweiß für die Zeitschriften *Vanity Fair*, *McCall's*, *Harper's Bazaar*, *Advertising Arts* und *House Beautiful*. Viele der in dieser Zeit entstandenen Farbabzüge sind nichts weiter als Fortsetzungen seiner Schwarzweiß-Experimente mit abstrakten Kompositionen. Bei den früheren Platinarbeiten waren die Gegenstände, aus denen die Bilder komponiert waren, eher ohne jeden symbolischen Inhalt. In Farbe strahlen diese Elemente jedoch eine überwältigende Präsenz aus. Ihr symbolischer Charakter wird durch die Plastizität des Farbprozesses noch verstärkt und gibt den Bildern eine Gewagtheit und unverhohlene Sinnlichkeit, die in den monochromatischen Fotografien nicht zu finden ist.

Outerbridges Schwarzweißfotografie *Fächer und Perlenkette* [1924, Abb. S. 55] ist zum Beispiel vorrangig eine Übung in abstrakter Komposition; der Carbro-Color-Abzug *Partymaske mit Muscheln* [1936, Abb. S. 201] dagegen ist nicht nur eine hervorragende Komposition, sondern auch ein Bild, das auf die zweifelhafte Pracht und Dekadenz eines Berliner Kabaretts anspielt. Während Outerbridges Platindrucke aus den 20er-Jahren mit dem vorherrschenden Trend der progressiven Kunst der Zeit in Verbindung gebracht werden können, sind seine Arbeiten in Farbe aus den 30er-Jahren ungewöhnlich und völlig überraschend. Ein Reporter

berichtete vom dritten U.S. Camera Salon [1937], dass die Menge vor Outerbridges farbigen Carbro-Abzügen stehen blieb, „offenbar wie betäubt von der Perfektion der Arbeit dieses Mannes. Das war zweifellos die künstlerische und technische Sensation des Salons."[15] Die Schwierigkeiten des Carbro-Color-Verfahrens mit seinem unerforschten sinnlichen und expressiven Potential boten Outerbridge die anspruchsvolle Herausforderung, die er gesucht hatte.

Eines der Meisterwerke der Farbfotografie aus dieser Zeit ist *Images de Deauville* [1936, Abb. S. 197]. Die Irritation durch die reflektierenden Oberflächen des Bildes basiert auf einer gezielten Veränderung der Wirklichkeit, auf Outerbridges Spiel mit der Perspektive und der Positionierung der abgebildeten Gegenstände. Outerbridge kombinierte einen überdimensionalen Würfel, eine Silberkugel, eine gelbe Pyramide, eine Muschel und ein Seestück in einem konstruierten Rahmen, vielleicht in Anspielung auf André Bretons Ausspruch, dass ein surrealistisches Gemälde ein Fenster sein solle, durch das man eine innere Landschaft sehen kann. Er machte sich die Bildkonventionen der Renaissance zunutze, und schuf durch die Betonung von Diagonalen einen illusorischen Eindruck von räumlicher Tiefe, der die Monumentalität verstärkte, die insgesamt schon durch den Maßstab der Fotografie entstand. Mit überraschenden Gegenüberstellungen von vertrauten Objekten stellte Outerbridge Konventionen infrage und übertrug Sichtweisen, die er sich durch seinen Kontakt zu den Surrealisten angeeignet hatte, auf den Bereich der Fotografie. Hierdurch gelang es ihm, neue Bedeutungen offenzulegen.

Die bedeutendsten seiner Carbro-Color-Abzüge sind jedoch diejenigen, die den weiblichen Körper zum Gegenstand haben. Wie schon Generationen von Künstlern vor ihm, hielt Outerbridge den Akt für einen legitimen Bereich künstlerischen Ausdrucks. Seinem ausgesprochen freizügigen, kreativen Umgang mit diesem Sujet nach dem Ersten Weltkrieg standen jedoch die konventionellen Vorstellungen einer Sozialmoral aus dem 19. Jahrhundert entgegen. Nach Schwierigkeiten mit der Eastman Kodak Company, die es abgelehnt hatte, einige seiner Fotografien zu entwickeln, äußerte Outerbridge ironisch, dass einer ganz einfachen, unschuldigen Aktstudie pornografische Bedeutung beigemessen worden sei. Er beklagte sich zwar über die sowohl kindischen als auch lächerlichen Versuche des Staates, „Sittsamkeit gesetzlich vorzuschreiben", sprach aber nicht viel davon. Als Mann von Welt ging er Konfrontationen mit den zensierenden Instanzen, z. B. Hollywoods gerade eingerichtetem Hays Office, lieber aus dem Weg. Outerbridge selbst veränderte manchmal seine Abzüge, wenn die öffentliche Ausstellung taktvolles Weglassen gebot, weil „das Gesetz anscheinend insbesondere Brustwarzen und Schamhaar zensiert, und obgleich sie nicht in der Lage sind, der Natur zu verbieten, diese körperlichen Attribute wachsen zu lassen, so können sie es doch zumindest den Menschen verbieten, sie zu fotografieren."

Zu den Prinzipien, die seiner Praxis beim Fotografieren weiblicher Formen zugrunde lagen, gehörten die folgenden:

> *„Wenn der Fotograf ein hübsches Modell mit einem provokanten Lächeln oder einem einladenden Funkeln in den Augen direkt in die Kamera blicken lässt, hat er eigentlich schon die Grenze zwischen einem Akt und einem bestimmten, unbekleideten Mädchen überschritten. Man könnte sagen, dass er damit die Welt der Kunst verlassen hat und in die Welt der Pornografie eingetreten ist."*

Es war ihm auch klar, dass Gegenüberstellungen von „weichem, warmem Fleisch vor kaltem, hartem Stein" und Kontraste, die „die einem Akt innewohnenden Eigenschaften unterstreichen", notwendige Komponenten für die Zusammenstellung eingängiger Kompositionen sind. „Das fundamentale Gesetz der Gegensätze in der Natur", fuhr er fort, „heiß und kalt, hart und weich, positiv und negativ, hell und dunkel, kann vorteilhaft zur Verstärkung eines dramatischen Effekts eingesetzt werden."

Unter den Arbeiten, die er für sich selbst anfertigte, waren Aktfotografien, die formalen ästhetischen Prinzipien folgten, einen starken erotischen Inhalt hatten und eine einzigartige, nie dagewesene Vision aufweisen. Wie das Carbro-Verfahren selbst, stellte der Akt eine besondere Herausforderung für ihn dar. „Der Akt", hielt er in seinen Schriften fest, „ist der bei Weitem schwierigste Gegenstand."[16]

Er beschrieb die Probleme der Farbspiegelungen, die durch ständig sich verändernde Konturen des Körpers hervorgerufen werden. Er fand, dass „die Umrisse der Figur sich von einem Moment zum nächsten durch die kleinste Bewegung verändern [...]. Der menschliche Körper ist ein bemerkenswert plastisches Ding." Frauenakte wie *Modell* [1923, Abb. S.129] oder *Odaliske* [1936] verdeutlichen besonders anschaulich Outerbridges Ideal der weiblichen Schönheit. Ihre Komposition nimmt auf berühmte Gemälde wie *Die Badende von Valpiçon* [1808], *Große Odaliske* [1814] oder *Das türkische Bad* [1863] des französischen Klassizisten Jean Auguste Dominique Ingres Bezug. Fotografien wie *Odaliske* und die beiden Versionen von *Akt mit Rahmen* [1938, Abb. S.8-9] bieten formale Lösungen für kompositionelle Probleme und sind exemplarische Beispiele für Farbtechniken; außerdem zeigen sie Outerbridges vollendete Fähigkeit, mit Hilfe von Form, Oberflächenstruktur und Farbe seinen Intentionen und Wünschen Ausdruck zu verleihen.[17]

Diese Aktfotografien entstanden im Zusammenhang mit der Wiederentdeckung der Frau als Mythos und Objekt der Begierde durch die Surrealisten. Thematisch waren sie mit den Arbeiten der surrealistischen Fotografen, etwa Henry List und Clarence John Laughlin, verwandt. Diese Künstler versuchten, Wünsche, Ängste und Enttäuschungen durch die Darstellung des symbolischen Inhalts des Unterbewussten sichtbar zu machen.[18] Doch sogar in diesem Zusammenhang bleiben viele von Outerbridges Akten, die auch zu seinen persönlichsten Fotografien zählen, einzigartig. In Anerkennung der Tatsache, dass die elegant posierenden Figuren mit den Objekten seiner Obsessionen versehen sind, ziehen wir es vor, die Diskussion ihrer Inhalte anderen zu überlassen und geben Outerbridges eigene Erklärung wieder:

> „[...] ein gutes, vollständiges Kunstwerk [...] sollte seine eigene Aussage natürlich in sich tragen. Buchillustrationen geben einen Text visuell wieder, und der Text erklärt seinerseits die Bilder, aber die höheren Kunstformen bestehen für sich allein, und da sie in sich ganz vollständig sind, benötigen sie keine andere Kunstform [Literatur], um ihre Bedeutsamkeit zu erhöhen."[19]

Im Vergleich mit dem übrigen Werk faszinieren die Carbro-Color-Studien wegen ihrer unkonventionellen Bildsprache. Die Behandlung der Figur als kompositorisches Element stellt eine Erweiterung seiner früheren Experimente im Umgang mit der Form dar. Wie die raffinierte Modulation der Tonwerte seiner Schwarzweißfotografien, so deutet auch die exquisite Wiedergabe der Struktur, des Lichts und der Farbe auf eine unvergleichliche Beherrschung seines

Mediums hin. Als Höhepunkt seiner schöpferischen Karriere definieren die Carbro-Color-Abzüge die Grenzen der Kamera als Mittel des künstlerischen Ausdrucks.

Von den 40er-Jahren bis Ende der 50er-Jahre konnte Outerbridge sowohl seine kommerziellen Arbeiten wie auch mehrere Fotoessays über seine Reisen durch die Vereinigten Staaten, Mexiko und Südamerika erfolgreich verkaufen. 1943 war er nach Hollywood und später nach Laguna Beach gezogen, wo er ein kleines Porträtstudio betrieb. Mit seiner zweiten Frau Lois Weir – einer erfolgreichen Modedesignerin, die er 1945 heiratete –, arbeitete er auch geschäftlich zusammen. Paul Outerbridge starb 1958 in Laguna Beach an Lungenkrebs.

Outerbridge zählt zu den führenden Fotografen, die sich mit der Entwicklung einer eigenständigen, fotografischen Ästhetik befassten. Er besaß als einziger seiner Kollegen die künstlerische Weitsicht und das technische Geschick, den Einsatz von Farbe durch die Anwendung seiner Erfahrungen bei der Verfeinerung der Schwarzweiß-Komposition zu perfektionieren. Er war einer der wenigen Visionäre der modernen Fotografie, die dieses Medium als Kunstform etablierten. Outerbridge verwendete seine Intuition, seine Leidenschaft und nicht zuletzt sein technisches Können zur Schaffung von überzeugenden, oftmals schönen, immer jedoch unvergesslichen Bildern, die seine Definition von Kunst als Sieg der Fantasie über die Unvollkommenheit der Wirklichkeit mit Leben erfüllten.

1] *Paul Outerbridge, „Patternists and Light Butchers", in:* American Photography, *46, Nr. 8 (August 1952), S. 54.*

2] *Während dieser Zeit schrieb Outerbridge eine längere Abhandlung mit dem Titel „What is Feminine Beauty", der in* Physical Culture *[Januar 1933], S. 37–39 und 74–77 erschien und zweifellos von den Büchern über Sexualität und das Erotische, die er in Paris gelesen hatte, beeinflusst war.*

3] *Um einen einzigen Carbro-Abzug herzustellen, waren drei Abzüge in unterschiedlichen Farben notwendig, die wie beim Siebdruck exakt auf das Papier aufgebracht werden mussten. Es dauerte bis zu zehn Stunden, bevor ein solcher Abzug fertig war und kostete mindestens 100 Dollar pro Bild, zur Zeit der amerikanischen Wirtschaftskrise [aber auch heute noch] eine beachtliche Summe.*

4] *Weber erinnerte sich: „Ich glaube auch heute noch, dass mein Unterricht an der White School die erste echte geometrische Annäherung an die grundlegende Konstruktion von Fotografien als Kunst war." Aus: John Pultz und Catherine Scallen,* Cubism and American Photography, *1910–1930 [Williamstown: Clark Art Institute, 1981], S. 42.*

5] *Maurice Burcel, „Paul Outerbridge, Jr.",* Creative Art, *12, Nr. 2 [Februar 1933], S. 110–112.*

6] *Unveröffentlichte Autobiografie, J. Paul Getty Center Archive, Los Angeles.*

7] *Paul Outerbridge, „Visualizing Design in the Common Place", in:* Arts and Decoration, *17, Nr. 5 [September, 1922], S. 320 ff.*

8] *Leon Battista Alberti,* Ten Books on Architecture *[Zehn Bücher über die Baukunst], Hrsg. J. Rykwert, Übersetzung J. Leoni [New York: Transatlantic Arts, 1966], VI, II, S. 113. „Ich definiere Schönheit - egal, in welchem Zusammenhang sie vorkommt - als Harmonie aller Teile, so proportioniert und miteinander verbunden, dass nichts hinzugefügt, weggenommen oder verändert werden kann, ohne das Ganze zu beeinträchtigen." Vgl. auch IX, V [insbesondere S. 194–195].*

9] *Graham Howe und G. Ray Hawkins, Hrsg.,* Paul Outerbridge, Jr.: Photographs *[New York: Rizzoli, 1980], S. 11.*

10] *Paul Strand, „Photography", in:* Camera Work, *Nr. 48–50 [Juni 1917], S. 112.*

11] *Robert Marks, „Portrait of Paul Outerbridge", in:* Coronet 7, *Nr. 5 (März 1940), S. 27.*

12] *Unveröffentlichte Autobiografie.*

13] *Siegfried Kracauer,* From Caligari to Hitler *[Princeton: Princeton University Press, 1947], S. 168.*

14] *Anlässlich des 50. Jubiläums der berühmten Ausstellung wurde eine Neuauflage des Katalogs veröffentlicht. Die U.S.-amerikanische Zeitschrift* Camera, *Nr. 10 [Oktober 1979] ist dieser Ausstellung gewidmet. Vgl. auch* Film und Foto *[New York: Arno Press, 1979].*

15] *U.S. Camera, Jahresschrift, 1937, S. 30*

16] *Er schrieb ausführlich darüber in einer Abhandlung mit dem Titel „What is Feminine Beauty" [vgl. S. 4, Anm. 2], und einem unveröffentlichten Aufsatz mit der Überschrift „The Nude".*

17] *Alle Zitate aus einem unveröffentlichten, undatierten Manuskript von Outerbridge mit dem Titel „The Nude", S. 1–6 passim [Outerbridge Archive, Special Collections, The Getty Center for the History of Art and the Humanities, Los Angeles].*

18] *Nancy Hall-Duncan,* Photographic Surrealism *[Cleveland: New Gallery of Contemporary Arts, 1979], S. 10.*

19] *Paul Outerbridge,* Clarence Laughlin and His Many Mansions: A Portfolio, *unveröffentlichtes Typoskript, datiert 12.5.52, im J. Paul Getty Center Archive, Los Angeles.*

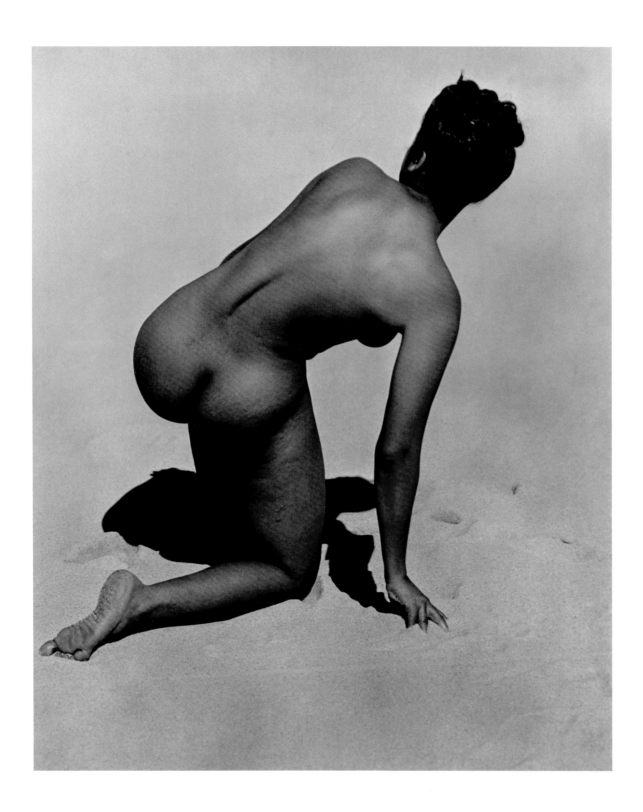

Woman Kneeling on Beach | Frau am Strand, kniend | Femme à genoux sur la plage
c. 1938

Das Carbro–Verfahren

Auszüge aus *Photographing in Color*
von Paul Outerbridge

Die meisten Fotografen, die in Farbe arbeiten, halten Carbro [carbon bromide] für das beste aller Farbverfahren. Es ist zwar kein ganz neuer Prozess, aber erst die steigende Nachfrage nach Farbfotos in der heutigen Werbung hat zu ernsthaften Bemühungen geführt, es aus dem Speziallabor heraus in eine breitere Anwendung zu bringen. [...]

Die Hauptgründe für die bisherigen Fehlschläge beim Carbro-Verfahren waren die mangelnde Standardisierung aller Vorgänge, die unzulängliche densitometrische Kontrolle der Negative, die fehlende Möglichkeit, die elektrische Spannung im Vergrößerungsgerät konstant zu halten, und die Tatsache, dass ungleichmäßige Pigmentschichten oft nicht haftfähig genug sind, um zu gewährleisten, dass sie während der Entwicklung auf den Zelluloid-Schichtträgern haften bleiben. [...] Mit der richtigen Ausrüstung und dem nötigen Wissen wird es immer leichter, einen Carbro herzustellen. Zweifellos ergibt das Carbro-Verfahren unter allen bisher entwickelten Techniken die schönsten Abzüge. [...]

Im Carbro-Verfahren ist die genaue zeitliche Planung aller Arbeitsvorgänge sowie die exakte Temperatur- und Luftfeuchtigkeitskontrolle unentbehrlich. Es ist von verschiedenen Voraussetzungen abhängig, so z. B. von der chemischen Zusammensetzung des Wassers, von Klima- und Wetterbedingungen, von der Lagerung sowie vom Alter der verwendeten Materialien. Wenn man bereit ist, die dafür erforderlichen Summen auszugeben und konzentriert zu arbeiten, kann man lernen, gute Carbro-Abzüge herzustellen und sogar Resultate von ziemlich gleichmäßiger Qualität zu erreichen, aber es ist kein Kinderspiel. [...]

DAS VORBEREITEN NEUER ZELLULOID-SCHICHTTRÄGER

Es gibt zwei Theorien über die Vorbereitung neuer Zelluloid-Schichtträger für den Carbro. Die eine besagt, dass die Schichtträger zuerst mit einer leicht scheuernden Seife gewaschen werden sollten [...]. Dabei sollte jedoch nie ein Material verwendet werden, das zu grobkörnig ist und die Oberfläche zerkratzen könnte. Nach der anderen Theorie reicht es aus, die Schichtträger durch einfaches Wachsen, Polieren, Trocknen und erneutes Wachsen und Polieren vorzubereiten. Wenn sie zu zerkratzt oder abgenutzt sind, sollte man sie wegwerfen.

Ganz neue Schichtträger ergeben zwar ein saubereres Bild, aber wenn sie etwas vorbereitet sind, ist die Handhabung leichter. Man sollte nie versuchen, sie mit sehr heißem Wasser zu reinigen, denn durch zu viel Wärme verbiegen sie sich und liegen dann nicht plan, wenn man die Pigmentschicht anreibt, oder versucht, alle drei Schichten genau übereinanderzulegen, um die Farbverteilung [die Farbbalance] zu überprüfen. [...]

DAS WACHSEN DER ZELLULOID-SCHICHTTRÄGER

[...] Auf die vier Ecken und in die Mitte der Zelluloid-Schichtträger werden einige Tropfen der Wachslösung verteilt. Der Polierblock wird wie folgt hergestellt: Auf den Boden eines etwa 5 x 5 cm großen und 2,5 cm hohen Holzblocks wird mit Heißkleber [heißem Leim] ein etwa 0,5 cm dickes Stück elastischer Filz [z. B. Klavierfilz] aufgeklebt. Auf dieselbe Weise wird ein zweiter, etwas größerer Block mit einer Grundfläche von etwa 5 x 10 cm gefertigt. Das sind die Werkzeuge, die man zum Wachsen und Säubern der Zelluloidfolie benötigt. Außerdem lassen sich damit Wachsreste vom vorläufigen Trägerpapier entfernen. [...]

DAS BROMIDPAPIER

Die Kopien auf Silberbromidpapier sind die Ausgangsbasis des Carbro-Verfahrens. Das beste Papier für diesen Zweck ist Ilingworth Normal Contrast Bromide Paper [...]. Es wird von fast allen Fotografen verwendet, die professionell mit der Carbro-Technik arbeiten, und ist in Rollen von 10 oder 3 m Länge und einer Breite von 102 cm erhältlich. Außerdem gibt es Pakete mit jeweils einem Dutzend Blättern in den Formaten 28 x 36 bzw. 20 x 25 cm. Wenn man viel arbeitet, erweisen sich die großen Rollen als sparsamer, denn sie sind schnell genug verbraucht; außerdem ist es ohnehin besser, Bromidpapier für Carbro-Abzüge in Rollenform zu kaufen. [Man kann auch Defender Velour Black für das zweifache Bleichbad nehmen, aber dann ist ein tieferer Druck erforderlich, um zum gleichen Ergebnis zu gelangen.] [...]

DAS FIXIEREN UND WÄSSERN

Die Bromid-Schichtträger sollten nicht länger als 15 Minuten in einer ganz frischen Lösung aus Fixiersalz verbleiben und

eine bis anderthalb Stunden lang gewässert werden. Wenn das Fixierbad schon älter ist, können die Abzüge ohne Schaden zu nehmen länger darin belassen werden, aber insgesamt ist es vorteilhaft, immer ein neues Bad zuzubereiten. Das Fixiersalz muss völlig abgewaschen sein, damit es nicht zu Problemen kommt. Daher empfiehlt es sich, mit einer Permanganatlösung die völlige Beseitigung des Salzes zu überprüfen. […]

NACHENTWICKLUNG UND AUFBEWAHRUNG
DER BROMIDSCHICHTTRÄGER

Für die Überprüfung und den Vergleich eines oder mehrerer Sätze von Bromidpapieren ist ein gewisses Einschätzungsvermögen notwendig, das man erst durch praktische Erfahrung und theoretische Kenntnisse erwirbt. Daher halte ich es beim Carbro-Verfahren für ratsam, die Bromidpapiere nachzuentwickeln und aufzubewahren, um sie zu einem späteren Zeitpunkt zum Vergleich des Tonwertes bestimmter Farben bei neuen Sätzen zur Verfügung zu haben. In Verbindung mit genauen Notizen ist ein gutes Archiv dieser Art unter bestimmten Voraussetzungen äußerst empfehlenswert. Aus einem Satz nachentwickelter Bromid-Schichtträger können fast exakte Duplikate von Farbbildern gemacht werden. Auf diese Art und Weise kommt man meiner Ansicht nach dem Originalabzug am nächsten. Zu diesem Zweck sollten die Bromidpapiere fünf Minuten lang nachentwickelt werden, vorzugsweise in einem einfachen Metol-Entwickler. Nach dieser zweiten Entwicklung reicht eine halbstündige Wässerung aus. Falls Schwierigkeiten auftauchen, sollte gründlicher gewässert werden. […]

DAS EINWEICHEN DES PIGMENTPAPIERS

[…] Auf dieselbe Art und Weise wird nach einer Minute das rote Pigmentpapier in dieselbe Schale eingetaucht, über das blaue, und nach einer weiteren Minute auch das gelbe. Wenn die Laboruhr nach der dritten Minute klingelt, wird sie erneut auf drei Minuten eingestellt. Das blaue Papier wird entnommen und an den beiden oberen Ecken an Klammern aufgehängt. Nach Ablauf einer weiteren Minute wird das rote Papier aus dem Bad genommen und zum Abtropfen aufgehängt. Nach der dritten und letzten Minute wird das gelbe Papier entnommen. Es ist also notwendig, dass alle Farb- oder Pigmentpapiere genau gleich lange in dem Bad eingeweicht und danach gleich behandelt werden.

DAS SENSIBILISIEREN UND BLEICHEN DES PIGMENTPAPIERS

Wenn die Uhr nach Ablauf der dritten Minute [insgesamt sind sechs Minuten vergangen] erneut klingelt, werden die Lösungen b und c in das Sensibilisierungsbad gegossen. Die Schale muss gut geschüttelt werden, damit sich die Lösungen richtig mischen. Nachdem der Sekundenzähler gestellt worden ist, wird das blaue Pigmentpapier in die Sensibilisierungslösung getaucht, wobei die Schale unablässig geschüttelt wird. Nach genau 60 Sekunden wird das rote Pigmentpapier eingetaucht,

und nach weiteren 60 Sekunden das gelbe. Nachdem das gelbe Papier 30 Sekunden in der Lösung gelegen hat, wird das blaue Papier vom Boden der Schale genommen und nach oben gebracht. Während des gesamten Vorgangs sollte die Schale leicht geschüttelt werden, damit die Papiere gleichmäßig sensibilisiert und gebleicht werden.

DIE ROLLENQUETSCHUNG

Ab jetzt muss schnell gearbeitet werden. 15 Sekunden vor Ablauf der drei Minuten wird das blaue Bromidpapier mit dem blauen Farbauszug aus der Einweichschale genommen, und hochgehalten, bis es nur noch tropft; dann wird es auf die Markierungen des oberen oder rechten Zelluloid-Schichtträgers im Rollenquetscher gelegt. Unmittelbar darauf wird das blaue Pigmentpapier aus dem Sensibilisierungsbad genommen und ohne es vorher abtropfen zu lassen auf die Markierungen des unteren oder linken Zelluloid-Schichtträgers gelegt. Der obere Schichtträger wird von seinem Haken gelöst und in die linke Hand genommen; bis sie in den Rollenquetscher eingelegt werden, werden das Bromid- und das Pigmentpapier voneinander getrennt gehalten. Mit der rechten Hand wird der Rollenquetscher so schnell wie möglich in Gang gesetzt und das durchgelaufene Sandwich [Mehrschichtenpaket] beiseite gelegt. Dafür wird eine Laboruhr auf zehn Minuten gestellt. Durch den engen Kontakt zwischen dem Bromid- und dem Carbro-Pigmentpapier, der im Rollenquetscher entsteht, wird das Bild vom Bromid auf die farbpigmenthaltige Papierschicht übertragen und diese bildmäßig gegerbt. Die nicht gegerbten Stellen werden im warmen Wasserbad abgewaschen, wodurch eine genaue Reproduktion des schwarzweißen Bromid-Bildes in der farbigen Gelatine hinterlassen wird. […]

DIE TRENNUNG DES SANDWICHS UND DAS ALKOHOLBAD

Eine neue, mit möglichst kaltem Wasser – die Temperatur darf 15° c nicht übersteigen – gefüllte Schale wird neben die dicke Glasscheibe auf die Arbeitsfläche gestellt. Wenn die Uhr nach zehn Minuten klingelt, wird der kombinierte blaue Brom- und Pigmentpapier-Verbund von der Zelluloidunterlage entfernt und in die Schale mit dem kalten Wasser gelegt. Dann wird das Bromidpapier vorsichtig unter Wasser vom pigmentierten Papier abgezogen und sofort mit der beschichteten Seite nach unten in die Wässerung gegeben.

Wenn es zu Luftblasen kommt, kann man anstelle von kaltem Wasser ein 25-prozentiges Alkoholbad von niedriger Temperatur verwenden. Dieses Alkoholbad hebt die Oberflächenspannung auf; vor dem Gebrauch sollte es gemischt und gekühlt werden, da durch die Mischung Wärme entsteht. Bei warmem Wetter sollten sowohl diese Schale als auch die Zelluloidfolie gut gekühlt werden, damit das Pigmentpapier beim Walzen nicht abrutscht. Das Pigmentpapier sollte nicht länger als 30 Sekunden nach der Entfernung des Bromidpapiers in diesem Bad verbleiben. […]

DAS WALZEN

Das Papier wird jetzt aus dem Wasser- oder Alkoholbad genommen, und ohne es vorher abtropfen zu lassen, wird das untere Ende mit der linken Seite der fest auf der Glasplatte verankerten Zelluloidfolie in Kontakt gebracht. Dieses Ende wird fest heruntergedrückt, und der Rest des Blattes so heruntergeklappt, dass sich keine Luftblasen bilden. Bei allen Walzvorgängen im Carbro-Verfahren kommt es auf den vollständigen Ausschluss von Luft zwischen den beiden Oberflächen an. Das herausgepresste Wasser sollte immer auch alle Luft mittransportieren. Die linke Seite des Pigmentpapiers wird mit der linken Hand fest heruntergedrückt, sodass keine Bewegung möglich ist. Dann wird der Abstreifer – entweder ein flacher Gummiabstreifer oder ein Fensterwischer, wie ich ihn benutze – langsam und gleichmäßig von links nach rechts über das Pigmentpapier gezogen, sodass alle Flüssigkeit und Luft herausgedrückt wird. […]

DIE ENTWICKLUNG DER ZELLULOID-SCHICHTTRÄGER

Man füllt zwei Schalen mit warmem [zwischen 43° und 46°C] und eine dritte mit kaltem Wasser. Man lässt den Zelluloid-Schichtträger mit dem blauen Pigmentpapier in die erste Schale gleiten und stellt eine Uhr auf zwei Minuten ein. Wenn es klingelt, kann man die überschüssige Gelatine, die von der chemischen Reaktion nicht gegerbt wurde, unter den Rändern des Papiers hervorquellen sehen. Man legt die Daumen unter Wasser auf gegenüberliegende Ecken des Pigmentpapiers und lässt es vorsichtig zur Seite gleiten. Dann wird das Papier langsam von der Gelatine abgezogen und weggeworfen, wobei die Zelluloidfolie an der Seite der Schale gehalten wird, um das überschüssige Pigment zu lösen, bis das Bad von der aufgelösten Gelatine trüb wird. Jetzt spült man die Zelluloidfolie im warmen Wasser, indem man es wie ein Pendel darin hin- und herschwingen lässt. Dann zieht man es mit beiden Händen von einer der Seite zur anderen aus dem Wasser, und zwar so, dass so viel überschüssige Gelatine wie möglich abgespült wird. Das Bild, das vom Bromidpapier übertragen wurde, dürfte jetzt deutlich in blauer Farbe zu sehen sein. Der Zelluloid-Schichtträger wird mit dem Bild nach oben in die zweite Schale mit warmem Wasser gelegt und dort belassen, während der Zelluloid-Schichtträger mit dem roten Pigmentpapier zum Einweichen in die erste Schale gelegt wird. […]

DIE ÜBERTRAGUNG DER BILDER

Die Carbro-Bilder werden für den endgültigen Abzug in der folgenden Reihenfolge zusammengestellt: das gelbe ganz unten auf dem Papierträger, als nächstes das rote, und das blaue zuoberst. Gelb ist nämlich ein lichtundurchlässiges Pigment, während Rot und Blau transparent sind. Wäre Gelb oben, könnte man die anderen Farben darunter nicht richtig sehen. Daher müsste man Gelb als erstes auftragen, wenn die drei Bilder gleich auf den endgültigen Papierträger gebracht würden; da es aber etwas schwierig ist, die Umrisse eines gelben

Bildes auf einem weißen Papier zu sehen, wäre das exakte Einpassen einer anderen Farbe darüber sehr kompliziert. […]

DAS ENTFERNEN VON WACHS VOM VORLÄUFIGEN TRÄGER

Die Wachsschicht muss nun vom vorläufigen Trägerpapier entfernt werden, da sonst das nächste [rote] Bild nicht haften bleibt. Der vorläufige Träger wird an den vier Ecken mit Reißzwecken an einem dafür bereitstehenden Brett angebracht. Mit einem in destilliertes Terpentin getauchten Wattebausch wird das Bild abgewischt. Dann geht man noch einmal mit frischer Baumwolle über die Oberfläche, und anschließend mit einem Baumwollflanelltuch, das um den größeren der beiden Polierblöcke gewickelt wird, mit denen schon die Zelluloidfolie poliert wurden. […]

DAS EINWEICHEN DES VORLÄUFIGEN TRÄGERS FÜR DEN ZWEITEN UMDRUCK

Der vorläufige Träger wird noch einmal in dasselbe Wasser eingetaucht. Wenn die Rückseite nass und etwas schlaff ist, wird er mit beiden Händen an den Ecken aus dem Wasser gehoben und langsam mit der Vorderseite auf die Wasseroberfläche gesenkt, um alle Luftblasen zu entfernen. Die Zelluloidfolie mit dem roten Bild muss wie gehabt vorher mit dem Bild nach oben und natürlich mit der Abbildung in der gleichen Richtung wie auf der Zelluloidfolie darunter gelegt worden sein. Eine Uhr wird auf fünf Minuten gestellt. Wenn diese Zeit abgelaufen ist, werden der Träger und die Zelluloidfolie wie vorher zusammen entnommen und so gut und so schnell wie möglich übereinandergefügt, wobei man sie gegen das Licht hält. Mithilfe der Wärme der Daumen, mit denen das Papier für kurze Zeit an den Rändern festgehalten wird, wird die gefundene Position locker fixiert. […]

DAS EINPASSEN DER ROTEN UND BLAUEN BILDER

Die Zelluloidfolie wird auf die Glasplatte gelegt und der vorläufige Träger ganz leicht abgestreift, um überschüssiges Wasser und Luft zu entfernen. Dann wird die Zelluloidfolie hochgehoben, und das Bild auf dem Papier wird gegen das Licht gehalten und hin- und herbewegt, bis es so gut wie möglich mit dem roten Bild übereinstimmt. Dabei wird der vorläufige Träger nur an den Rändern festgehalten. Dann wird der vorläufige Träger erneut leicht abgestreift, und nachdem die umgedrehte Zelluloidfolie auf eine neue fotografische Aufsaugschicht gelegt worden ist, wird mit dem Abstreifer das Wasser von der Rückseite abgezogen. Nachdem die Feuchtigkeit von der Glasplatte abgewischt worden ist, wird eine neue, trockene Aufsaugschicht auf die Glasplatte, und der Zelluloid-Schichtträger mit dem darunter befindlichen vorläufigen Träger neben die Platte gelegt. Sollten Luftblasen zu sehen sein, müssen sie mit einem kleinen Abstreifer entfernt werden, bevor mit dem genauen Einpassen begonnen werden kann. […]

Wenn dieser Bereich eingepasst ist, kann man, wenn man in der Mitte des Bildes angekommen ist, möglicherwei-

se feststellen, dass der Abzug schon so trocken ist, dass sich ein weiteres Abstreifen erübrigt. So schnell es gelingen kann, die Bilder richtig übereinanderzulegen, so schnell können sie sich auch wieder verschieben. Wenn die Bilder einmal an die richtige Stelle gerückt sind, sollten sie dort fest genug haften. Sollte man andererseits zu viel hin- und herschieben müssen, um die Bilder richtig übereinander zu legen, sollte die Zelluloidfolie besser wieder ins Wasser gegeben und der vorläufige Träger unter der Wasseroberfläche vorsichtig an der Stelle, die Schwierigkeiten bereitet, vom Zelluloid-Schichtträger abgehoben werden. Liegt das Problem in der unteren Hälfte des Abzugs, brauchen die Bilder natürlich nur bis zur betreffenden Stelle voneinander getrennt werden. Nachdem die Zelluloidfolie mit einer schnellen Aufwärtsbewegung aus dem Wasser genommen worden ist, können die voneinander getrennten Bilder wieder übereinandergefügt werden, indem man mit ganz leichtem Druck mit dem Abstreifer darübergeht. […]

DAS EINPASSEN DES GELBEN BILDES

Sobald das Einpassen der blauen und roten Bilder beendet ist, wird der Zelluloid-Schichtträger wie vorher zum Trocknen vor einen Ventilator gehängt. Wenn der vorläufige Träger getrocknet ist und sich von der Zelluloidfolie ablöst, wird hoffentlich ein perfekt übereinandergefügtes violettes Bild zu sehen sein. Wie schon zuvor das blaue Bild, wird auch dieses mit Terpentin gesäubert. Dann geht man wie beim letzten Mal vor und weicht das kombinierte Blau und Rot auf dem vorläufigen Träger fünf Minuten lang mit dem Gelb auf der Zelluloidfolie ein. Nach Ablauf dieser Zeit werden die Schichtträger entnommen und wie schon bei den beiden vorhergehenden Bildern übereinandergefügt; dabei darf nicht vergessen werden, dass immer nur das auf dem Zelluloid-Schichtträger befindliche Bild bewegt werden darf. […]

DIE ÜBERTRAGUNG AUF DEN ENDGÜLTIGEN TRÄGER

Nachdem der vorläufige Träger mit dem gesamten übertragenen Bild vom Zelluloid-Schichtträger gelöst ist, sollte er wie oben beschrieben gründlich mit Terpentin gereinigt werden. Dann wird der Rand mit den Reißzwecklöchern und eventuellen Rissen beschnitten, bis ein etwa ein Zentimeter breiter Rand übrigbleibt. Dann wird das Bild mit der Vorderseite nach oben in eine große Schale mit kaltem Wasser getaucht, in der der endgültige Papierträger schwimmt. Das Papier wird durch das Wasser hin- und hergezogen, bis die gesamte Oberfläche bedeckt ist. Mit der Vorderseite nach oben wird es dann eine Minute lang stehen gelassen, wobei es völlig unter Wasser bleiben muss. [Dann wird es aus dem Wasser genommen, abgesenkt und wieder hineingelegt - auf die oben beschriebene Weise, damit keine Luftblasen entstehen. Nachdem es für eine weitere Minute mit der Vorderseite nach unten im Wasser belassen worden ist.] [Danach] wird die Bildschicht über den endgültigen Papierträger geschoben, der mit beiden Händen gehalten wird. Der vorläufige Träger und die Ober-

fläche des Papiers werden an den oberen Ecken mit den Daumen zusammengehalten; beide Träger werden senkrecht nach oben aus dem Wasser gehoben, damit das Wasser abtropfen kann und sich zwischen den beiden Oberflächen keine Luftblasen ansammeln. Der endgültige Papierträger wird mit dem Bild nach oben auf eine Glasplatte, und der vorläufige Träger darauf gelegt. Mittels eines Abstreifers werden wie oben beschrieben die beiden Oberflächen zusammengedrückt; man drückt dabei in alle Richtungen, damit so viel Feuchtigkeit wie möglich aus dem Sandwich herausgepresst wird. Je trockener das Material und je fester der Zusammenhalt, um so besser. Nachdem die Träger beiseite gelegt worden sind und alles Wasser von der Glasplatte entfent worden ist, wird eine neue Aufsaugschicht auf die Platte gelegt, darauf der endgültige Papierträger, und darauf wieder eine neue Aufsaugschicht. Mit größerem Druck als bisher wird mit einer Walze längs und quer darübergerollt. Dann legt man das Ganze auf eine dicke Glasplatte und stellt zum Beschweren Flaschen mit fotografischen Lösungen darauf, die insgesamt etwa fünf Kilo wiegen. Die Laboruhr wird auf eine halbe Stunde gestellt.

DAS ENTWICKELN DES ENDGÜLTIGEN TRÄGERS

Kurz bevor die halbe Stunde abgelaufen ist, wird eine Schale mit 43° C warmem Wasser vorbereitet. Wenn die Uhr läutet, wird die Kombination von endgültigem und vorläufigem Träger auf die Wasseroberfläche gelegt. Der vorläufige Träger liegt unten, damit das warme Wasser die Gelatine so bald wie möglich zu lösen beginnt. Mit der hohlen Hand wird Wasser über die Rückseite des endgültigen Trägers verteilt, damit er plan liegt. Eine Laboruhr wird auf zwei Minuten eingestellt. Dieser Vorgang ist der Entwicklung des Pigmentpapiers auf der Zelluloidfolie sehr ähnlich. […]

DAS ABTROPFEN UND TROCKNEN

Der endgültige Abzug wird schließlich für ein paar Minuten mit Reißzwecken an einen Regalrand gehängt. Um den Abzug zu befestigen, werden in der Zwischenzeit von einem einfachen, kommerziellen, gummierten Band passende Stücke abgeschnitten und ein glattes Brett, z. B. ein Zeichenbrett, vorbereitet. Der Abzug wird dann genau mittig auf das Brett gelegt. Wenn er einmal Kontakt mit der Unterlage hat, darf er nicht wieder abgehoben werden. Das Band wird mit einem Wattebausch benetzt, die Ecken des Abzugs werden damit auf das Brett geklebt, wobei mit den Fingerspitzen von der Mitte nach außen geglättet wird. Das Band muss fest angedrückt werden; man kann auch ein kleines Tuch dazu verwenden. Sollten sich die Ränder des Gelatinebildes wölben, können sie mit einer weichen, in Alkohol oder einer Lösung aus Alkohol und Wasser getauchten Kamelhaarbürste heruntergedrückt werden. […]

[New York: Random House, 1940]

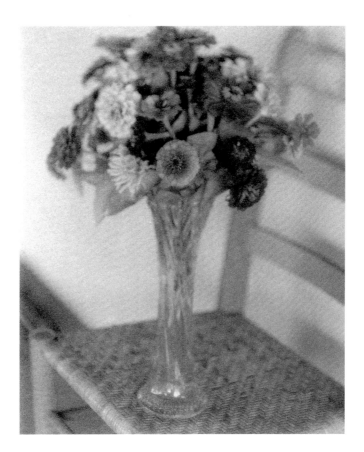

Flowers in Vase on Chair | Blumen in einer Vase auf einem Stuhl |
Fleurs dans un vase posé sur une chaise
1922

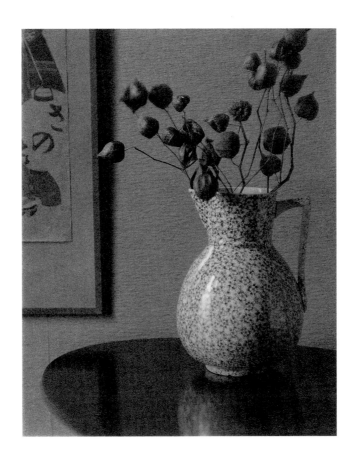

Vase with Dried Flowers | Vase mit getrockneten Blumen |
Vase et fleurs séchées
c. 1924

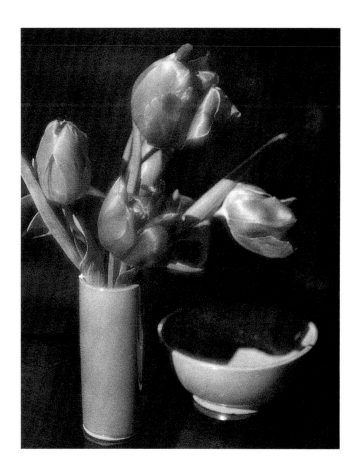

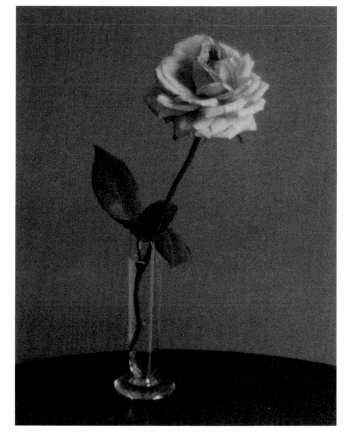

Tulips in Vase | Tulpen in einer Vase | Tulipes dans un vase
1923

Rose in Vase | Rose in einer Vase | Rose dans un vase
c. 1926

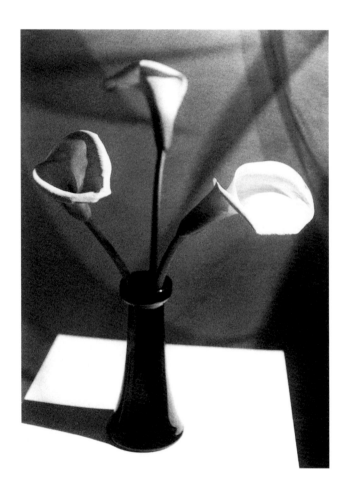

Calla Lilies in a Vase | Callalilien in einer Vase | Arums dans un vase
1926

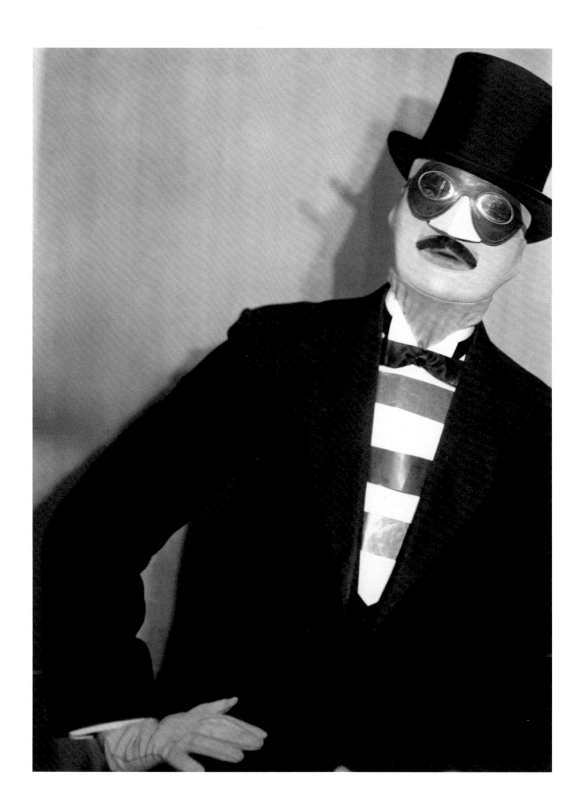

Self-Portrait | Selbstporträt | Autoportrait
c. 1927

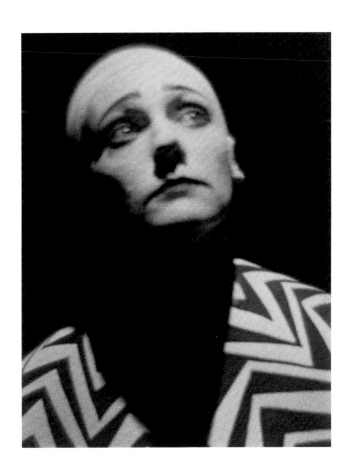

Pierrot
1922

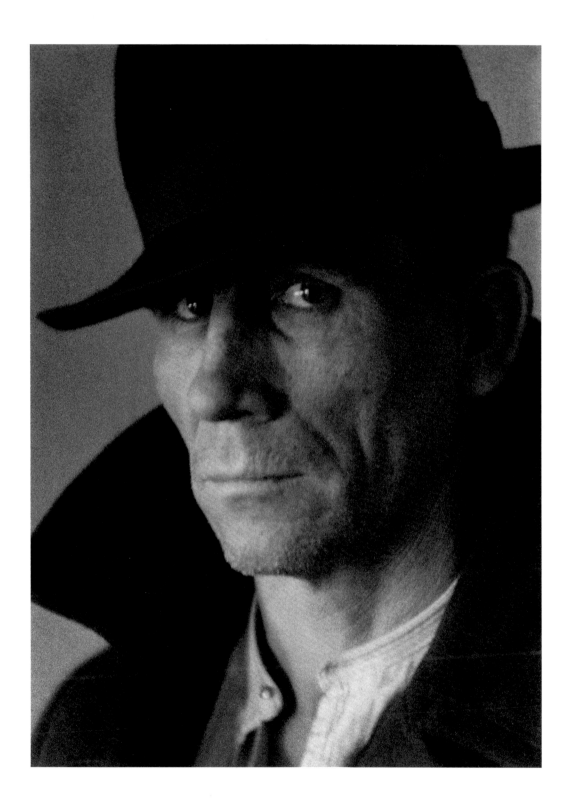

Study of a Man | Männerstudie | Étude d'homme
1923

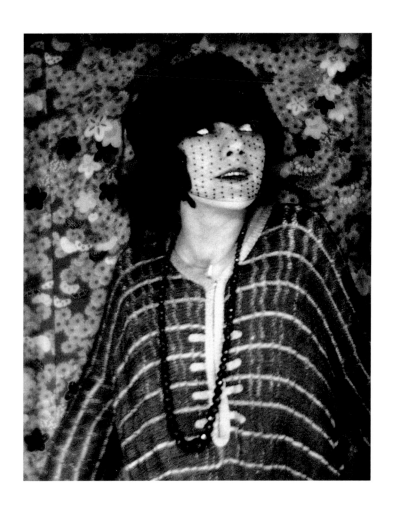

Paula
c. 1922

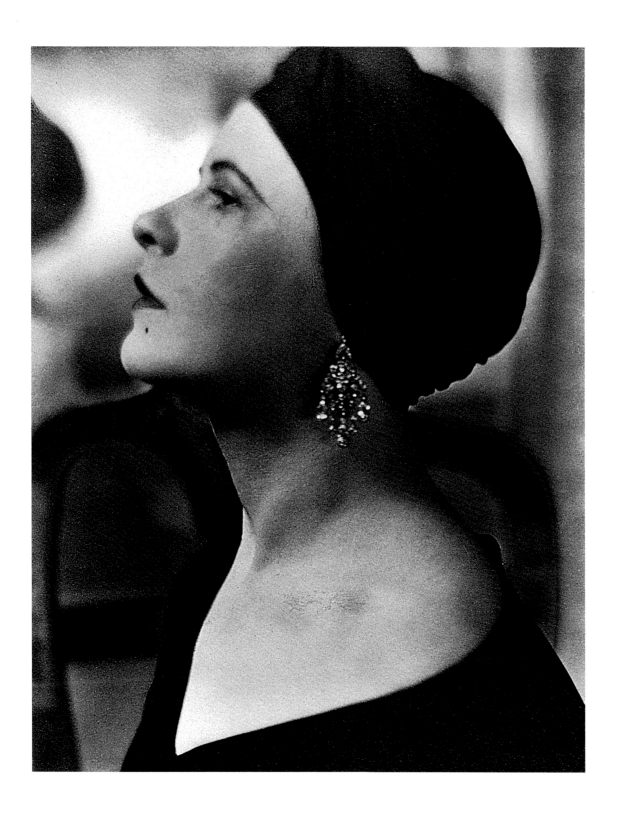

Woman with Turban | Frau mit Turban | Femme au turban
c. 1930

If the test of artistic worth is that an object be the means of aesthetic enjoyment,
who will deny that through photography such objects may be and have been created.

Wenn der künstlerische Wert darin besteht, dass ein Objekt ästhetischen
Genuss vermittelt, so kann man nicht abstreiten, dass solche Gegenstände
mit Hilfe der Fotografie geschaffen werden können und schon geschaffen
worden sind.

Si le fait qu'un objet puisse procurer un plaisir esthétique prouve qu'il possède
une valeur artistique, qui pourra donc réfuter que de tels objets peuvent être,
et ont été, créés par la photographie ?

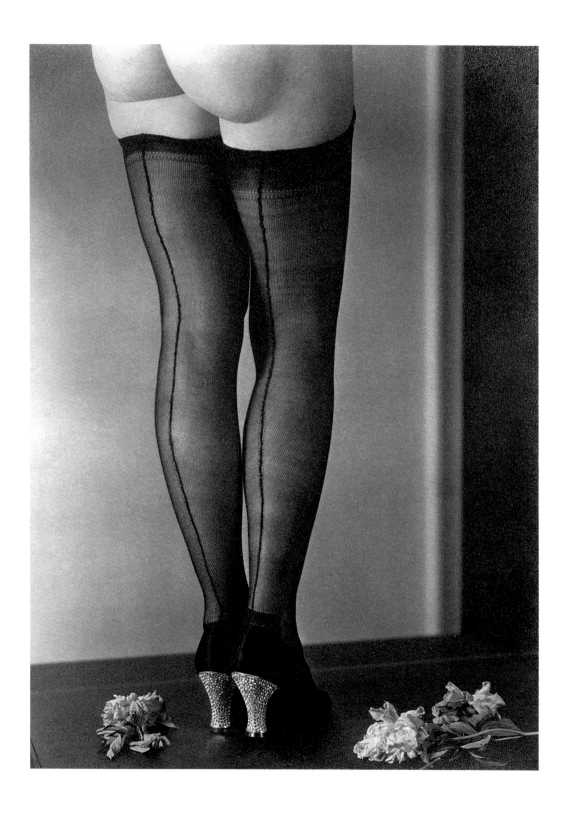

Legs in Stockings with Flowers | Beine in Strümpfen und Blumen | Jambes gainées de bas et fleurs
c. 1928

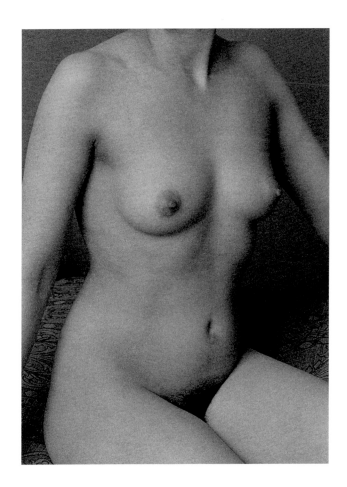

Nude | Akt | Nu
c. 1923

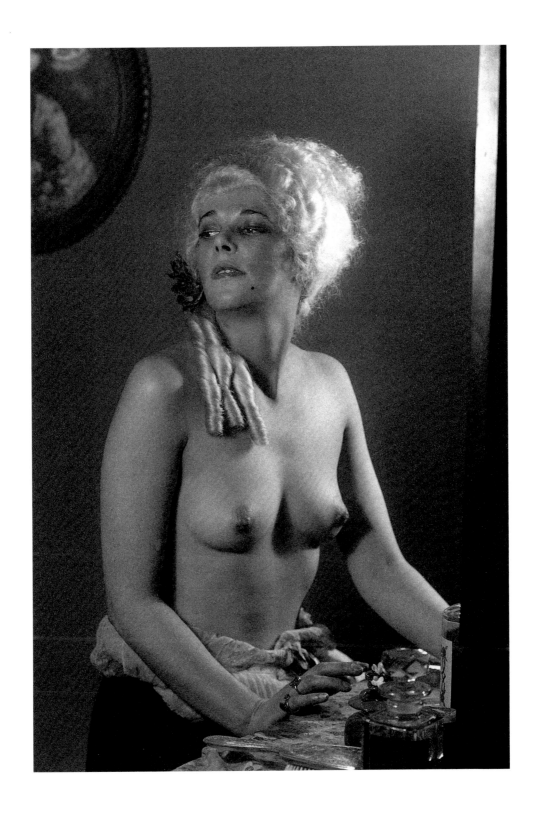

Paula
1923

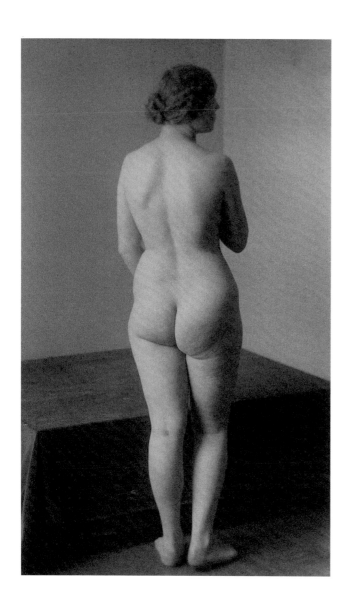 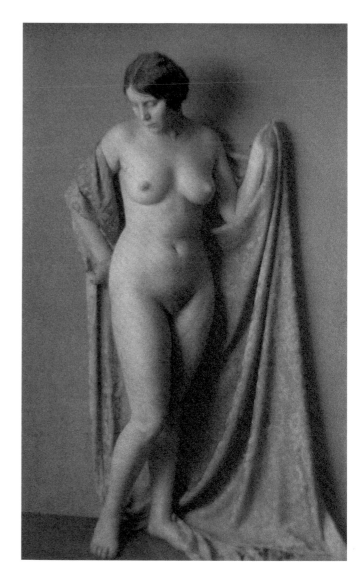

Standing Nude Facing Corner | Stehender Akt in eine Ecke
blickend | Nu debout, face à un coin
c. 1923

Nude | Akt | Nu
1923

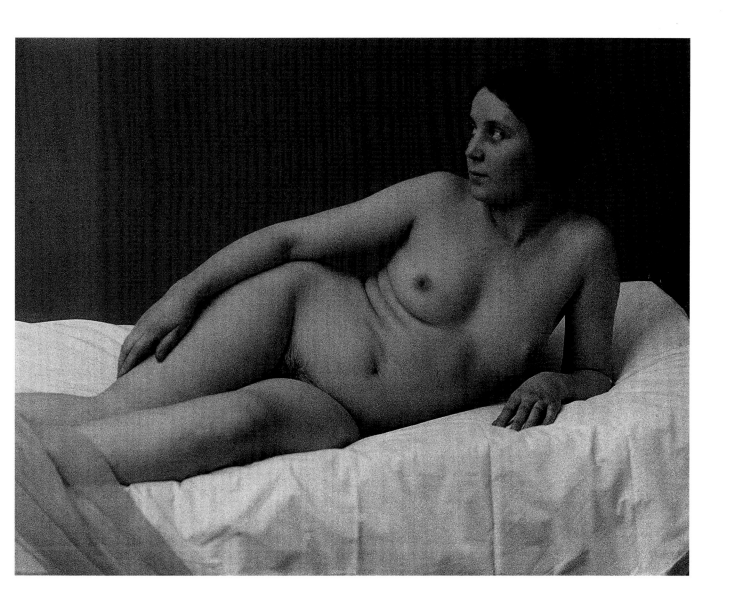

Reclining Nude | Liegender Akt | Nu couché
1923

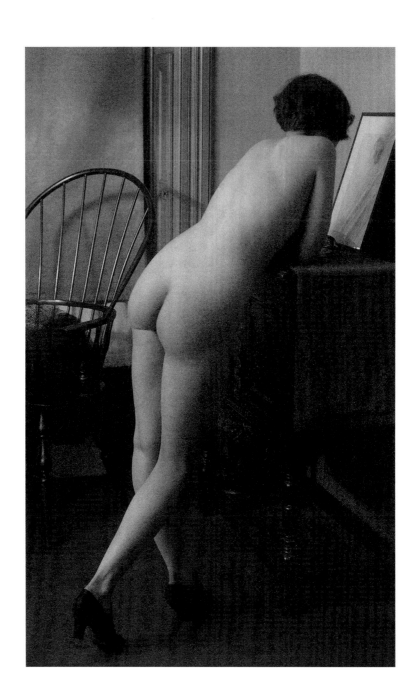

Standing Nude with Chair | Stehender Akt mit Stuhl | Nu debout avec chaise
c. 1924

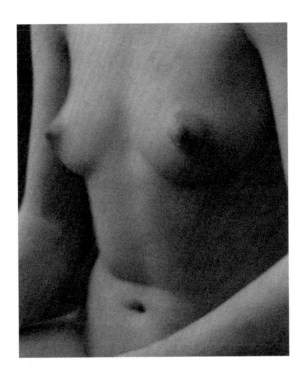

Semi-Abstraction | Halbabstraktion | Semi-abstraction
1923

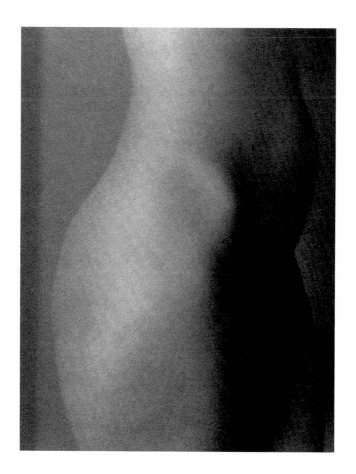

Nude Torso | Nackter Torso | Torse nu
1923

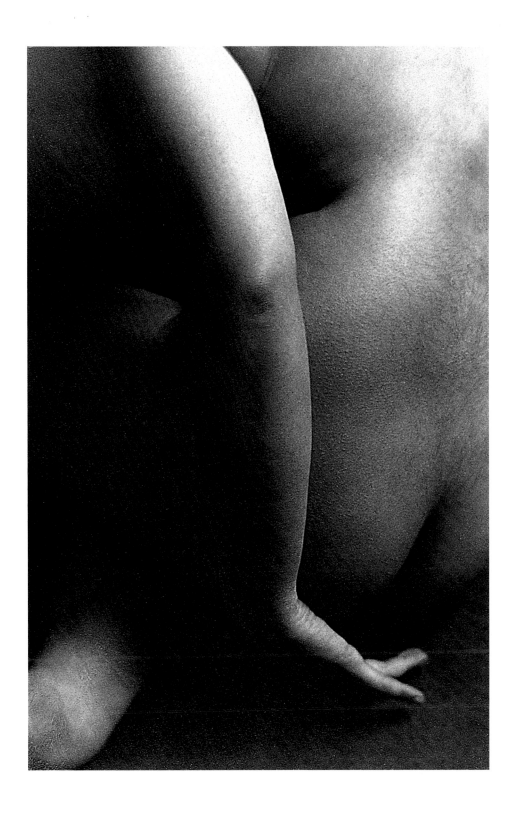

The Arm | Der Arm | Le bras
1930

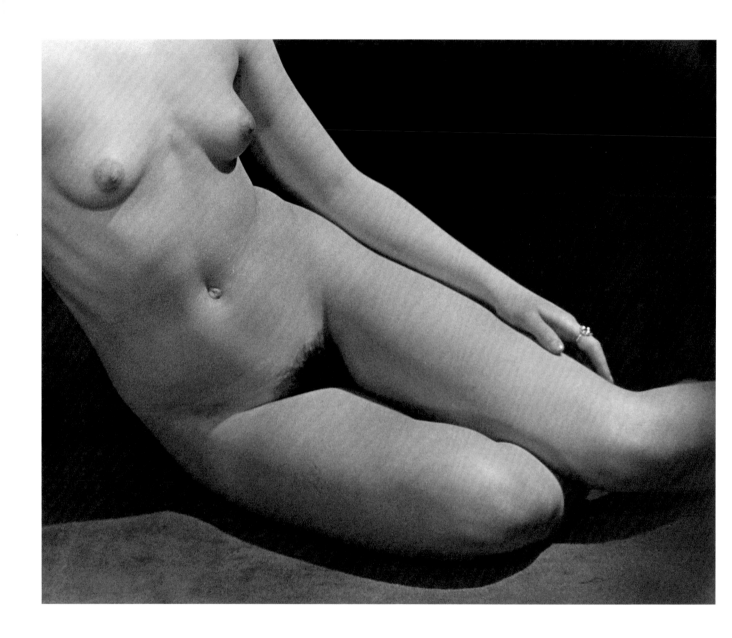

Reclining Nude | Liegender Akt | Nu couché
c. 1923

Nudity is a state of fact; lewdness, to coin a phrase, is a state of mind.

Nacktheit ist ein Sachverhalt; Lüsternheit, um es aphoristisch auszudrücken,
ist eine Gesinnung.

La nudité est un état de fait ; l'obscénité, si je peux m'exprimer ainsi,
est un état d'esprit.

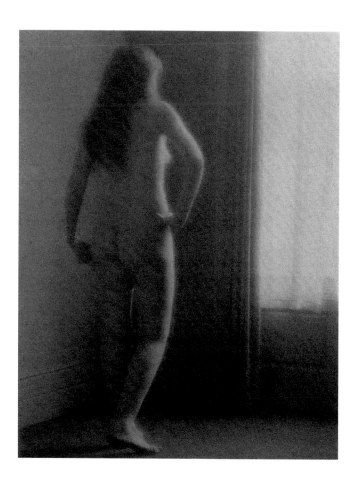

Nude Standing at Window | Stehender Akt am Fenster | Nu devant une fenêtre
c. 1922

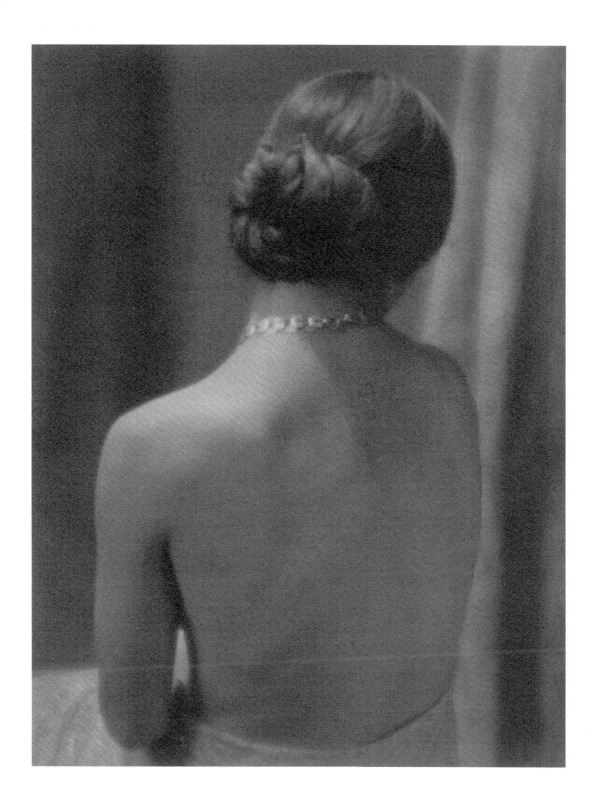

Model | Modell | Modèle
1923

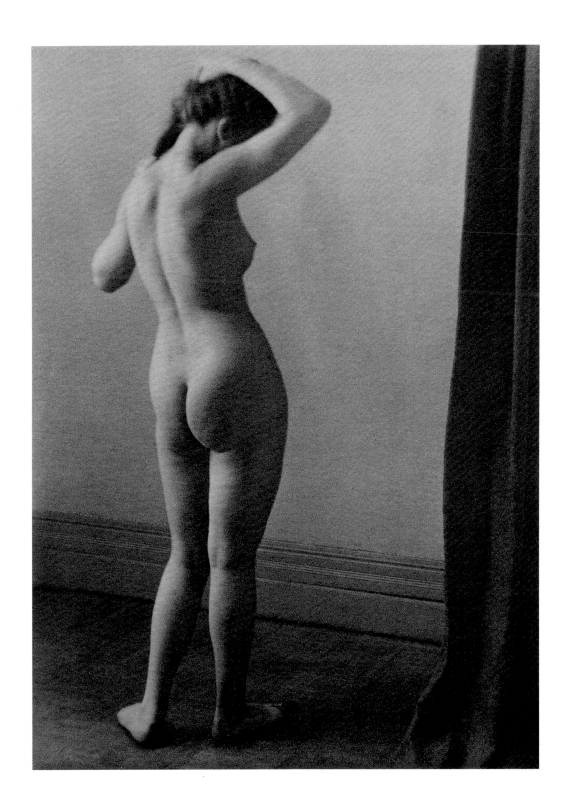

Nude Standing with Drape | Stehender Akt mit Vorhang | Nu debout avec tenture
1923

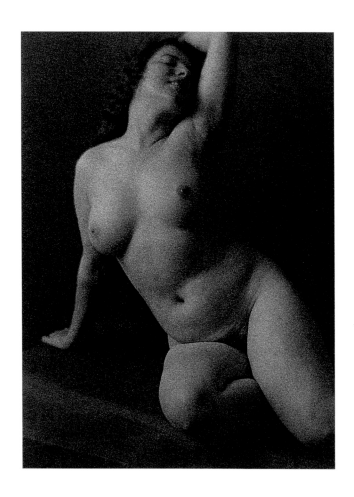

Nude | Akt | Nu
c. 1922

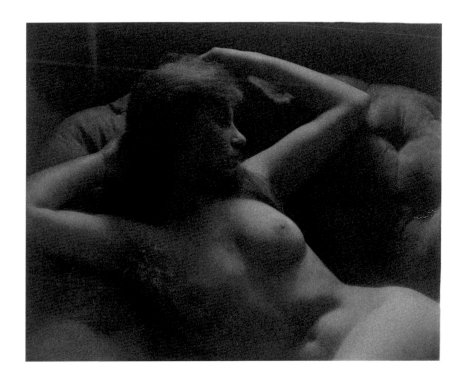

Nude on Sofa | Akt auf einem Sofa | Nu sur un sofa
1923

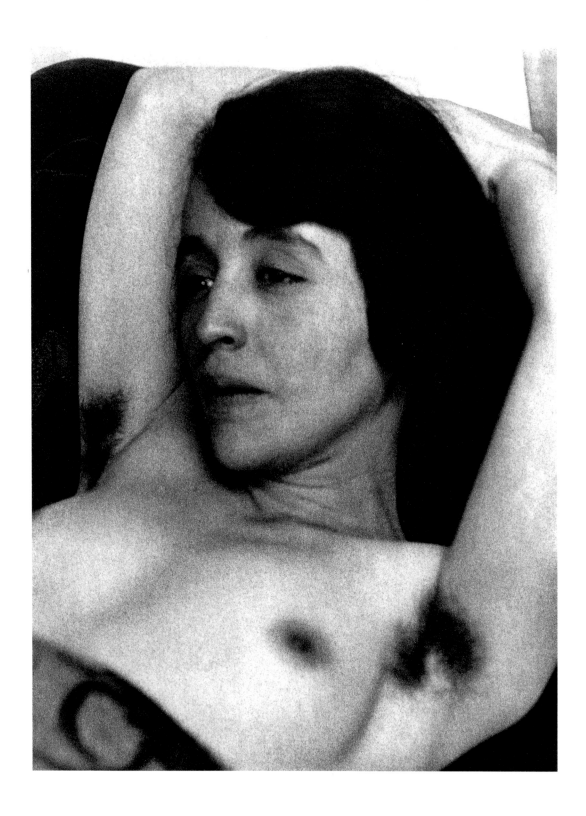

Study | Studie | Étude
1923

As art is an intellectual as well as an emotional language, the most important thing
in any picture is that it has something to say.

Da Kunst eine intellektuelle wie emotionale Sprache ist, ist das Wichtigste bei
jedem Bild, dass es etwas zu sagen hat.

L'art étant un langage intellectuel tout autant qu'affectif, le plus important
pour une image est qu'elle ait quelque chose à dire.

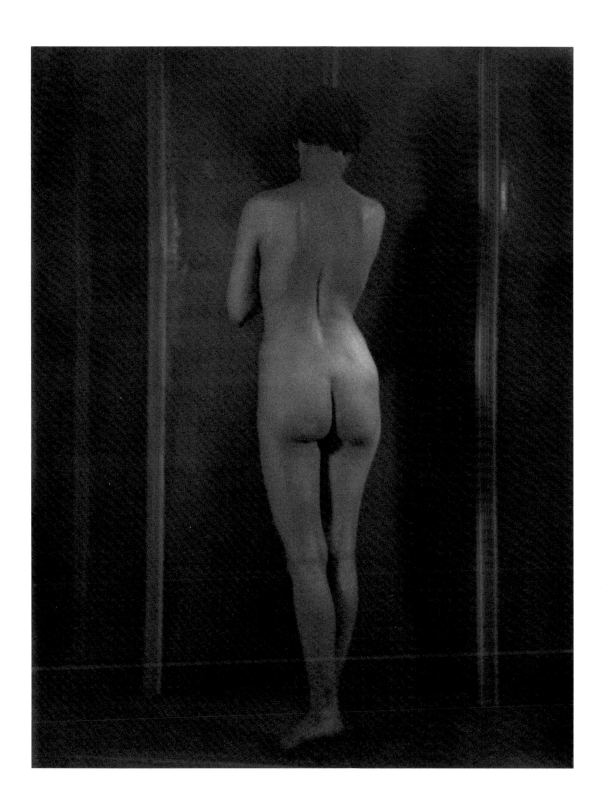

Standing Nude | Stehender Akt | Nu debout
c. 1923

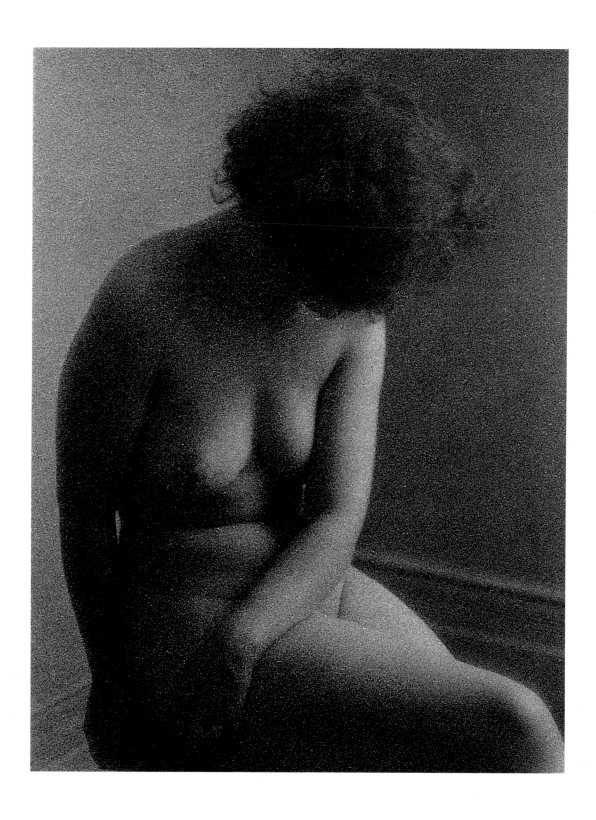

Seated Nude | Sitzender Akt | Nu assis
c. 1922

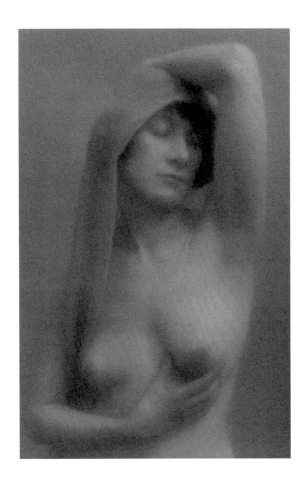

Study | Studie | Étude
1922

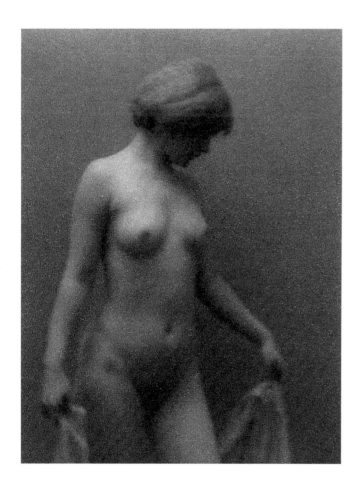

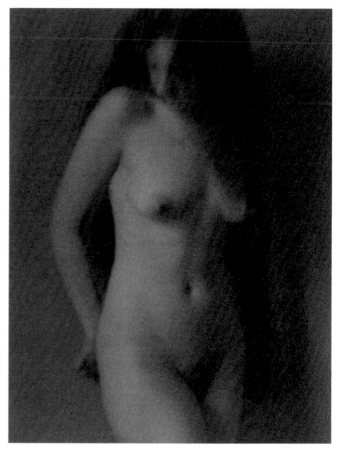

Nude | Akt | Nu

c. 1922

Standing Nude | Stehender Akt | Nu debout

1922

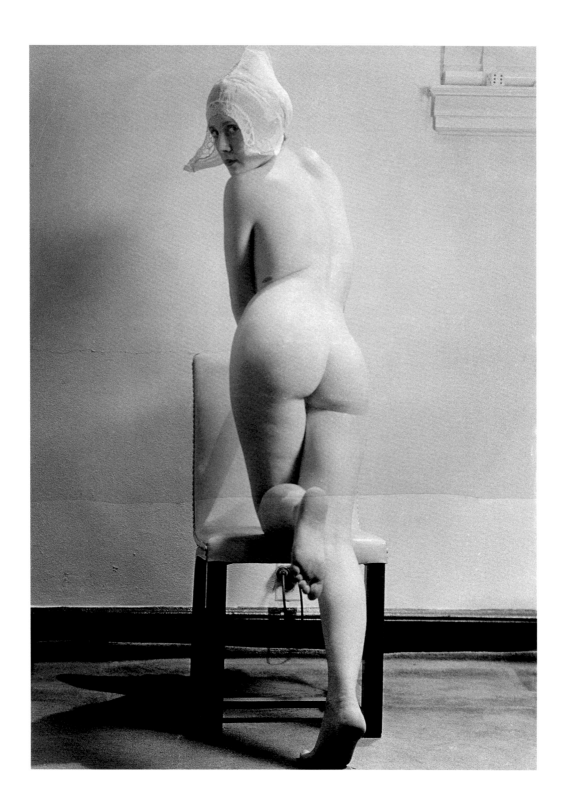

Dutch Girl | Junge Holländerin | Jeune Hollandaise
c. 1938

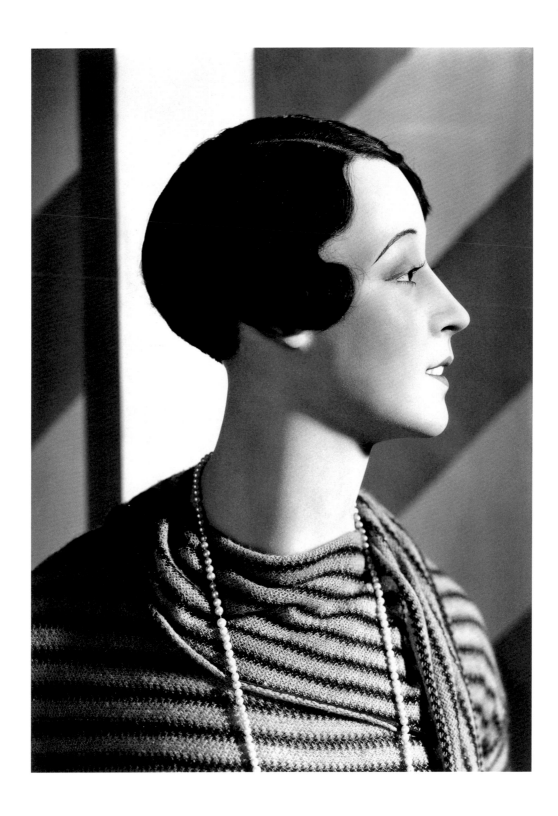

Mannequin
c. 1928

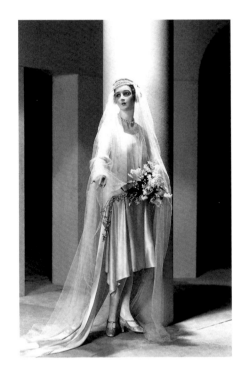

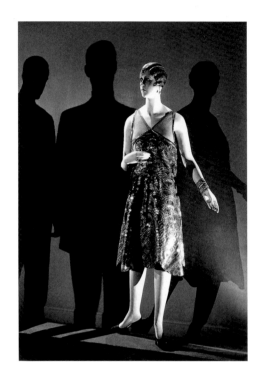

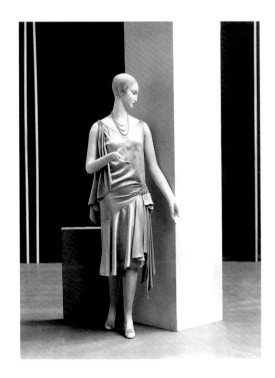

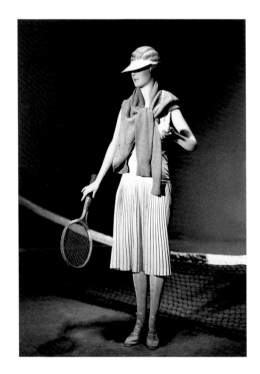

Mannequin
c. 1928

Mannequin
c. 1928

Mannequin
c. 1928

Mannequin
c. 1928

The nude should be relatively impersonal, and a fatal error is to have a model establish too personal or intimate contact with the person viewing the picture.

Der Akt sollte relativ unpersönlich sein, und es ist ein fataler Fehler,
das Modell einen zu persönlichen oder intimen Kontakt mit dem Betrachter
der Aufnahme herstellen zu lassen.

Le nu doit être assez impersonnel, et une erreur fatale consiste à
avoir un modèle qui établisse un contact trop personnel ou intime avec
la personne pratiquant la prise de vue.

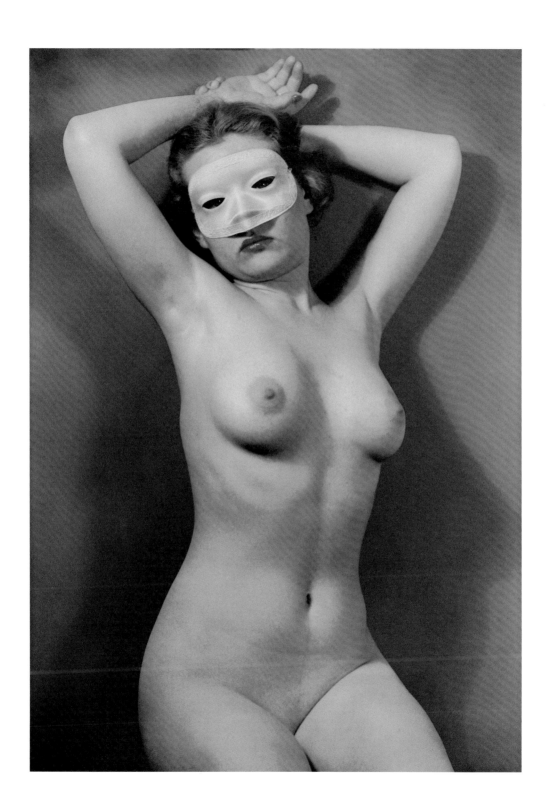

Woman with Mask | Frau mit Maske | Femme avec masque
c. 1937

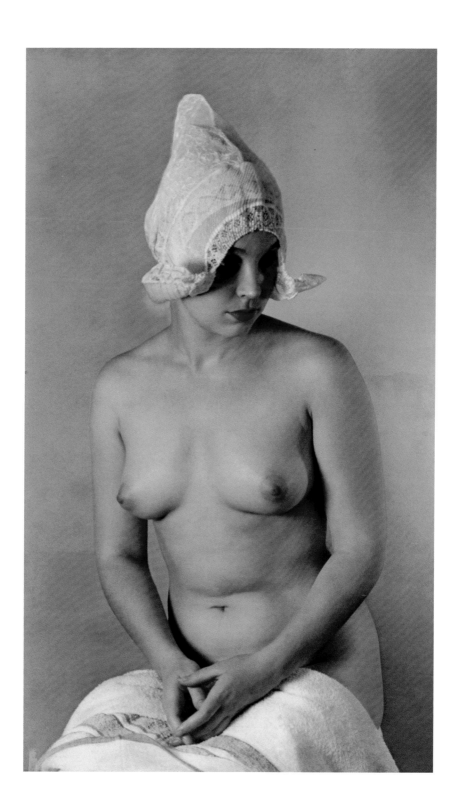

The Dutch Girl | Junge Holländerin | Jeune Hollandaise
1936

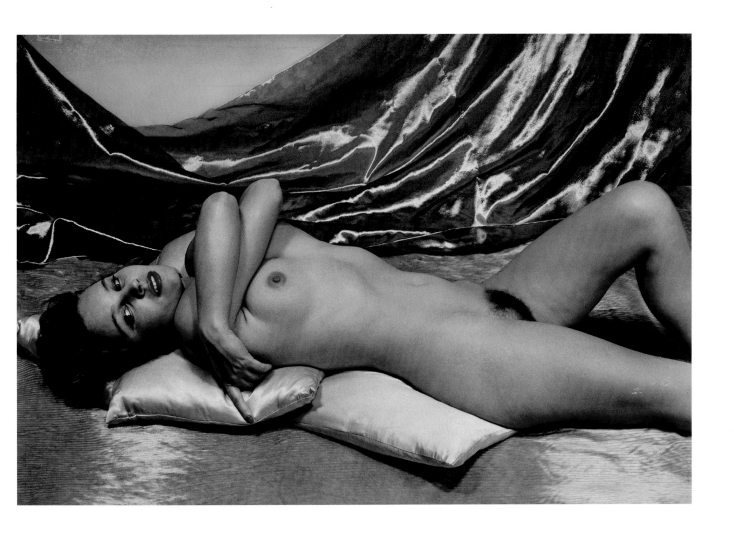

Reclining Nude | Liegender Akt | Nu couché
c. 1937

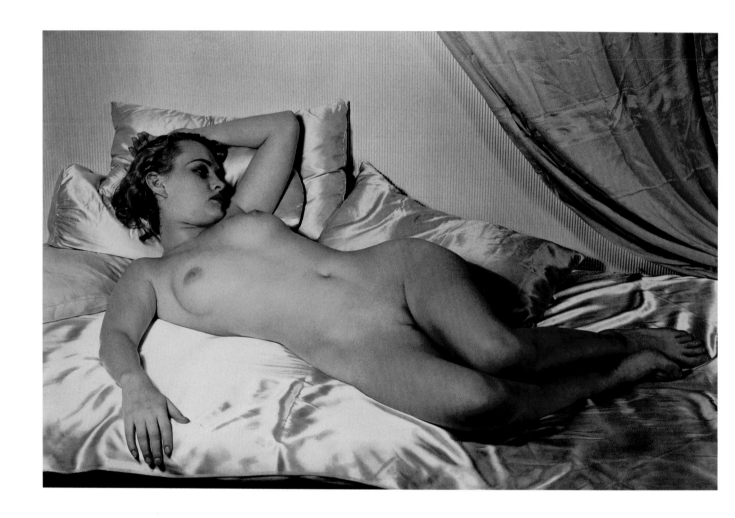

Reclining Nude | Liegender Akt | Nu couché
c. 1936

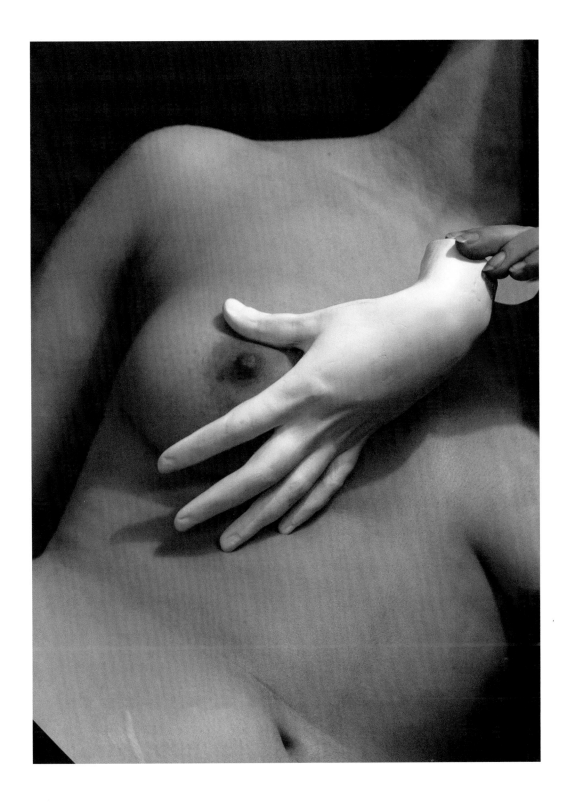

Nude Torso with Hand | Nackter Torso mit Hand | Torse nu avec une main
c. 1936

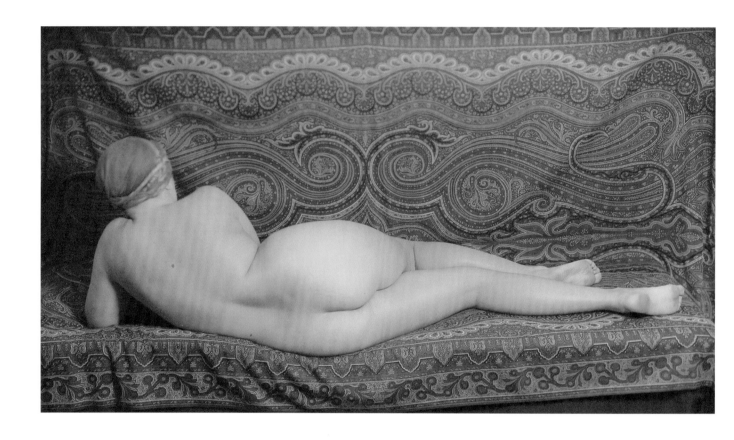

Nude on Bed | Akt auf einem Bett | Nu sur un lit
c. 1936

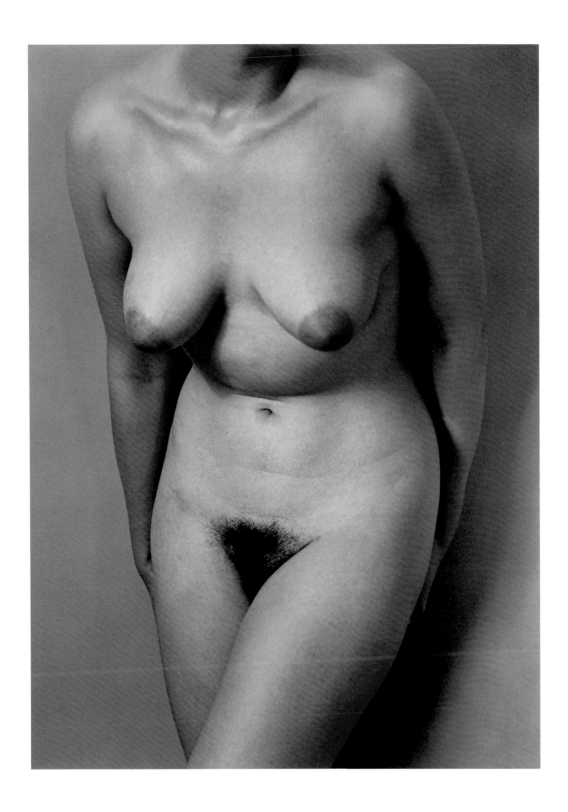

Nude | Akt | Nu
c. 1935

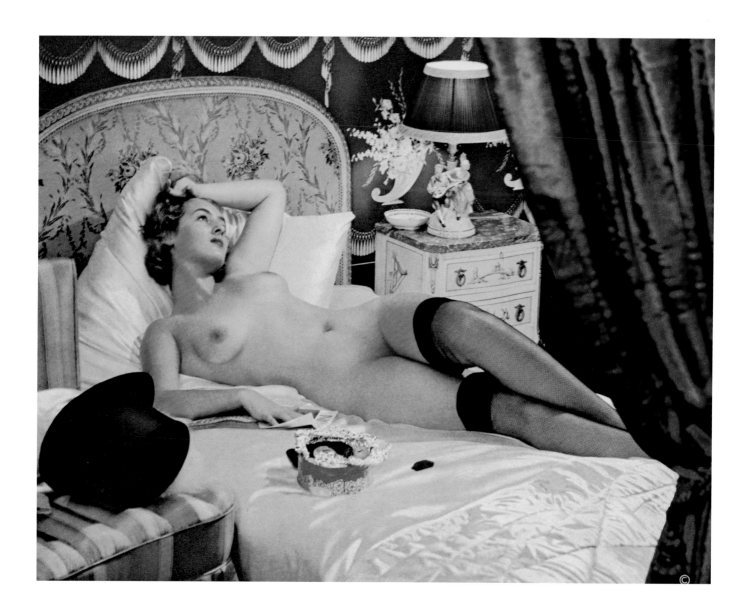

Nude on Bed | Akt auf einem Bett | Nu sur un lit
c.1936

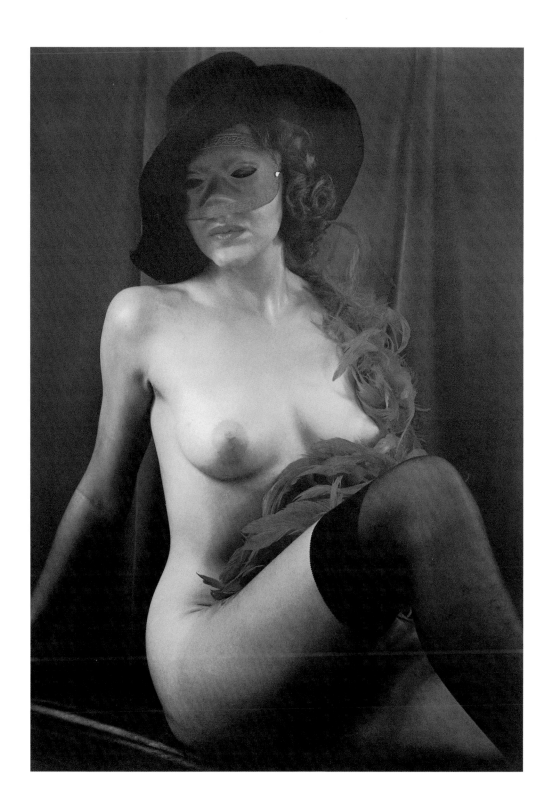

Masked Nude with Hat | Maskierter Akt mit Hut | Nu masqué avec chapeau
c. 1936

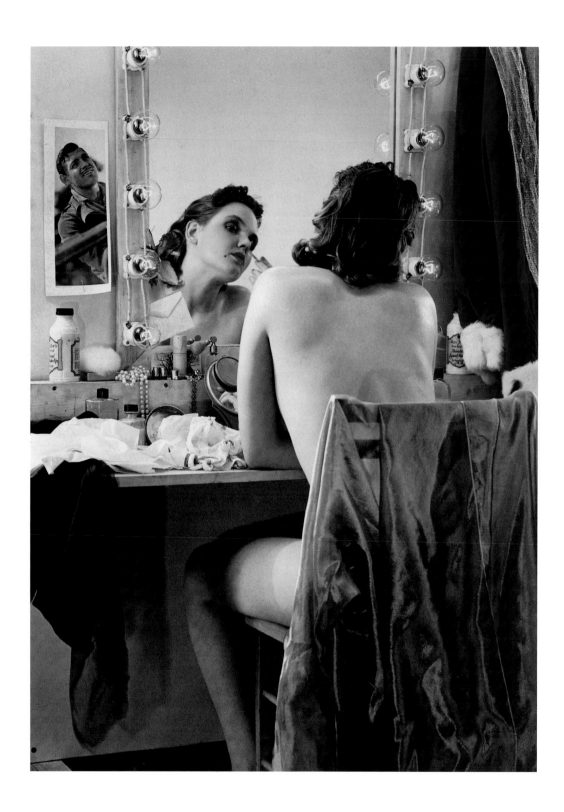

Nude Sitting at Dressing Table | Sitzender Akt an einer Frisierkommode | Femme nue à sa coiffeuse
c. 1936

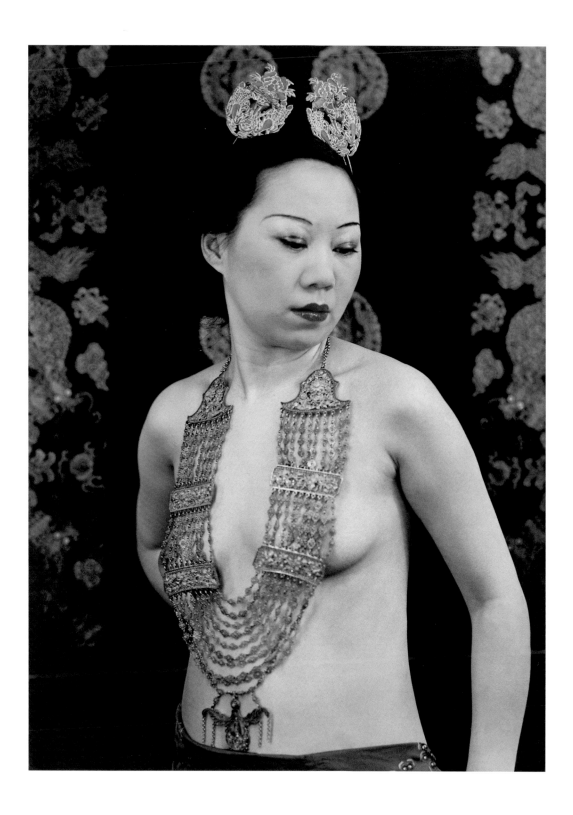

Oriental Nude with Jewels | Orientalischer Akt mit Schmuck | Nu oriental et bijoux
c. 1936

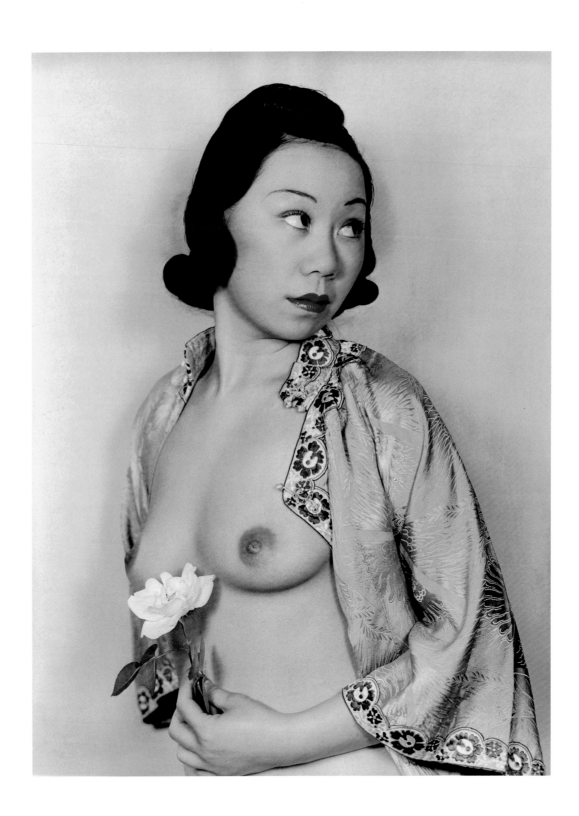

Chinese Girl | Junge Chinesin | Jeune Chinoise
1938

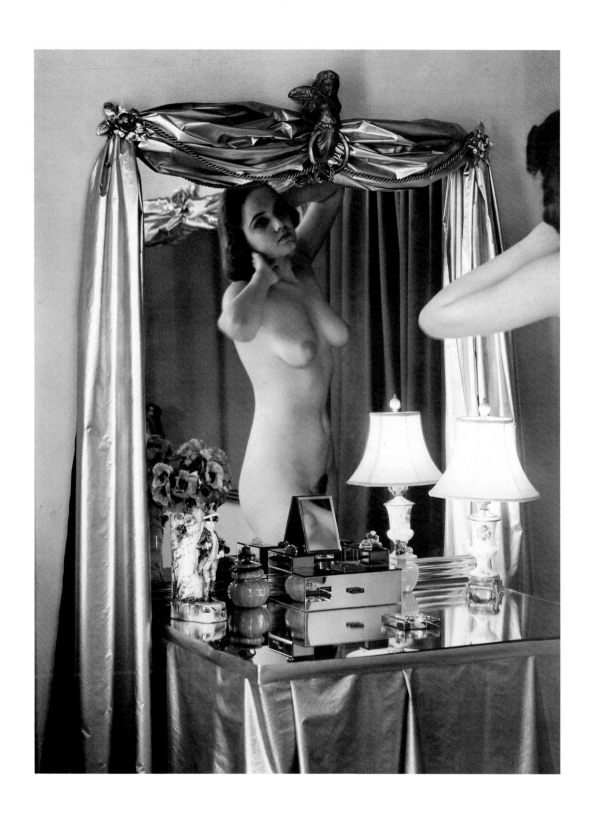

Nude Standing at Dressing Table | Stehender Akt an einer Frisierkommode | Nu debout devant une coiffeuse
1936

What is color? No object of itself alone has color. We know that even the most brightly colored object, if taken into total darkness, loses is color. Therefore, if an object is dependent upon light for color, color must be a property of light—and so it is.

Was ist Farbe? Kein Ding an sich ist farbig. Wir wissen, dass selbst ein noch so bunter Gegenstand in völliger Finsternis seine Farbigkeit verliert. Daher muss, wenn ein Objekt zur Farbigkeit Licht benötigt, die Farbe eine Eigenschaft des Lichtes sein – und so ist es in der Tat auch.

Qu'est-ce que la couleur ? Aucun objet n'a de couleur en soi. On sait que même l'objet le plus intensément coloré, s'il se trouve dans l'obscurité la plus totale, perd sa couleur. C'est pourquoi, si la couleur d'un objet dépend de la lumière, la couleur doit être une propriété de la lumière – ce qui est le cas.

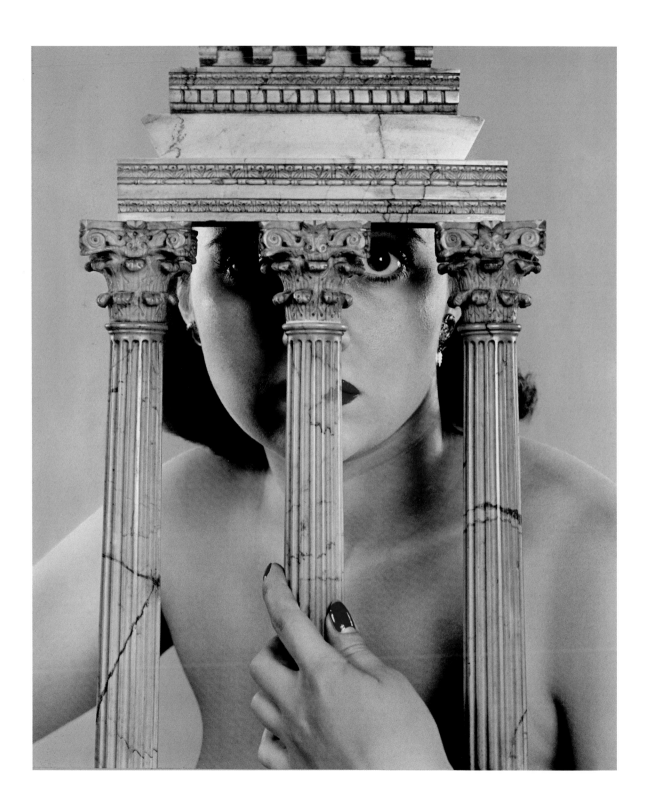

Nude behind Roman Columns | Akt hinter römischen Säulen | Nu derrière des colonnes romaines
c. 1935

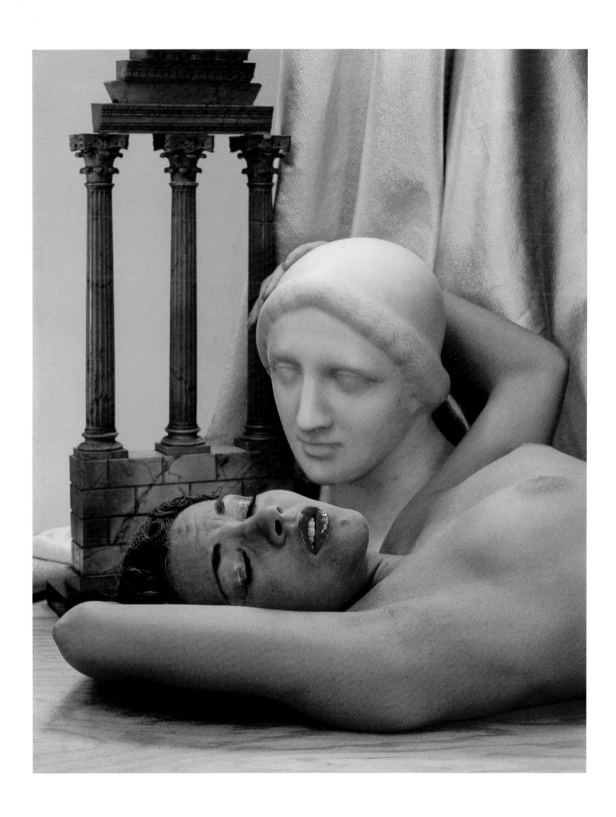

Cyclops | Zyklop | Cyclope
c. 1935

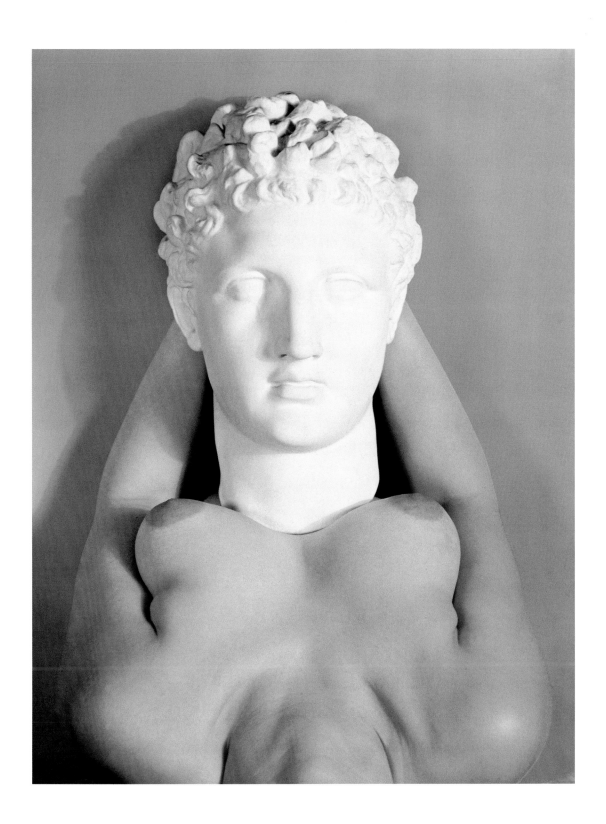

Phoenix Rising | Aufsteigender Phönix | Résurrection du Phénix
1937

160

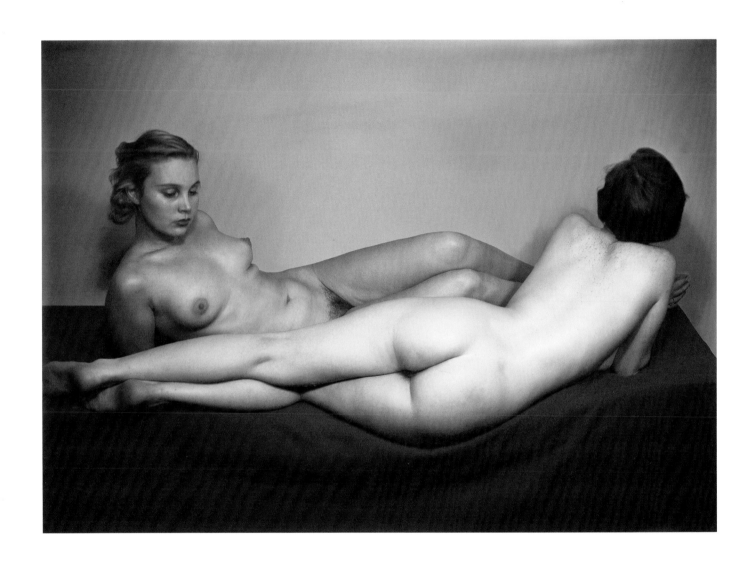

Two Women | Zwei Frauen | Deux femmes
1936

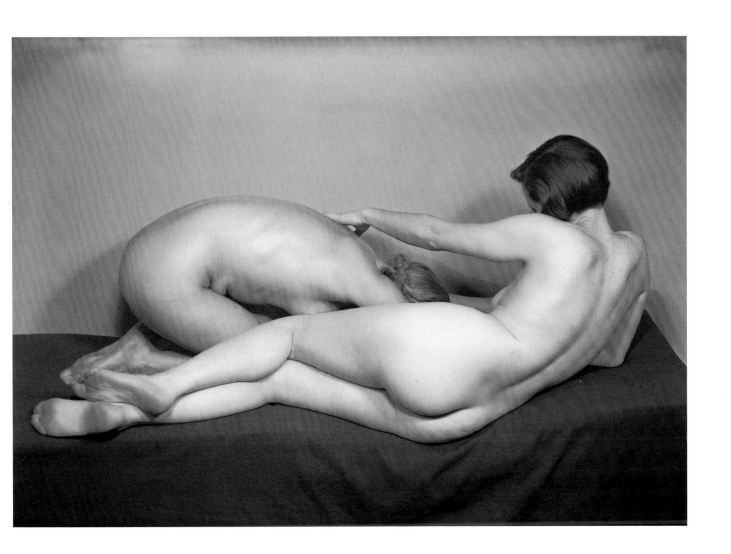

Two Women | Zwei Frauen | Deux femmes
1936

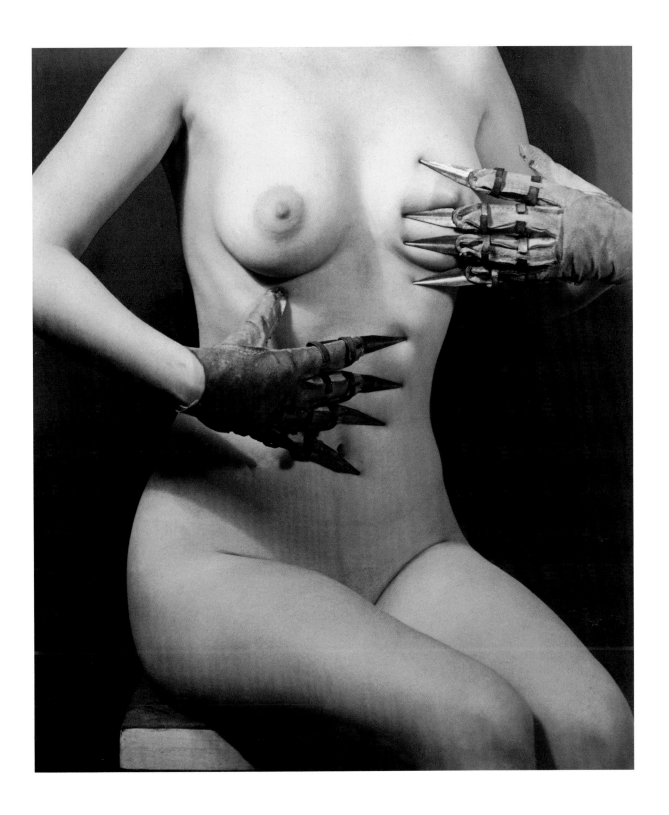

Woman with Claws | Frau mit Krallen | Femme avec griffes
c. 1937

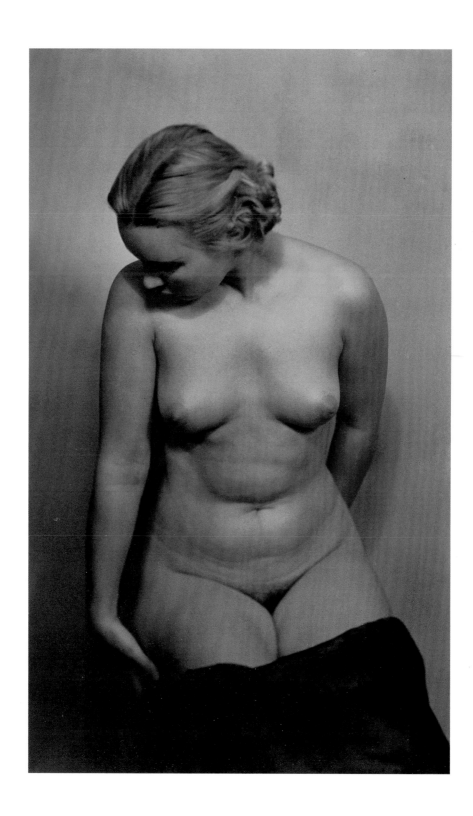

Nude with Fabric on Lap | Akt mit Stoff auf dem Schoß | Nu avec une étoffe sur les genoux
c. 1938

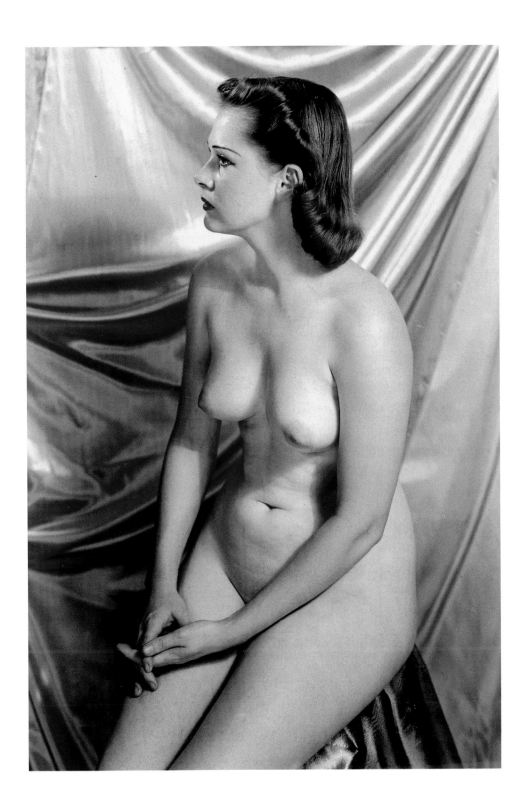

Seated Nude | Sitzender Akt | Nu assis
1935

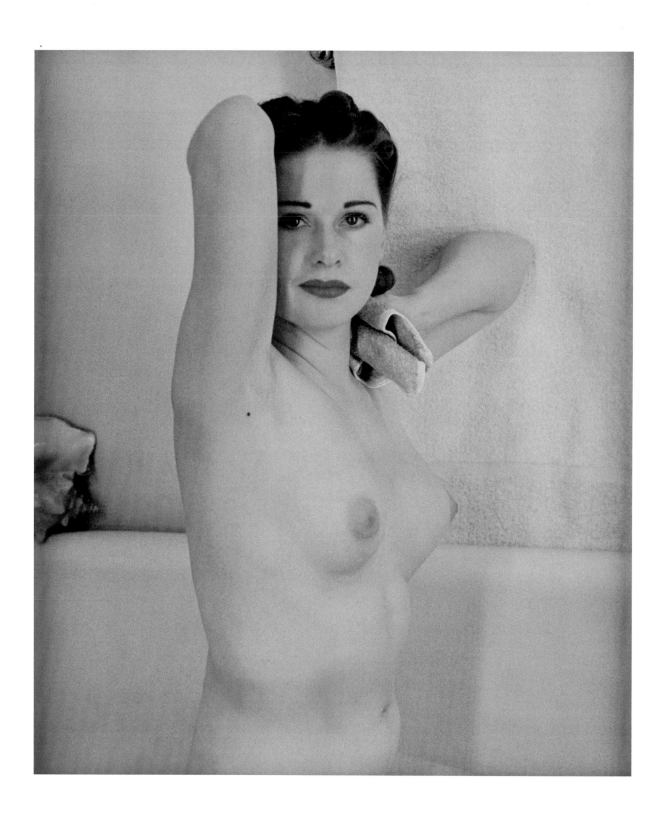

Nude in Bath | Akt im Bad | Nu dans la salle de bains
c. 1936

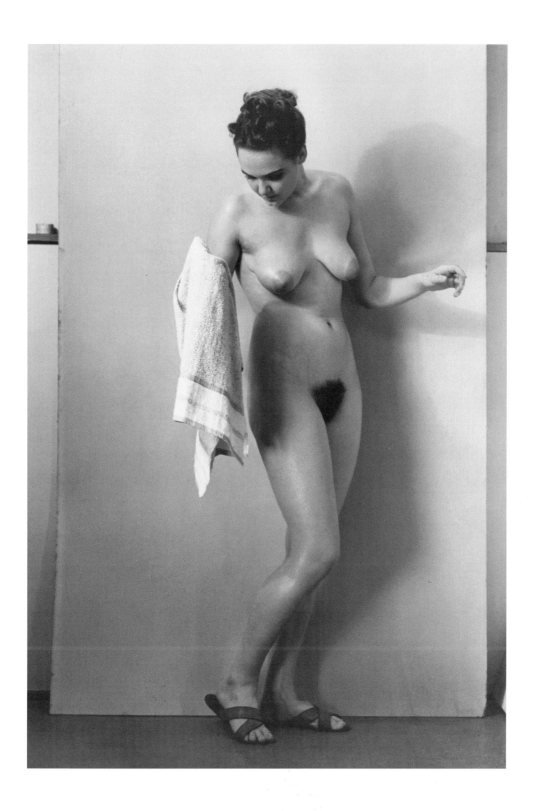

Nude with Towel | Akt mit Handtuch | Nu avec une serviette
1936

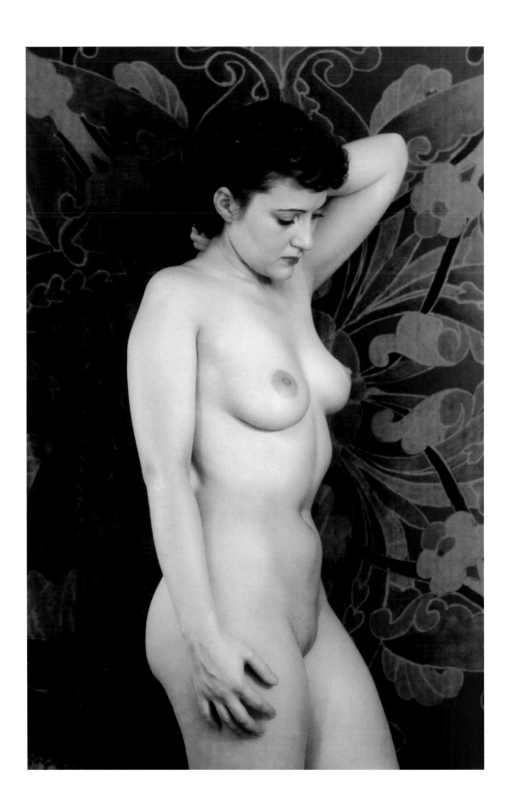

Standing Nude | Stehender Akt | Nu debout
c. 1935

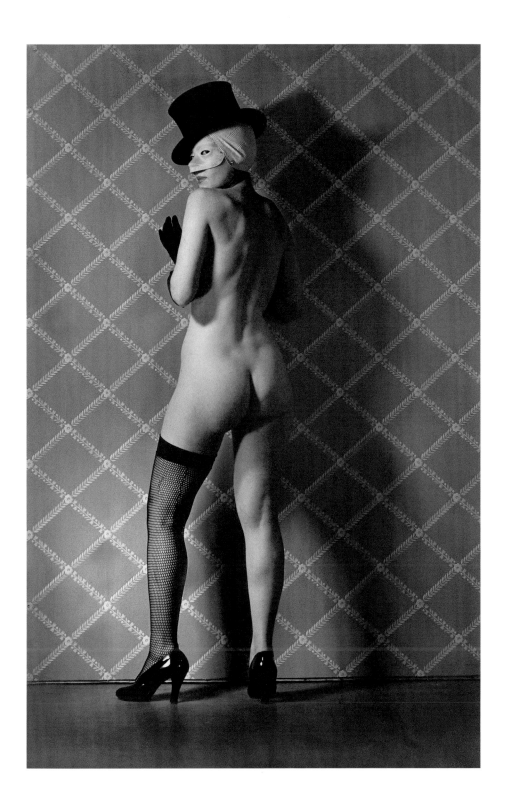

Nude with Mask and Hat | Akt mit Maske und Hut | Nu avec masque et chapeau
c. 1936

The graphic arts and music are the languages of the emotions, and through long association with ideas certain colors and certain movements provoke definite emotional response.

Die bildende Kunst und die Musik sind die Sprachen der Gefühle, und durch Assoziationsketten beschwören bestimmte Farben und bestimmte Sätze ganz eindeutige emotionale Reaktionen herauf.

Les arts graphiques et la musique sont les langages des émotions, et par une longue association d'idées, certaines couleurs et certains mouvements peuvent provoquer une réponse émotionnelle précise.

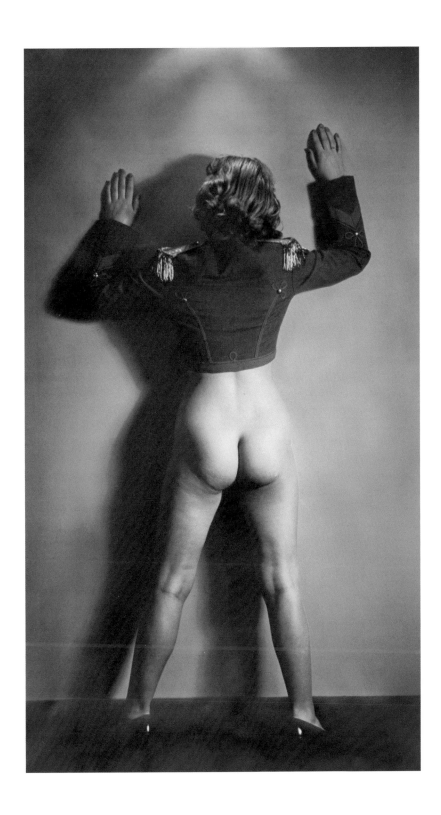

Nude with Bandleader's Jacket | Akt mit Kapellmeisterjacke | Nu portant une veste de chef d'orchestre
1936-38

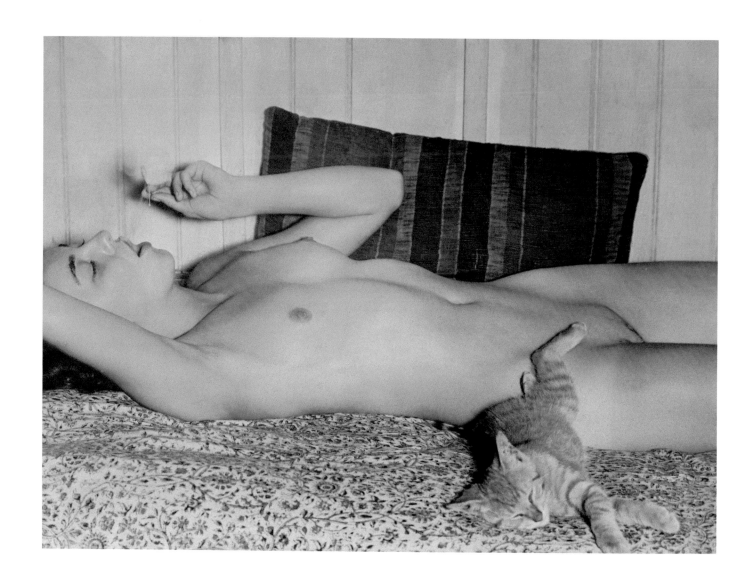

Nude with Cat | Akt mit Katze | Nu avec chat
c. 1939

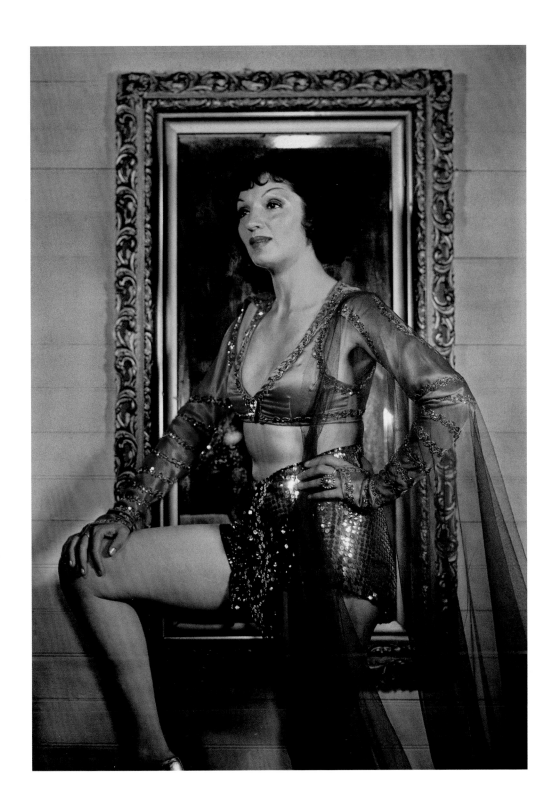

Backstage at the Folies Bergère | Hinter den Kulissen in den Folies Bergère | Les coulisses des Folies Bergère
1937

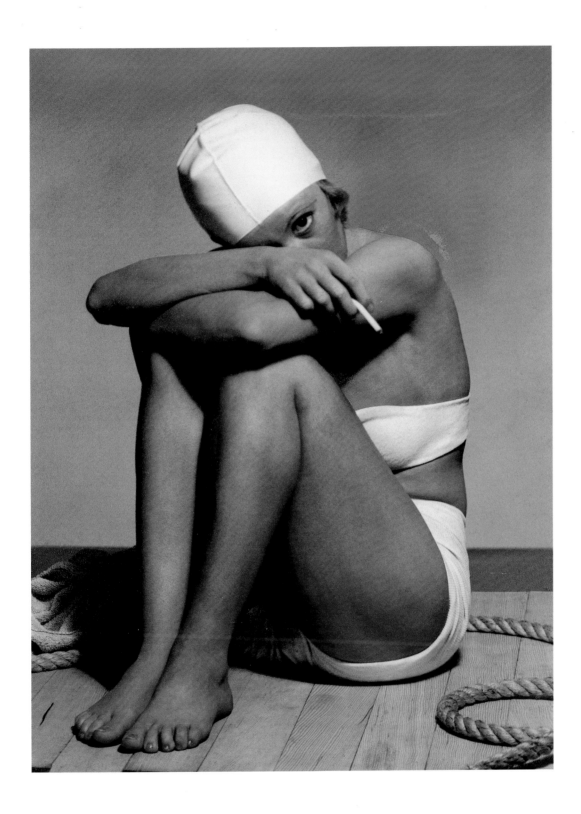

Girl in Bathing Suit | Mädchen im Badeanzug | Jeune femme en costume de bain
1936

One very important difference between monochromatic and color photography is this: in black-and-white you suggest; in color you state.

Ein ganz wichtiger Unterschied zwischen monochromatischer und Farbfotografie ist der: In Schwarzweiß deutet man an; in Farbe stellt man fest.

Il y a une différence très importante entre la photographie monochrome et la photographie en couleurs : en noir et blanc, on suggère ; en couleurs, on affirme.

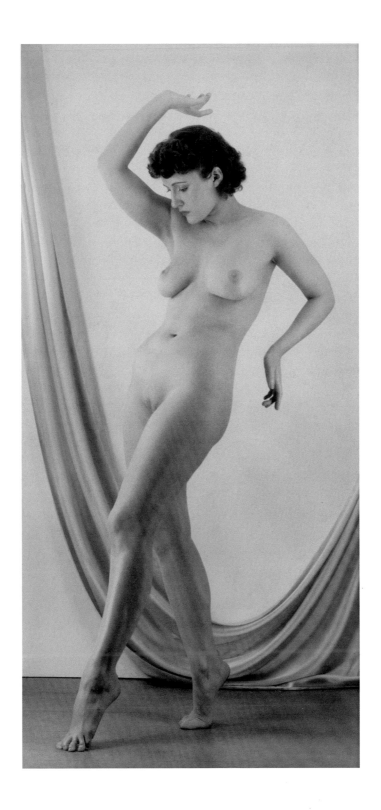

Nude with Drape of Green Material | Akt mit Drapierung aus grünem Stoff | Nu avec un drap vert
c. 1937

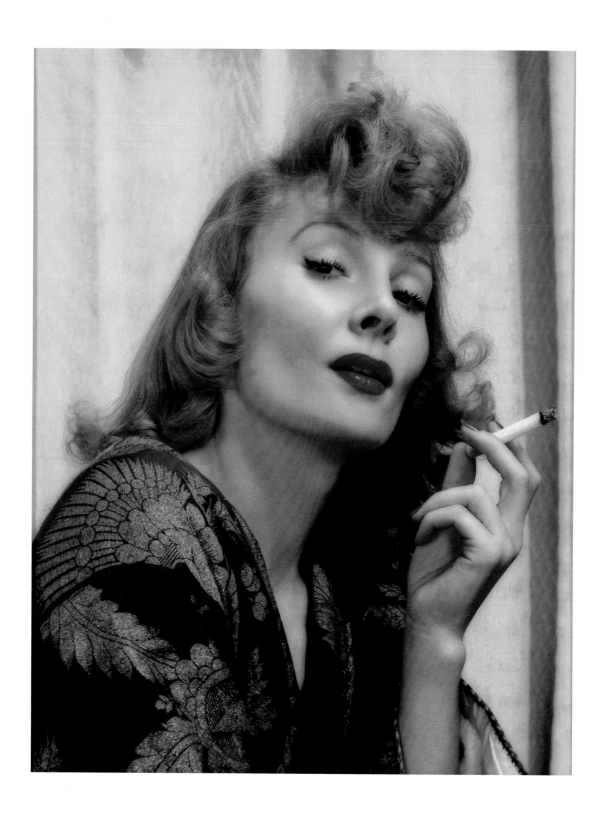

Redhead | Rotschopf | Rouquine
c. 1937

Paul Outerbridge, Jr.

M. F. Agha

Un de mes amis m'a raconté une histoire exquise à propos de Paul Outerbridge :

Il y a peut-être un an de cela, il semblerait que tout le Paris des gens «qui comptent» se soit mis en pleine effervescence à l'annonce d'une nouvelle époustouflante : la photographie, qui venait d'être glorifiée comme un des beaux-arts à part entière, allait connaître une ère de splendeur. En effet, le célèbre photographe américain Paul Outerbridge était en train de faire construire à Paris le plus grand studio photographique du monde. Et c'est le plus grand fabricant de mannequins en cire du monde qui finançait ce beau projet – déjà évalué à quelque 1 500 000 francs. «C'est fantastique.»

La nouvelle devint de plus en plus fantastique au cours des mois suivants ; le nouveau studio allait avoir un équipement censé être le dernier cri en matière de technologie au service de l'art : des rails électriques suspendus transporteraient une quantité inouïe d'éclairages puissants et se déplaceraient automatiquement au moindre mouvement de la main que ferait Outerbridge ; bientôt il n'y aurait plus aucun obstacle matériel entre la conception de l'artiste et sa concrétisation !

L'exaltation atteignit son paroxysme lorsqu'on annonça qu'après de longs mois de planifications et de constructions, le studio était enfin terminé et que le grand moment approchait : Outerbridge en personne allait prendre une photo. Et finalement, au jour J tant annoncé, Outerbridge se présenta dans le studio – et la séance de pose commença : les rails s'ébranlèrent, les assistants se mirent à courir d'un côté et de l'autre, des lumières clignotèrent. La grande œuvre d'art était née ; tout le monde retint son souffle pendant quelques minutes, et Outerbridge émergea de la plus grande chambre noire du monde pour enfin présenter au public en adoration : l'image d'un œuf !

Bien évidemment, le gars qui m'a raconté cette histoire était un philistin, incapable de comprendre la signification d'un œuf et encore moins son rôle dans l'art moderne – mais cette histoire dépeint Outerbridge à la perfection. Il existe bien d'autres histoires – qui voyagent par-delà les continents et les mers.

À Berlin, on vous racontera qu'Outerbridge détruisait ses plaques après avoir procédé au tirage de quelques épreuves, donnant ainsi à ses photos publicitaires la même valeur qu'à des photos d'art – tout comme le font les grands maîtres avec leurs esquisses. À Paris, on vous apprendra que Outerbridge réalisa 4000 plaques [ou était-ce 10 000 ?] avant de comprendre comment il fallait s'y prendre pour bien photographier un œuf. À New York, les collègues de Outerbridge vous diront à quel point la profession lui doit énormément, car il fut l'un des pre-

miers à réussir, par la seule force de sa volonté et de son imagination, à faire passer les prix à deux chiffres généralement acquittés pour le travail publicitaire à des prix à trois, voire quatre chiffres.

L'esthète superficiel comparera son œuvre à celle de Brancusi [pour peu qu'il soit d'humeur complimenteuse] ou à des travaux pratiques de la Clarence White School of Photography [s'il est plutôt du genre dépréciatif]. Mais seul l'historien d'art remettra Outerbridge à sa juste place, celle d'un pionnier appartenant à cette école de la photographie moderne, tellement proche du mouvement moderne en peinture, que certains puristes ne voient là qu'une imitation. Il y a effectivement une grande ressemblance entre la guitare symbolique de Picasso, reprise dans les innombrables toiles de ses successeurs, et les œufs de Outerbridge, tout aussi populaires parmi les photographes engagés dans le mouvement «moderne». L'aspiration à créer une «forme qui ait du sens» et ce magnifique détachement de tout ce qui «raconte une histoire» sont les véritables fondements de l'art de Outerbridge. La romance et les légendes ne sont, pour ce pionnier, qu'un moyen de se protéger, une manière de percer l'indifférence des foules à l'esprit peu ouvert à l'art.

Le mouvement moderne en photographie semble mûr pour une autopsie. Les critiques amorcent la question des origines et des responsabilités.

En Allemagne, les écrivains conservateurs récusent énergiquement que la photographie moderne soit née dans leur pays. Et de pointer du doigt Camera Work, Broom, les photographies de Paul Strand et la photographie publicitaire américaine, comme autant d'influences responsables de la corruption de la jeunesse allemande, et qui la firent s'écarter du dogme sacré du pictorialisme. Outerbridge est l'un des premiers et des plus importants offenseurs et mérite, à ce titre, notre profond respect.

Dr. M. F. Agha, [Directeur de artistique
Vogue *et* Vanity Fair *1928 à 1942], in:*
Advertising Arts, *New York, mai 1931*

Un moderniste directif

La vie et l'art
de Paul Outerbridge

La carrière artistique de Paul Outerbridge [1896-1958] couvre deux décennies, et plus précisé-
ment la période entre les deux guerres mondiales, années souvent considérées par de nombreux
experts parmi les plus créatives, les plus prolifiques et les plus exceptionnelles de tout le
XXᵉ siècle. Le travail de Outerbridge en est une excellente illustration. Une analyse rétrospective
de son œuvre montre comment il réussit à traduire les préoccupations esthétiques qui étaient
celles de l'avant-garde à cette époque-là dans le langage spécifique de la photographie ; s'y révèle
également la manière extraordinaire dont il parvint à utiliser ce langage pour créer des images
qui commencent tout juste maintenant à être comprises dans le contexte artistique précis qu'il
avait imaginé.

Les années créatives et stimulantes de l'entre-deux-guerres servirent de contexte à l'épa-
nouissement de son art et de ses idées. Outerbridge comptait parmi ses amis et associés quel-
ques-uns des artistes avant-gardistes les plus importants de cette période : Marcel Duchamp,
Man Ray, Picasso, Picabia, Constantin Brancusi, Alexander Archipenko et Max Ernst. Tous ces
artistes l'influencèrent, surtout lors de ses années passées à Paris, de 1925 à 1928. Outerbridge,
pour sa part, était leur pair sur le plan spirituel et leur semblable sur le plan de l'innovation.
C'est du moins ainsi qu'il fut généralement considéré au cours de sa brillante carrière. Dans sa
vie, il connut le succès commercial tout en faisant preuve d'une vision neuve et moderniste qui
apporta un changement significatif dans la création publicitaire. Dès les années 1920, il se fit un
nom dans les magazines de mode en tant que photographe doué pour la publicité et créateur gra-
phiste de talent. Il consacra les années 1930 à étudier à fond et perfectionner sa technique de
tirage en couleurs. Avec l'élaboration de son procédé en trichromie Carbro, il atteignit à une
expression transcendante avec des épreuves en couleurs d'une qualité extraordinaire, qui sont
restées des paradigmes photographiques.

Paul Outerbridge apporta sa contribution à l'histoire de la photographie par la virtuosité
technique incomparable qu'il appliqua à un sens original de la création abstraite et géométrique.
Qui plus est, ses innovations dans le domaine du tirage en couleurs, plusieurs essais et son
ouvrage *Photographing in Color*, qu'il publia en 1940, démontrent bien que la photographie pou-
vait servir au mieux et les intérêts commerciaux et les passions personnelles. Outerbridge était
capable de transformer des objets ordinaires en abstractions virtuelles dans lesquelles les motifs
harmonieux de volumes et de lignes, de lumière et d'ombre, changeaient notre manière habi-
tuelle de percevoir ces objets. Il ne s'agissait d'ailleurs pas que de thèmes commercialement por-

teurs, mais aussi de la transposition du corps féminin en une investigation du concept de «beauté féminine», comme il le déclarait lui-même: la femme en tant que forme idéalisée, fétiche et théâtre. À la différence de nombre de ses contemporains, comme Walker Evans par exemple, dont l'appareil photo était la conscience, Outerbridge était replié sur lui-même. À l'instar de Moholy-Nagy et de Man Ray, il démythifia l'appareil photo. C'était l'œil et l'esprit – et pas l'instrument – qui produisaient l'art; l'imagination – et pas les circonstances– qui faisait l'image. Le sujet et l'éclairage rendaient l'ordinaire extraordinaire. Outerbridge reprit à son compte la plupart des préoccupations esthétiques qui avaient cours en Allemagne dans la période qui suivit la Première Guerre mondiale: la pureté de la forme prônée par la *Neue Sachlichkeit* [La Nouvelle Objectivité], ou encore les tendances populaires que l'on pouvait observer dans le cinéma expressionniste et le cabaret allemand, et qui se complaisaient dans l'exploration du sexuel et du psychologique. En transposant ces élans modernistes sur du papier sensible, Outerbridge poussa la photographie encore plus loin dans le domaine de l'esthétique et de la connaissance du moi profond. Ne serait-ce que pour cette raison, son œuvre reste unique, pour son époque mais aussi pour la nôtre.

Une photographie de Paul Outerbridge à l'âge de vingt-cinq ans [prise en 1921, ill. p. 248] en dit long sur l'ensemble des thèmes et des intérêts esthétiques qui devaient préoccuper ce jeune photographe débutant pendant les vingt années qui allaient suivre. Un sens raffiné et sobre des lignes et des formes, un intérêt méticuleux pour la mode, du goût et un traitement abstrait de la personne humaine traduisent assez bien la manière dont il se présente. Sur la photographie, ces traits se manifestent à travers la coiffure continentale, les cheveux lissés en arrière, une pose gracieuse et des gestes délicats, une cravate et un col de smoking blancs, un gilet et une veste sombres bien ajustés avec des revers en velours, et des souliers vernis. Juché au faîte d'un toit de New York [insinuant ainsi une position d'observation en hauteur et à l'écart sur la cité qui s'étend au-dessous de lui], Outerbridge apparaît comme l'esthète par excellence, un cosmopolite de l'après-guerre qu'on aurait pu rencontrer au théâtre ou faisant de l'esbroufe dans les boîtes de nuit de Manhattan. Comme pour parachever sa passion pour le cinéma hollywoodien, il présentait une troublante ressemblance avec Tyrone Power, au moins dans un film avec Fred Astaire et Ginger Rogers [il faudra toutefois attendre une décennie avant que ces vedettes n'honorent le grand écran]. Outerbridge aurait donc pu être leur prototype dans le monde réel. Ironiquement, cet homme fortuné et raffiné en vint très vite, dans sa vie d'adulte, à éviter les soucis et les contraintes de l'élite sociale dont il était issu. Il chercha au contraire à explorer la vie plus expressive et moins conventionnelle de la bohème artistique en Europe.

En 1925, Outerbridge et sa jeune femme Paula Smith, qu'il avait épousée quatre ans plus tôt, s'installèrent à Paris. En tant que tout jeune membre de l'avant-garde et tiraillé entre deux mondes antagonistes – le grand style mesuré d'un côté et le laisser-faire bohémien de l'autre –, Outerbridge comprit l'importance d'une créativité radicale et directe, comme celle précisément de sa génération, qui sortait à peine, avec ses blessures psychiques et son appétit de vivre, d'une des pires conflagrations de notre histoire: la Première Guerre mondiale. Outerbridge était un homme de son temps, et il intégra dans son style de vie l'esthétique caractéristique d'une avant-garde qui gravitait autour de la société essentiellement urbaine des cafés européens et

new-yorkais, société qui possédait à la fois la bienséance d'avant-guerre et la curiosité impétueuse de l'après-guerre.

Pour bien comprendre l'orientation formelle et la complexité psychologique des images de Outerbridge, il est essentiel d'examiner sa vie et les influences qu'il subit, en les replaçant dans un contexte historique plus large : il y eut une vie de famille privilégiée mais mouvementée ; une adolescence pendant la Première Guerre mondiale ; des études à la Clarence White School of Photography ; l'exposition des praticiens new-yorkais du modernisme – Alfred Stieglitz, Paul Strand et Edward Steichen ; un séjour à Paris et un à Berlin au moment où ces deux grandes villes faisaient l'expérience d'une inventivité radicale et prolifique ; et enfin des amitiés et des collaborations avec les grands noms de l'avant-garde. S'il a assimilé l'influence de ces derniers, Outerbridge a également créé des images d'une vision extrêmement personnalisée. Ses images sont nourries d'une esthétique cohérente et en évolution constante, et qui atteint à une expression supérieure avec ses photographies en noir et blanc et, plus tard, avec ses clichés exceptionnels et brillants en trichromie Carbro. La Deuxième Guerre mondiale transforma la culture comme l'avait fait la Grande Guerre. À partir de 1941, l'étoile de Outerbridge se mit à décliner. Il survécut à la popularité immédiate du style qu'il avait perfectionné. Il mourut dans l'anonymat en 1958.

Tout au long de sa carrière, Paul Outerbridge souscrivit à l'idée que « l'art est la vie vue à travers le désir de perfection et de beauté de l'homme – une fuite loin des réalités sordides de la vie dans un monde créé par son imagination » [1]. Cette conception de la fonction de l'art devint sa « véritable étoile Polaire ». L'esthétique personnelle du jeune Outerbridge se fit jour grâce à l'assimilation de styles internationaux comme le précisionnisme – une technique de mise au point directe et extrêmement précise, aux antipodes du flou artistique du pictorialisme romantique – qu'il choisit pour ses images nettes, abstraites et géométriques, et dont Charles Sheeler et Paul Strand étaient les praticiens exemplaires, et au surréalisme – ce courant fantastique, psychologiquement complexe à l'intérieur de la création artistique, auquel Man Ray initia Outerbridge – qui se manifeste dans ses photos de femmes effectuées avec le procédé Carbro. D'abord simple moyen d'investigation supplémentaire de la forme abstraite, son approche du thème de la femme changea au cours des années 1930 avec des images en couleurs de plus en plus théâtrales et obsessionnelles. Libéré du décorum propre aux années qui précédèrent la Première Guerre mondiale, Outerbridge passa plus d'une dizaine d'années, au cours des années 1930, à photographier des modèles féminins portant des masques, des jarretières, des bas de soie, des dentelles, des chaussures à hauts talons et des gants à griffes de métal, produisant des images qui mettaient un terme aux idées entourant le nu classique tout en en proposant une interprétation. [2]

Outerbridge avait compris combien l'aspiration à la beauté pouvait traduire dans des formes quotidiennes, élégantes et séduisantes, des objets de beauté qui assuraient du plaisir ; ce pouvait être de la nourriture, l'intérieur d'un logement ou un corps humain. Cette aptitude à comprendre les plaisirs physiques et la mode élégante assura le succès de sa carrière dans la publicité. À travers des ensembles conçus et élaborés avec soin, isolés de leur environnement naturel, Outerbridge observait, puis disposait une boîte, un fruit, une femme nue ou sa propre personne, avec une exactitude méticuleuse et une précision extravagante qui trahissaient une sensualité exceptionnelle. C'est cette sensualité qui devait nourrir l'élaboration de son procédé

couleurs Carbro, car la couleur ajouta une richesse tangible aux surfaces et au contenu de ses photographies dans les années 1930. [3]

En 1917, alors que l'Amérique était engagée dans le premier conflit mondial, Outerbridge se porta volontaire dans le Royal Flying Corps. Il y fut victime d'un surmenage physique qui mit un terme à sa carrière d'aviateur et l'amena à se reposer la question de son devenir professionnel. En 1918, après quinze mois de services, il décida de descendre le long de la côte californienne afin de trouver un travail dans lequel il pourrait investir ses talents et son imagination. Il arriva à Hollywood au début de l'année 1919 en espérant se lancer dans le cinéma. Mais il vint rapidement à manquer d'argent et fut contraint de s'en retourner à New York. Contrairement aux désirs de sa famille, Outerbridge se décida à l'âge de 19 ans, après trois mois d'apprentissage dans une boîte de courtage de Wall Street, à épouser une carrière artistique. En 1915, il était entré à la Art Students League de New York pour y étudier l'anatomie et l'esthétique. À peu près à la même époque, il créa des affiches pour le théâtre. En 1921, il continua ses études à la Clarence White's School of Photography. Sa décision était un défi à ce qu'on attendait, conformément aux conventions sociales, d'un fils de chirurgien réputé de New York et rejeton d'une vieille famille éminente. Mais contrairement aux doutes de sa famille, après quelques mois à peine passés à la Clarence White School, son talent prit de l'envergure ; non seulement grâce à un médium qui le passionnait tout en satisfaisant ses aspirations esthétiques, mais aussi au contact de personnes et d'idées appartenant au monde de l'art européen. La même année, il épousa Paula Smith, une jeune femme qu'il avait rencontrée lors d'un de ses fréquents voyages aux Bermudes, dont son père était originaire et où des parents à lui maintenaient des affaires. Elle devait l'accompagner en Europe et, à l'occasion, poser pour lui.

Ces années furent parmi les plus importantes pour l'épanouissement de ce qui devait devenir son style distinctif. À la White School, il se remit en question dans la classe de Max Weber qui lui enseigna les théories de la composition d'Arthur Wesley Dow et les préceptes de son propre ouvrage, *Essays on Art* [1916], dans lequel il préconisait de prendre en considération la théorie cubiste abstraite bidimensionnelle pour photographier des objets à trois dimensions. [4]

«Estimant que la plus grande partie de ce qui pouvait être fait de mieux en art avait déjà été accompli en peinture et en sculpture, et que cette forme d'expression plus nouvelle était plus en relation avec les progrès et le rythme de la science et de l'époque modernes» [5], Outerbridge décida de se consacrer entièrement à la photographie. «Je me mis à travailler énormément, pour la première fois avec une réelle motivation dans ma vie, et je fis de rapides progrès.» [6] Tous les jours, dans une pièce de la maison familiale transformée en studio, il effectuait des prises de vue en série [avec un appareil 10,16 x 12,7, notant avec minutie le matériel, l'équipement et les procédés qu'il utilisait] d'objets familiers tels une bouteille de lait, un saladier rempli d'œufs, une ampoule électrique ou encore une boîte en bois, les éclairant et les disposant en des compositions simples mais très gracieuses. Vers 1922, ses photos parurent dans *Vogue* ; cette année-là et jusqu'en 1923, il entretint une rivalité amicale avec son camarade d'études Ralph Steiner, et entama un dialogue avec Alfred Stieglitz tout en étudiant également avec Archipenko.

Outerbridge a rarement photographié un objet directement à partir de son aspect naturel, comme le fait Ansel Adams. Il n'était pas séduit par la beauté des apparences superficielles ; il

s'intéressait plutôt à la recherche des principes formels non apparents de la beauté à l'intérieur d'une composition. Pour y parvenir, il effectuait de nombreuses études afin «de traduire la beauté existant dans les objets les plus simples et les plus humbles». Par rapport à ses photographies en noir et blanc, ses dessins recherchaient la relation existant entre les rythmes linéaires et les surfaces noires et blanches. Pour parvenir à ses fins en photographie, Outerbridge arrangeait et réarrangeait les objets jusqu'à ce qu'il obtienne un concept correspondant à ce qu'il avait voulu dessiner. Cette volonté de création, manifeste dans « la répartition de l'ombre par rapport à la lumière, de la lumière par rapport à l'ombre, et dans l'équilibre général entre les surfaces et les tons », représentait un analogue synthétique de la nature dans la forme d'une image abstraite de l'harmonie. Utilisant «l'objectif de l'appareil photo pour peindre avec la lumière elle-même, exactement comme un artiste utiliserait la peinture et le pinceau», il dérobait à la forme son sens avec la dextérité d'un voleur de bijoux. Décrivant l'une de ses images les plus réussies de cette période, H.O. Box [1922, ill. p. 10], Outerbridge explique cette photo comme une tentative

> «de remplir le rectangle[…] avec des zones de lumière et d'ombre harmonieusement et agréablement réparties. On pourra observer à ce sujet l'usage qui a été fait de l'ombre de la scie sur le fond et l'arrière-plan, ainsi que l'ombre d'une planche [située en dehors de l'image] contre laquelle repose la scie. Les dents de la scie ont été volontairement oblitérées et exclues du champ visuel, pour qu'elles ne deviennent pas un élément gênant, et afin de mettre l'objet en harmonie avec les autres lignes droites de la composition[…] L'attention est spécialement attirée sur les fines gradations de la scie, allant de l'ombre la plus sombre à la lumière la plus extrême».

Justifiant ses manipulations artistiques, le photographe conclut qu' «il ne fait pas un portrait de ces objets mais qu'il les utilise simplement pour former une composition purement abstraite».[7] Dans des images comme *Le Col d'Ide* [1922, ill. p. 49] et *Deux œufs dans un moule à tarte* [1923, ill. p. 42], la perfection équilibrée de la composition de Outerbridge illustre la définition que le théoricien de la Renaissance Leon Battista Alberti donnait de la beauté formelle : aucun élément ne peut être ajouté ou enlevé sans perturber la pertinence du tout.[8] Pour Marcel Duchamp, *Le Col d'Ide* était plus qu'une simple publicité réussie ou qu'une solution intelligente à un problème de création, c'était un ready-made. Cette réclame de Outerbridge avait attiré son attention, et il avait déchiré la page du numéro de novembre de *Vanity Fair* de la même année pour la punaiser sur le mur de son atelier. La considérant comme un objet trouvé transformé en objet d'art par l'imagination de l'artiste, Duchamp interpréta la photographie de ce col posé sur un échiquier comme un témoignage de plus en faveur d'une redéfinition de l'objet d'art.

Comme dans les photographies de Charles Sheeler et de Paul Strand, la structure formelle des images soigneusement construites de Outerbridge présentait fréquemment un certain parallélisme avec l'abstraction en peinture. Avec *Saltine Box* [1922, ill. p. 11], décrite par Outerbridge comme une «abstraction créée pour l'appréciation esthétique de la ligne sur ligne et du ton sur ton, sans aucune association sentimentale»[9], il réalise une élégante composition cubiste, uniquement en manipulant la lumière.

Même si le platine fut abandonné immédiatement après la Première Guerre mondiale, Outerbridge insistait sur l'utilisation du papier au platine pour ses photographies à cause de la richesse des tons qu'il conférait à ses négatifs. Une notice de son journal de l'époque indique

qu'il recherchait un exemplaire du dernier numéro de *Camera Work* datant de 1917. Il contenait en effet onze photographies accompagnées d'un texte de Paul Strand, qui était à fond pour la «nouvelle manière de voir». Strand préconisait une photographie directe, non pictorialiste, susceptible de transformer des objets fonctionnels et ordinaires en des images dynamiques de la beauté. Il soulignait dans son essai de *Camera Work* un aspect qui était très important pour Outerbridge :

> *« C'est dans l'organisation de l'objectivité que pénètre le point de vue du photographe à l'égard de la vie, et une conception formelle née des émotions, de l'intellect, ou des deux à la fois, lui est nécessaire avant toute exposition, tout comme pour un peintre avant de poser son pinceau sur la toile. Les objets doivent être disposés de telle manière qu'ils expriment les causes dont ils sont les effets, ou bien ils peuvent être des formes abstraites qui créent une émotion non reliée à l'objectivité en tant que telle. »* [10]

Outerbridge adopta avec enthousiasme les principes formels de cette nouvelle esthétique. Lui aussi était préoccupé à l'époque par l'abstraction formelle, et il s'exclamait : «Le problème auquel on s'attaque ici est celui de la transformation d'une étincelle absolument noire et blanche en un feu d'artifices [...] !» [11] Faisant preuve d'un talent naturel pour la photographie, il connut rapidement un grand succès. En 1925, il ambitionnait des défis esthétiques encore plus rigoureux et se sentait prêt à les relever.

Lorsqu'il partit s'installer à Paris, cette même année, après avoir rassemblé une somme considérable de travaux photographiques, il travailla pour *Vogue* où il photographia des accessoires de mode. C'est là qu'il fit la connaissance d'Edward Steichen [qui devait rester son rival toute sa vie durant], de Man Ray et de Berenice Abbott. Ces deux derniers le présentèrent à Marcel Duchamp, Brancusi, Picasso, Stravinsky et Picabia, parmi bien d'autres artistes. L'immersion dans ce monde du modernisme, univers d'idées et d'entretiens stimulants, de maîtrise technique, de succès financier et de reconnaissance artistique, lui procura un puissant antidote aux indécisions et aux doutes professionnels qui avaient marqué ses premières années. Il resta en Europe jusqu'en 1929, passa trois années à Paris et deux à Berlin. La concurrence qui l'opposait à Steichen l'amena à quitter *Vogue*, et il se mit à travailler pour d'autres magazines, déclarant dans son autobiographie :

> *« Je gardai le boulot chez* Vogue *peut-être trois mois et partis pour les raisons suivantes : politique intérieure, malentendu et conflit avec le patron en raison d'une trop grande confiance en moi et un manque total de connaisssance des affaires et entêtement, etc. Mes travaux, fort appréciés et estimés, ne furent jamais l'objet de critiques. »* [12]

Durant la période où il travailla à son compte, Outerbridge s'associa avec Mason Siegel – leader mondial pour la fabrication de mannequins en cire – et monta un studio de photographie évalué à 1 500 000 francs, qui ferma moins d'un an après son ouverture. Avant la fermeture définitive, le photographe réalisa cependant plusieurs images des modèles de cire dans d'étranges positions et avec des supports insolites. Ces mannequins immobiles et froids lui fournirent un thème qui devait réapparaître quelques années plus tard dans ses photos de nus féminins, émotionnellement distantes et pourtant chargées d'érotisme.

Après sa séparation de sa femme Paula en 1927, Outerbridge déménagea en 1928 pour s'installer à Berlin. Là, il s'engagea dans le cinéma allemand, qu'il admirait énormément. Il a

sans doute ait étudié avec Georg Wilhelm Pabst, réalisateur alors en vue parmi tous ceux qui cultivaient le nouveau réalisme. Pas le moins du monde intéressé par la création de compositions «pictorialistes» comme l'était Friedrich Wilhelm Murnau, Pabst composait avec le matériau que lui procurait la vie réelle pour atteindre à la véracité, exactement comme le faisait August Sander avec la photographie. [13] Peu de temps après, Outerbridge trouva plus agréable d'aller travailler en Angleterre avec Ewald André Dupont qui, en collaboration avec le cameraman Karl Freund, avait dirigé l'excellent film *Variety* en 1925. Dupont avait transformé le réalisme conventionnel du long métrage en utilisant des angles de vue inhabituels et des expositions répétées, une démarche que Outerbridge trouvait semblable au travail qu'il avait lui-même réalisé trois ans auparavant. Fait révélateur, *Variety* est une sordide histoire de music-hall dans laquelle la beauté sensuelle d'une trapéziste jette son partenaire dans une rage jalouse et le conduit au meurtre. Coutumier des boîtes de nuit parisiennes et des cabarets berlinois, Outerbridge intégrait à ses images de plus en plus de symboles associés à cette vie, y ajoutant une curieuse note de féti-chisme, particulièrement apparente dans ses dernières études de nus réalisées selon le procédé couleurs Carbro.

Déçu par ses tentatives infructueuses de faire carrière dans l'industrie du cinéma, par l'échec de son entreprise avec Siegel et par un mariage raté, il finit par s'en retourner à New York en 1929. Deux importantes expositions montrent cependant bien qu'il réussit à l'époque à percer les rangs fermés de l'avant-garde internationale. L'exposition *Film und Foto*, qui eut lieu à Stuttgart en 1929, compte parmi les expositions photographiques les plus importantes et les plus complètes jamais organisées. Internationale par son envergure, l'exposition comptait Outerbridge au nombre des exposants américains. [14] Plus tard, Beaumont Newhall invita Outer-bridge à figurer dans son exposition géante de 1937 au Museum of Modern Art, *The History of Photography*, ainsi que dans la fameuse manifestation qu'il organisa à San Francisco en 1940, *Pageant of Photography*. Son travail, à ce que l'on raconte, aurait produit une excellente impres-sion qui renforça sa réputation aussi bien en Europe qu'aux États-Unis. La Julien Levy Gallery exposa également l'œuvre de Outerbridge, contribuant encore davantage à prouver qu'il avait la stature d'un grand artiste, indépendamment de son médium. Galerie pionnière dans la défense de la photographie considérée comme un art, la Levy Gallery fut pendant deux décennies l'un des lieux d'exposition les plus importants de New York. Cette collaboration hissa Outerbridge aux côtés d'un Moholy-Nagy, des surréalistes et autres contemporains avant-gardistes.

En 1930, Outerbridge estima que sa photographie en noir et blanc avait atteint les limites de ses possibilités. Sans se laisser décourager par les conditions financières du moment, il com-prit que la couleur allait bientôt devenir un élément majeur sur les marchés d'art et de la photo-graphie commerciale. Il se plongea alors dans l'étude extrêmement novatrice [et coûteuse!] de la couleur. Ses recherches minutieuses devaient le mener au développement du procédé couleurs Carbro, qu'il expose en détail dans *Photography in Color*, un ouvrage publié en 1940 par Random House. Plusieurs heures laborieuses d'efforts soutenus et d'investissement financier aboutirent à la réalisation d'une simple épreuve couleurs Carbro. Ce procédé est unique en photographie parce que les pigments utilisés sont les mêmes que pour la peinture à l'huile. Non seulement ces pigments sont d'une résistance exceptionnelle, mais ils assurent une qualité extradimen-

sionnelle, les ombres étant de manière évidente plus profondes dans leur brillance et les rehauts finement gradués dans leur surface mate. En mettant en valeur l'aspect palpable des objets photographiés, l'effet de relief augmente l'illusion de profondeur et souligne les éléments constitutifs de la composition de manière plus nette que ne le permettaient les autres techniques. Outerbridge recourait immuablement à ce procédé pour réaliser ses images, ce qui témoigne bien de l'intensité d'une vision servie uniquement par une patience infinie et une précision quasi obsessionnelle. Ce qui lui importait, c'était de comprendre comment les propriétés physiques de cette technique de photographie en couleurs donnaient à ses épreuves un tel effet de ressemblance avec la réalité. Outerbridge évaluait avec précision la qualité de son travail et exigeait en conséquence – et recevait – des rémunérations très élevées, de l'ordre de 750 dollars pour une épreuve couleurs. Les premiers modèles réalisés par exemple pour le magazine *Life*, un hebdomadaire illustré de photographies, furent assemblés et diffusés par Henry Luce pour inciter les commanditaires et les publicistes à annoncer dans le magazine. Un de ces exemplaires réalisés par Luce contenait une couverture de Outerbridge et cinq de ses photographies en couleurs, exemples de « la beauté et l'art que l'on pouvait saisir avec un appareil photo et de la couleur ». Bien qu'il se montrât au début réticent à payer au photographe son prix fort habituel, Luce finit par céder.

En 1930, Outerbridge aménagea un studio couleurs dans sa maison de campagne à Monsey, dans l'État de New York. Pendant les années qui suivirent, il réussit à bien vivre du travail commercial en couleurs et en noir et blanc qu'il effectuait pour les magazines *Vanity Fair*, *McCall's*, *Harper's Bazaar*, *Advertising Arts* et *House Beautiful*, pour n'en citer que quelques-uns. Un grand nombre des clichés en couleurs qu'il réalisa pendant cette période sont, en substance, le prolongement de ses expérimentations en noir et blanc dans une composition abstraite. Dans les toutes premières œuvres sur support platine, les objets à partir desquels les images sont réalisées tendent à être vidés de leur contenu symbolique. Mais en couleurs, ces mêmes éléments se retrouvent dotés d'une présence presque écrasante ; leur caractère symbolique est rendu encore plus séduisant par la tangibilité élevée que leur confère le procédé couleurs, de sorte que les images conservent une forte suggestivité et une sensualité affirmée, qui sont absentes des images monochromes.

Par exemple, la photographie en noir et blanc *Éventail et collier de perles* [1924, ill. p. 55] apparaît à l'origine comme un exercice de composition abstraite ; l'épreuve couleurs Carbro *Masque de fête et coquillages* [1936, ill. p. 201] est non seulement une admirable composition, mais aussi une image qui évoque le charme clinquant et la décadence d'un cabaret berlinois. Si les épreuves platine de Outerbridge datant des années 1920 peuvent être rattachées au courant général artistique avant-gardiste de la période où elles furent créées, son travail en couleurs des années 1930 est absolument unique, exceptionnel et suggestif. D'après un reporter qui se trouvait au troisième Camera Salon de 1937, la foule fit masse devant l'exposition des épreuves couleurs Carbro de Outerbridge, « apparemment stupéfiée par la perfection de son travail. Ce fut sans aucun doute l'événement artistique et technique le plus sensationnel de ce salon ». [15] La difficulté du procédé couleurs Carbro et son potentiel inexploré de sensualité et d'expressivité offraient à Outerbridge le défi précis qu'il avait toujours recherché.

Images de Deauville [1936, ill. p. 197] est un chef-d'œuvre en couleurs particulier qui fut créé pendant ces années-là. L'effet de désorientation produit par plusieurs plans se reflétant dans l'image résulte de la dislocation de la réalité causée par les jeux de Outerbridge avec la perspective et par le curieux mélange des objets représentés. Faisant peut-être allusion à l'affirmation d'André Breton selon laquelle une peinture surréaliste devrait être une fenêtre par laquelle on regarde un paysage intérieur, Outerbridge met en situation un dé surdimensionné, une sphère argentée, une pyramide jaune, une palourde et un paysage marin à l'intérieur d'une construction de cadres. S'appuyant sur les conventions picturales établies à la Renaissance, il fait en sorte que les angles de chaque cadre forment des figures orthogonales en perspective qui produisent une illusion de profonde récession spatiale tout en accentuant l'impression de monumentalité créée par l'échelle globale de la photographie. En manipulant les règles établiespour révéler de nouvelles significations dans la juxtaposition inattendue d'objets familiers, Outerbridge n'a fait qu'étendre à la photographie des attitudes qu'il avait acquises au contactdes artistes surréalistes. Son œuvre la plus substantielle parmi toutes les photographies couleurs Carbro, toutefois, est celle qui traite le thème de la femme. Outerbridge considérait le nu comme un sujet légitime de l'expression artistique, comme l'avaient fait avant lui et plusieurs siècles durant de nombreux artistes. Pourtant, les mœurs sociales du XIXe siècle résistaient à son exploration créative, absolument désinhibée et typique de l'après-Grande Guerre, de ce thème. À la suite de difficultés avec la Eastman Kodak Company qui avait refusé de développer quelques clichés de son film, Outerbridge observa avec une ironie désabusée qu'une étude de nu, parfaitement simple et innocente, avait pu donner lieu à des connotations pornographiques. Bien qu'il déplorât que «le travail commercial d'un État qui se met à légiférer la pudeur soit une procédure à la fois infantile et ridicule», il resta silencieux sur ce sujet. En honnête citoyen, il ne demandait pas mieux que d'éviter les confrontations avec les autorités de la censure comme le bureau de Hay à Hollywood, nouvellement investi de ce pouvoir. Outerbridge altérait lui-même parfois ses clichés lorsqu'une exposition publique promettait un tirage délicat, car «la loi semblait bannir en particulier les bouts de sein et les poils pubiens, et comme ils étaient incapables d'empêcher la nature de faire pousser ces attributs physiques, ils se permettaient au moins d'empêcher les gens de les photographier ».

Les principes sous-tendant sa manière de photographier la femme englobent des considérations comme celles qui suivent :

> «*S'il observe directement à travers un viseur un beau mannequin nu avec un sourire provocateur ou avec une lueur dans son regard, le photographe a généralement franchi la frontière qui existe entre le nu et une fille en particulier qui s'est déshabillée. On peut dire qu'il a quitté le monde de l'art pour celui de la pornographie.*»

Outerbridge s'était également rendu compte que des juxtapositions comme celles qui consistaient à «rapprocher une chair douce et chaude de la pierre dure et froide» et des constrastes comme ceux qu'«accentuent les caractéristiques inhérentes aux formes du nu» étaient des éléments indispensables à la création d'une véritable composition. «La loi fondamentale des contraires dans la nature», poursuivait-il, «le chaud et le froid, le dur et le mou, le positif et le négatif, le sombre et le clair peuvent être avantageusement utilisés pour renforcer un effet spectaculaire. »

Lorsqu'il travaillait pour lui seul, il réalisa des nus qui expriment des principes esthétiques formels, un puissant contenu érotique et une vision exceptionnelle, sans précédent. Comme le procédé Carbro lui-même, le nu représentait pour Outerbridge un défi considérable. «Le nu», maintenait-il dans ses écrits, «est de loin le plus difficile de tous les sujets.»[16] Il notait les problèmes de la réflexion des couleurs, augmentés par le fait que les contours du corps se modifient constamment. Il trouvait que «la courbe d'une silhouette change en permanence au moindre mouvement [...] Le corps humain est un objet plastique remarquable.» Des nus féminins comme *Modèle* [1923, ill. p. 129] ou *Odalisque* [1936] illustrent bien l'idéal de beauté féminine de Outerbridge. Ses compositions se réfèrent à des tableaux célèbres, tels *La Baigneuse Valpinçon* [1808], *La Grande Odalisque* [1814] ou *Le Bain turc* [1863] du peintre classique Jean Auguste Dominique Ingres. Solutions formelles à des problèmes de composition et exemplifications de la technique couleurs, des photos comme *Odalisque* et les deux versions de *Nu avec cadre* [1938] confirment le talent consommé de Outerbridge à faire de la forme, de la texture et de la couleur une expression de l'intention et du désir. [17]

Les nus furent réalisés dans le contexte de la redécouverte par les surréalistes de la femme en tant que mythe et objet d'obsession. Ces œuvres s'apparentent thématiquement aux tentatives des photographes surréalistes comme Henry List et Clarence John Laughlin de rendre visible les désirs, les larmes et les frustrations en recourant à la représentation des contenus symboliques du subconscient. [18] Cependant, même vus dans ce contexte, beaucoup des nus de Outerbridge, qui comptaient également parmi ses œuvres les plus personnelles, restent uniques. On peut faire remarquer que les personnages qui posent aussi élégamment pour Outerbridge sont affublés des accessoires qui correspondaient aux obsessions du photographe. Mais laissons ces interprétations de côté. Comme le dit si bien Outerbridge :

> *« [...] une œuvre d'art achevée [...] devrait véhiculer son propre message, inhérent à elle-même. Les illustrations d'un livre visualisent le texte, et le texte explique les images, mais les plus hautes formes de l'art existent par elles-mêmes et, étant très complètes en elles-mêmes, ne nécessitent pas le recours à une autre forme d'art [comme la littérature] pour mettre en valeur leur signification. »* [19]

Il en va ainsi des études photographiques de Outerbridge par le procédé couleurs Carbro. Elles sont probablement plus fascinantes que ses autres œuvres à cause de leur imagerie non conventionnelle. Le traitement du personnage comme un élément de la composition est un prolongement des toutes premières expérimentations de Outerbridge dans la manipulation de la forme. Comme les subtiles modulations de ton des photographies noir et blanc, l'admirable rendu de la texture, de la lumière et de la couleur témoigne d'une maîtrise inégalée de son médium. Point culminant de sa carrière, les épreuves en couleurs par le procédé Carbro marquent les limites de l'appareil photo en tant que médium de l'expression artistique.

À partir des années 1940 et tout au long des années 1950, Outerbridge réussit à bien vendre son travail commercial et plusieurs documentaires photo sur ses voyages à travers les États-Unis, le Mexique et l'Amérique latine. Il s'installa à Hollywood en 1943, puis à Laguna Beach où il ouvrit un petit studio de portraits photographiques. En 1945, il se maria une seconde fois, cette fois-ci avec Lois Weir, une créatrice de mode prospère avec laquelle il monta une affaire. En 1958, il mourut d'un cancer du poumon à Laguna Beach, en Californie.

Figure éminente parmi les photographes qui ont cherché à développer une esthétique propre à la photographie. Outerbridge était le seul à posséder la perception artistique et la finesse technique nécessaires pour explorer ce médium inédit qu'était la couleur en utilisant son expérience de l'épurement de la composition en noir et blanc. Il faisait partie des quelques visionnaires de la photographie moderne qui firent de ce médium un langage artistique à part entière. Outerbridge employa toute son intuition, son dévouement et ses connaissances techniques à créer des images fortes, souvent magnifiques, toujours mémorables, qui répondaient à sa définition de l'art – qui est aussi la nôtre – à savoir : une victoire de l'imagination sur les imperfections de la réalité.

1] *Paul Outerbridge, « Patternists and Light Butchers »,in :* American Photography, *46, n° 8 (août 1952), p. 54.*

2] *Pendant ce temps, Outerbridge rédigea également un long traité intitulé « Qu'est ce que la beauté féminine ? », publié dans* Physical Culture *[janvier 1933], p. 37-39 et p. 74-77, sans aucun doute influencé par les livres sur la sexualité et l'érotisme que le photographe étudia pendant son séjour à Paris.*

3] *Pour réaliser une simple épreuve en Carbro, trois expositions en trois couleurs différentes étaient nécessaires et, tout comme pour la sérigraphie, exigeaient une impression précise sur le papier. Il fallait dix heures pour développer un seul cliché et cela coûtait au minimum de cent dollars par image, ce qui représentait pendant la Dépression [et encore aujourd'hui] un gros investissement.*

4] *Weber se souvint : « À mon avis, à partir de ce jour-là, l'enseignement que je dispensais à la White School fut la première approche authentique et géométrique de la construction de base de la photographie considérée comme un art. », in : John Pultz et Catherine Scallen* Cubism and American Photography, 1910-1930 *[Williamstown : Clark Art Institute, 1981], p.42.*

5] *Maurice Burcel, « Paul Outerbridge, Jr. »,in :* Creative Art, *12, n° 2 [février 1933], p. 110-112 passim.*

6] *Autobiographie non publiée, J. Paul Getty Center Archive, Los Angeles*

7] *Paul Outerbridge, « Visualizing Design in the Common Place »,* Arts and Decoration, *17, n° 5 [septembre 1922, p. 320 et suivantes]*

8] *Leon Battista Alberti,* Ten Books on Architecture, *éd. J. Rykwert, trad. J. Leoni [New York : Transatlantic Arts, 1966], VI, II, 113. « Je définirais la Beauté comme une Harmonie de toutes les Parties, quel que soit le sujet, et dont le rapport de proportion et de connection est tellement juste, que rien ne pourrait être ajouté, enlevé ou changé si ce n'est pour le pire. » Voir également IX, V [surtout pages 194-195].*

9] *Graham Howe et G. Ray Hawkins, éd.,* Paul Outerbridge, Jr.: Photographs *[New York: Rizzoli, 1980], p. 11.*

10] *Paul Strand, « Photography », in :* Camera Work, *n° 48-50 [juin 1917],p 112.*

11] *Robert Marks, « Portrait of Paul Outerbridge », in :* Coronet 7, *n° 5 [mars 1940], p. 27.*

12] *Autobiographie non publiée.*

13] *Siegfried Kracauer,* From Caligari to Hitler *[Princeton : Princeton University Press, 1947], p. 168.*

14] *Pour la célébration du 50ᵉ anniversaire de*

cette fameuse exposition, le catalogue fut réimprimé en Allemagne et aux États-Unis. Le périodique Camera *n° 10 [octobre 1979] consacra tout ce numéro à l'exposition. Voir également* Film und Foto *[New York : Arno Press, 1979].*

15] U.S. Camera, *annuel, 1937, 30*

16] *Il écrivait abondamment sur ce sujet – un essai « Qu'est-ce que la beauté féminine ? » [publié dans* Physical Culture, *1933], et un autre essai non publié intitulé « Le Nu » – qui l'aida à clarifier ses intentions à propos de ce nouveau thème.*

17] *Toutes les citations proviennent d'un manuscrit non publié et non daté de Outerbridge, intitulé « The Nude », 1-6 passim [Outerbridge Archive, Special Collections, The Getty Center for the History of Art and the Humanities, Los Angeles].*

18] *Nancy Hall-Duncan,* Photographic Surrealism *[Cleveland : New Gallery of Contemporary Arts, 1979], p. 10.*

19] *Paul Outerbridge, « Clarence Laughlin and His Many Mansions : A Portfolio », tapuscrit non publié daté du 12.5.52, déposé au J. Paul Getty Center Archive, Los Angeles.*

Le procédé Carbro

Extraits du livre *Photographing in Color* de Paul Outerbridge

D'après la plupart des photographes concernés, le procédé Carbro est de loin le plus satisfaisant de tous ceux qui existent pour l'impression de photographies en couleur. Ce n'est pas qu'il soit très récent, mais il a fallu attendre que le marché publicitaire actuel suscite une demande suffisante de photos couleur pour que l'on s'efforce enfin, avec tant soit peu d'intelligence, de généraliser dans la pratique ce procédé qui a longtemps été confiné aux laboratoires. [...]

Les échecs que le procédé Carbro a connus jusqu'à ces derniers temps sont imputables à une série de facteurs : l'absence de normalisation de toutes les opérations, l'absence de contrôle densimétrique des négatifs, l'absence de contrôle du voltage de l'agrandisseur, l'insuffisance de l'adhésion des colorants aux négatifs lors de la phase de développement. [...] Mais aujourd'hui, avec l'équipement adéquat et les connaissances requises, il est de plus en plus simple de tirer des épreuves Carbro. Parmi tous les procédés d'impression dont disposent les photographes, celui-ci est sans aucun doute celui qui produit les plus belles images. [...]

Le procédé Carbro nécessite beaucoup de précision dans le minutage de toutes les opérations ainsi que dans le contrôle de la température et de l'humidité. Il est soumis à un assez grand nombre de paramètres, parmi lesquels la composition chimique de l'eau utilisée, les conditions climatiques, le temps qu'il fait, les mesures de conservation et l'ancienneté des matériaux. Mais à condition de bien vouloir investir l'argent nécessaire et de ne pas ménager ses efforts de concentration et d'intelligence, on peut apprendre à réaliser de bonnes images carbro. On arrivera même à obtenir des résultats assez cohérents, mais non sans se heurter à quelques difficultés en chemin. [...]

LA PRÉPARATION DES NOUVEAUX NÉGATIFS

Il existe deux théories pour préparer les nouveaux négatifs utilisés dans le procédé Carbro. Soit on les lave avec un léger abrasif ou de la poudre à récurer, mais en évitant des matériaux trop rugueux qui pourraient les rayer ; soit on se contente de les enduire d'une couche de cire qu'on polit, qu'on laisse entièrement sécher, puis on les recouvre d'une seconde couche qu'on polit aussi, afin de les rendre prêts à l'emploi. S'ils sont trop rayés ou trop usés, il faut les jeter. Car la netteté de l'image dépend de la fraîcheur du film, même si une légère érosion produit un travail un peu plus satisfaisant. Il ne faut jamais essayer de nettoyer les négatifs dans de l'eau très chaude sous peine de les voir s'incurver sous l'effet de la chaleur. Et en cas d'incurvation importante, on aura du mal à les coucher correctement au moment de racler la couche pigmentaire, ou bien au moment de les superposer tous les trois pour examiner l'harmonie chromatique de l'image finale. [...]

L'OPÉRATION DE CIRAGE

[...] Aux quatre coins et au centre de chaque négatif, on commence par vaporiser quelques gouttes d'une préparation à base de cire. Puis on prend un polissoir qu'on aura fabriqué au préalable de la façon suivante : il s'agit d'un carré de bois d'environ 5 centimètres de côté et de 2,5 centimètres de hauteur, recouvert d'une pièce de feutre doux [semblable au feutre des pianos] de 5 ou 6 millimètres d'épaisseur que l'on a fixée avec de la colle forte sur la face du dessous, et d'un autre carré de bois identique, mais de 10 centimètres de côté et de 5 centimètres de hauteur. Voilà l'instrument nécessaire au cirage et au polissage du négatif, ainsi qu'à l'élimination des restes superflus de cire sur le papier de tirage. [...]

LE PAPIER POUR L'IMPRESSION AU BROMURE

Pour l'impression Carbro, il faut commencer par se procurer du papier au bromure. Sous ce rapport, c'est le papier Ilingworth Normal Contrast Bromide Paper [...] qui fournit les meilleurs résultats. D'ailleurs, c'est le papier utilisé par la majorité des meilleurs utilisateurs du procédé Carbro. On le trouve en rouleaux d'environ 9 mètres de long et d'un mètre de large, ou bien de 3,5 mètres de long et d'un mètre de large. On le trouve aussi par paquets de douze feuilles prédécoupées de 28 sur 35 centimètres, ou bien de 20 sur 25 centimètres. Si on a beaucoup de travail, les grands rouleaux sont plus économiques car on en vient assez vite à bout. De plus, c'est en rouleau qu'il vaut mieux acheter le papier au bromure si on utilise le procédé Carbro. Mais dans la méthode du blanchiment à deux bains, on peut aussi employer le papier Defender Velour Black, à condition de travailler l'impression en profondeur pour obtenir des résultats identiques. [...]

LE FIXAGE ET LE LAVAGE

Les épreuves au bromure doivent être fixées dans une solution d'hyposulfite pendant 15 minutes, mais pas plus, puis lavées pendant une durée comprise entre une heure et une heure et demie. À mesure que vieillit la solution d'hyposulfite, on peut y laisser les images plus longtemps sans aucun risque, mais à long terme, il est toujours préférable de la renouveler. Il faut complètement éliminer les traces d'hyposulfite [faute de quoi, on s'expose ensuite à des difficultés] ; et pour s'assurer qu'il n'en reste aucune, on utilisera une solution de permanganate.

LE RETIRAGE ET LA CONSERVATION DES ÉPREUVES AU BROMURE

À force d'expérience et de connaissances, on acquiert un certain jugement critique qui est essentiel pour analyser et comparer l'équilibre des couleurs sur un ou plusieurs ensembles d'épreuves au bromure. C'est pourquoi il me semble important de retirer et de conserver ces épreuves dans l'utilisation du procédé Carbro : on peut ainsi s'en servir ultérieurement pour comparer l'intensité de l'impression et vérifier la valeur chromatique de certaines couleurs obtenues dans de nouveaux tirages en les confrontant à des couleurs identiques ou semblables d'anciennes images. Cette bibliothèque de référence, pour ainsi dire, qui s'ajoute au carnet du photographe, est d'une valeur considérable dans certaines circonstances. À partir d'un ensemble d'épreuves au bromure, on peut retirer de nouveaux clichés presque parfaits. Selon moi, c'est la meilleure méthode pour se rapprocher le plus possible de l'image originale. Dans cette optique, le temps de retirage doit être de cinq minutes, et si possible grâce à un appareil de développement très simple. Après ce second tirage, il suffit de laver l'épreuve pendant à peu près une demi-heure. Si des problèmes surgissent, il faut continuer l'opération de lavage.

L'IMMERSION DU PAPIER PIGMENTÉ

[…] Au bout d'une minute, on plonge le papier pigmenté rouge dans le même bain, au-dessus du papier bleu, en suivant la même procédure. Une minute plus tard, on y plonge le papier jaune. Encore une minute plus tard, on remet le minuteur à zéro et on ôte le papier bleu que l'on suspend par les deux coins supérieurs pour le faire sécher. Au bout d'une autre minute, on procède de la même manière avec le papier rouge puis, une minute plus tard encore, avec le papier jaune. Il faut veiller à faire tremper et sécher chacun des trois papiers recouverts de la couche de gélatine pigmentée pendant la même durée, et à les manipuler aussi de la même manière.

LA SENSIBILISATION ET LE BLANCHIMENT DU PAPIER PIGMENTÉ

Quand le minuteur sonne de nouveau, au bout de la troisième minute [c'est-à-dire six minutes après le début de l'opération], on verse les solutions b et c dans le bain de sensibilisation et on mélange bien l'ensemble par un mouvement d'oscillation de la cuvette. Une fois le second chronomètre enclenché, on plonge le papier pigmenté bleu dans le bain de sensibilisation lorsque les deux aiguilles sont sur le 12, sans cesser d'effectuer ce mouvement oscillatoire dans les deux sens. Au bout de soixante secondes, on plonge le papier rouge puis, soixante secondes plus tard, le papier jaune. Trente secondes après avoir immergé le papier jaune, on ôte la feuille bleue et on la ramène à la surface. Il faut délicatement agiter la cuvette pendant toute l'opération pour parvenir à une sensibilisation et à un blanchiment impeccable.

LE RACLAGE DANS LA CENTRIFUGEUSE

C'est à ce moment-là qu'il convient d'accélérer le rythme. Trente secondes avant la fin des trois minutes, on ôte l'épreuve au bromure bleue de la bassine et on la met à sécher à la verticale jusqu'à ce qu'elle commence à s'égoutter. Puis on la plaque sur le négatif du dessus ou de droite dans la centrifugeuse. On enlève tout de suite le papier bleu pigmenté du bain de sensibilisation et, sans le mettre à sécher, on le plaque sur le négatif du bas ou de gauche. On détache le négatif du haut qui était suspendu et, en le tenant de la main gauche, on maintient séparées l'épreuve au bromure et la feuille pigmentée jusqu'à ce qu'elles entrent dans la centrifugeuse. De la main droite, on active aussi vite que possible cet appareil puis on fixe la superposition qui en est issue pendant dix minutes. C'est grâce au contact parfait entre l'épreuve au bromure et le papier Carbro de couleur que l'image se transfère ou s'impressionne dans la gélatine pigmentée. Les éléments qui ne se sont pas solidifiés disparaîtront dans le bain d'eau chaude et laisseront une reproduction parfaite de l'image d'impression en noir et blanc sur la gélatine colorée. […]

LA SÉPARATION DE L'ÉPREUVE ET DE L'IMAGE ET LE BAIN D'ALCOOL

Il faut préparer un nouveau bain d'eau froide – la plus froide possible, d'une température en tout cas inférieure à 16 degrés – et l'installer à côté de l'épaisse plaque en verre sur le plan de travail. Une fois les dix minutes écoulées, on détache de la pellicule la combinaison du papier pigmenté et de la feuille au bromure bleue et on plonge celle-ci dans le bain d'eau froide. Ensuite, il faut décoller soigneusement sous l'eau la feuille de bromure du papier pigmenté et mettre la première à laver, côté émulsion vers le bas. Au cas où des bulles d'air resteraient infiltrées entre les deux, on peut les éliminer en remplaçant ce bain d'eau froide par un bain composé à 25 % d'alcool à faible température. Ce bain d'alcool permet d'ôter les irrégularités de la surface. Il faut bien le mélanger, puis le faire refroidir avant de l'utiliser, parce que le mélange augmente la chaleur d'une solution. S'il fait beau, il faut même le glacer, et rafraîchir le négatif pour empêcher que le papier de tirage ne glisse sur l'épreuve au bromure pendant l'opération. Ce papier ne doit pas rester plus de trente secondes dans le bain après qu'on en a ôté l'épreuve au bromure. […]

LE RACLAGE

Il faut à présent ôter l'image du bain d'eau ou d'alcool et, sans la laisser égoutter, mettre en contact sa partie inférieure avec le côté gauche du négatif couché sur la plaque de verre. On exerce alors une forte pression en faisant pivoter le reste de manière à éliminer tout l'air. Dans le procédé Carbro, toutes les opérations de raclage visent à expulser l'air infiltré entre les deux surfaces en contact. L'élimination de la pellicule d'eau doit toujours s'accompagner de l'élimination des bulles d'air. Pour cela, il faut maintenir bien à plat le papier coloré en appuyant la main gauche sur le côté gauche et en évitant toute possibilité de mouvement ; à l'aide d'une raclette plate à bord de caoutchouc, ou bien d'une raclette utilisée pour nettoyer les vitres [c'est personnellement ce type-là que j'utilise], on polit le papier pigmenté à partir du côté gauche, en commençant au tiers de la distance qui le sépare du bord et en effectuant un mouvement lent et régulier vers la droite pour éliminer toute trace d'air et d'humidité. […]

LE DÉVELOPPEMENT DES NÉGATIFS

On remplit deux bassines d'eau chaude [entre 43 et 46 degrés] et une troisième d'eau froide. Puis on glisse le papier pigmenté bleu dans la première bassine pendant deux minutes. Au bout de ce laps de temps, le surplus de gélatine qui n'a pas été solidifié par la réaction chimique s'écoulera des bords du papier. Sous l'eau, on saisit par les pouces deux angles opposés du papier coloré et on le fait doucement glisser d'un côté à l'autre. On le détache ensuite doucement de la feuille de papier enduite de gélatine et, une fois qu'on l'a jeté, on continue à maintenir celle-ci contre un côté de la bassine pour éliminer l'excédent de colorant. L'eau se trouble. Puis on rince la feuille à l'eau chaude en effectuant un mouvement pendulaire, en la tenant des deux mains, en la sortant de l'eau et en la secouant pour éliminer autant de gélatine que possible. L'image transférée depuis l'épreuve au bromure apparaît alors en bleu dans toute sa netteté. Ensuite, il faut placer la feuille gélatinée dans la seconde cuvette d'eau chaude, côté émulsion vers le haut, et l'y maintenir tout le temps que l'image pigmentaire rouge est plongée dans le premier bain. […]

LE TRANSFERT DES IMAGES

Sur l'épreuve finale, les images carbro apparaissent dans l'ordre suivant : d'abord l'image jaune contre le papier, puis l'image rouge, et enfin l'image bleue tout en haut. Cet ordre s'explique par le fait que le pigment jaune est opaque tandis que les pigments bleu et rouge sont transparents. Ainsi, si le pigment jaune se trouvait en haut, on ne verrait pas bien les autres couleurs à travers. Par conséquent, si les trois images étaient directement transférées sur le papier à report, il faudrait d'abord coucher l'image jaune. Et comme il est un peu difficile de distinguer les contours d'une image jaune sur un fond blanc, il serait assez difficile de lui superposer une autre couleur.[…]

L'ÉLIMINATION DE LA CIRE SUR LE PAPIER À REPORT

La couche de cire qui s'est détachée du négatif doit à présent être éliminée du papier de tirage, sinon l'image suivante [de couleur rouge] ne se fixera pas. Il convient donc de punaiser le papier de tirage sur un tableau conservé à cet effet, puis de tremper un bout de coton dans du white-spirit et d'essuyer l'image. On balaie ensuite la surface avec un nouveau bout de coton sec, puis avec un morceau de flanelle qui entoure le plus grand des deux bouts de bois utilisés pour polir les négatifs. Il faut éliminer autant de cire que possible. […]

L'IMMERSION DU PAPIER DE TIRAGE POUR LE SECOND TRANSFERT

On prend le papier de tirage et on le replonge dans la même eau. Une fois la face émulsionnée mouillée et un peu ramollie, on le sort de l'eau en le prenant par deux coins et on le ramène doucement à la surface du bain pour en extraire toutes les bulles d'air qui pourraient y demeurer. Au préalable, on aura pris soin de glisser en dessous le négatif rouge en suivant la même méthode et, bien entendu, en plaçant l'image dans le même sens, côté émulsion vers le haut. On laisse agir pendant cinq minutes, puis on sort les deux feuilles de l'eau comme auparavant et, en les tenant à la lumière, on les plaque l'une contre l'autre le plus vite et le mieux possible. À condition de les maintenir sans bouger pendant quelques instants, les pouces vont dégager, sur le bord du papier, une chaleur qui va permettre à la nouvelle image d'apparaître.

LA SUPERPOSITION DES IMAGES ROUGE ET BLEUE

On couche le négatif sur la plaque en verre et on racle le papier de tirage très doucement pour en éliminer le surplus d'air et d'humidité. Puis on prend le négatif, et l'image se transfère sur le papier grâce à la lumière projetée. On tient seulement ce papier de tirage par ses bords jusqu'à ce qu'il adhère aussi parfaitement que possible à l'image pigmentaire rouge. On donne ensuite un léger coup de raclette sur le papier, on retourne le négatif sur le buvard neuf et on racle l'eau au verso, ainsi que sur la plaque de verre. Ensuite, on étale un autre buvard sur la plaque de verre et on place à côté le négatif qui recouvre le papier de tirage. Si l'on voit des bulles d'air, il faut les enlever avec une petite raclette avant de commencer l'opération de superposition. […] Après la superposition de cette partie, on se rendra peut-être compte, en se rapprochant du milieu de l'image, qu'elle a suffisamment séché pour rendre inutiles d'autres opérations de raclage. Mais si le transfert se fait trop facilement, le décollage se fera tout aussi facilement. Il faut que les deux parties adhèrent assez fortement pour bien rester en place une fois qu'on les a mises en contact. D'un autre côté, si la superposition requiert un trop grand effort, il vaut mieux replonger le négatif dans l'eau et, sous la surface, décoller doucement le papier de tirage là où l'on se heurte à des problèmes. Si le problème survient à l'extrémité inférieure, ce n'est bien sûr pas la peine de séparer plus loin les deux feuilles ;

puis, après avoir sorti le négatif de l'eau en le soulevant d'un geste rapide, on peut à nouveau faire adhérer les deux négatifs de séparation à l'aide de la raclette. […]

LA SUPERPOSITION DE L'IMAGE JAUNE

Après avoir terminé la superposition des images bleue et rouge, il faut accrocher le négatif et le faire sécher devant un ventilateur comme auparavant. Une fois que le papier de tirage a séché et qu'il s'est détaché du négatif, on obtient une image mauve dont les deux composantes colorées, espérons-le, coïncident parfaitement. Il faut alors nettoyer cette nouvelle image avec du white-spirit comme on l'a fait auparavant pour l'image bleue puis, toujours selon le même processus, la plaquer sur le papier de tirage avec le négatif jaune pendant cinq minutes. Au bout de ces cinq minutes, on retire l'ensemble de l'eau et on procède à la superposition des feuilles, comme pour les deux autres images précédemment, en n'oubliant jamais que c'est toujours l'image du négatif que l'on déplace. […]

LE TRANSFERT VERS LE PAPIER À REPORT

Une fois que le papier de tirage, avec l'image complète, s'est détaché, il faut le nettoyer avec du white-spirit selon la méthode préalablement décrite en s'assurant que cette opération de nettoyage a été menée jusqu'à son terme. Ensuite, on découpe le bord extérieur où figurent les trous de punaises ou les empreintes des pouces [ainsi que, le cas échéant, quelques petites déchirures] jusqu'à un centimètre environ de l'image même. On la plonge alors dans la grande cuvette d'eau froide où flotte le dernier papier à report, côté émulsion vers le haut. On tire celui-ci sous l'eau, pour que toute sa surface soit recouverte, puis on le dresse à la verticale sans cesser de l'immerger complètement pendant une minute. Ensuite, on le retire de l'eau avant de l'étendre à la surface du bain, selon la méthode précédemment décrite pour éviter des formations de bulles d'air. Là, on le laisse reposer, côté émulsion vers le bas, pendant une minute, puis on le ramène sur le papier à report en saisissant celui-ci des deux mains, les pouces plaqués sur les deux coins supérieurs, avant d'ôter le tout pour le mettre à sécher et éliminer l'air qui aurait pu s'infiltrer entre les deux surfaces. On le couche ensuite sur une plaque en verre, côté émulsion vers le haut, en appliquant le papier de tirage sur lui. Pour bien les faire adhérer, on balaie ces deux feuilles dans tous les sens à l'aide de la raclette, jusqu'à ce que l'on ait fait sortir le maximum d'humidité possible. Plus l'ensemble sera sec, plus le contact sera parfait, mieux cela vaudra. C'est alors qu'il faut saisir le papier par un coin, le soulever de la feuille de verre, éliminer toute l'eau avec la raclette, étendre un nouveau buvard sur la feuille de verre, y coucher le papier à report et lui ajouter un autre buvard. Ensuite, il faut passer l'ensemble au rouleau, dans le sens de la longueur et dans celui de la largeur, en appuyant plus fort qu'auparavant. Enfin, on presse le tout sous une épaisse plaque de verre, sur laquelle on dispose des flacons de solutions photographiques d'un poids total d'environ cinq kilos, et on laisse reposer pendant une demi-heure.

LE DÉVELOPPEMENT DE L'ÉPREUVE FINALE.

Juste avant la fin de cette demi-heure, on fait couler de l'eau à 43 degrés dans une cuvette. Quand la demi-heure s'est écoulée, on place la combinaison du papier de tirage et du papier à report, le premier en dessous, à la surface de l'eau. [On met le papier de tirage en dessous pour que l'eau chaude fasse fondre la gélatine soluble aussi vite que possible.] Dans le creux de la main, on recueille un peu d'eau et on l'étale au dos du papier à report pour le maintenir bien à plat. On laisse agir deux minutes. Cette opération ressemble beaucoup au développement des images pigmentaires des négatifs.

L'ÉGOUTTAGE ET LE SÉCHAGE

On punaise ensuite la dernière image obtenue sur le bord d'une étagère pendant une ou deux minutes. Pendant ce temps, on peut en profiter pour couper quelques bouts de ruban adhésif ordinaire suivant la longueur requise, et préparer une planche lisse, semblable à un tableau, pour y fixer l'image. Sur cette planche, on dispose l'épreuve en prenant soin de bien la centrer avant de la déposer, car une fois qu'elle sera mise en place, il ne sera plus possible de la déplacer. Il suffit alors de mouiller le ruban adhésif avec un bout de coton et de coller les bords de l'image sur la planche en exerçant une pression du bout des doigts et en effectuant un geste de l'intérieur vers l'extérieur sur toute la longueur. Il faut veiller à ce que le ruban adhère bien et, le cas échéant, on peut utiliser une petite serviette pour renforcer l'adhésion. Si les bords de l'image gélatinée ont la moindre tendance à se recourber, on peut aussi les plaquer avec une brosse souple en poils de chameau imbibée d'alcool, ou bien avec un mélange d'eau et d'alcool.

[New York : Random House, 1940]

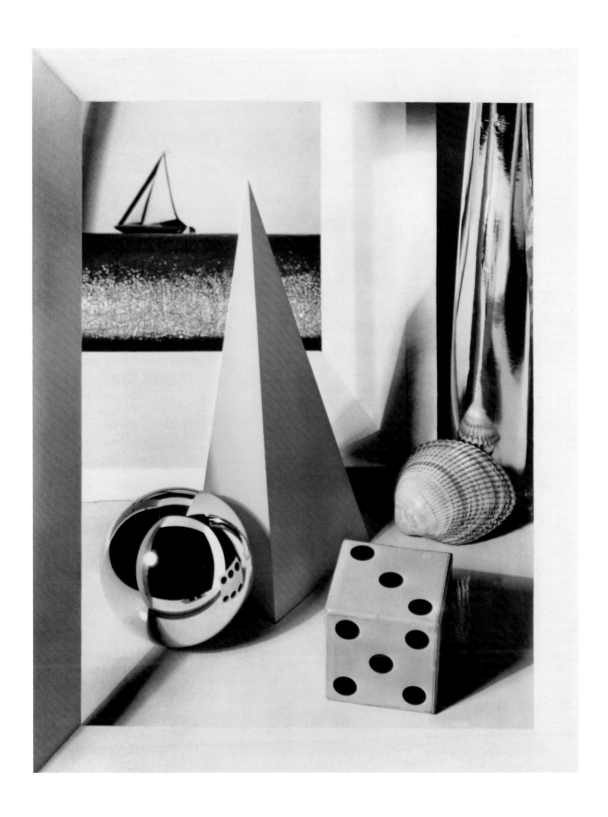

Images de Deauville
c. 1936

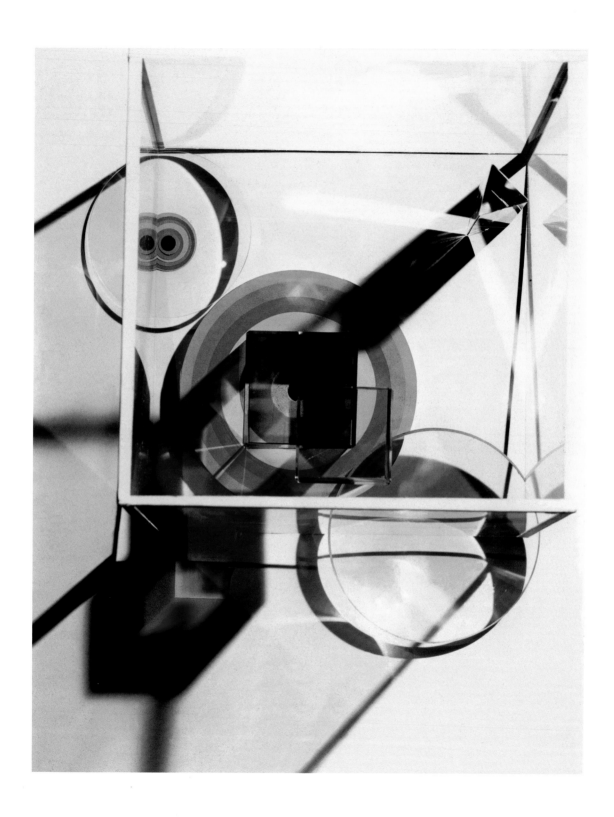

Political Thinking | Politisches Denken | Pensée politique
c. 1938

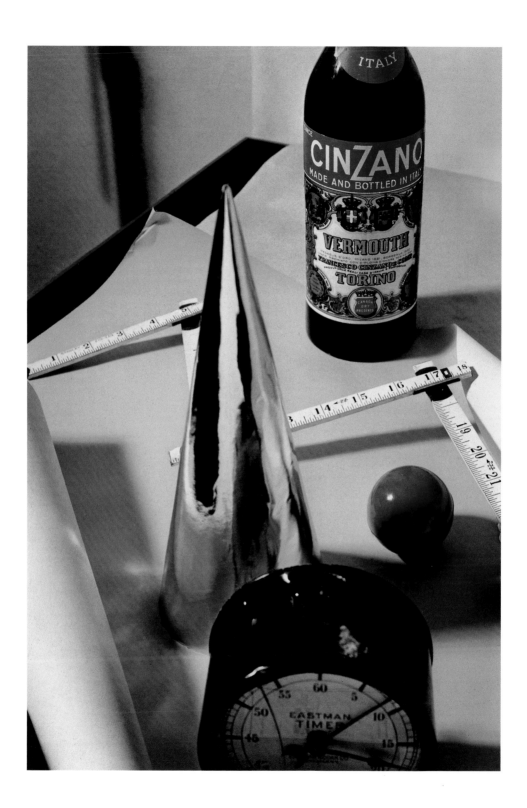

Kandinsky
1937

I think that still life presents perhaps the greatest possibilities for purely creative work in color photography, for to put life into still life, into inanimate objects, to create new rhythms and patterns requires imagination.

Ich glaube, dass das Stilleben die vielleicht größten Möglichkeiten zur rein kreativen Arbeit in der Farbfotografie bietet, denn um Leben in ein Stilleben, in leblose Objekte zu bringen, um neue Rhythmen und Muster zu schaffen, dafür ist Fantasie erforderlich.

Je pense que la nature morte présente peut-être les plus grandes possibilités de travail purement créatif pour la photographie en couleurs, car mettre de la vie dans une nature morte, dans des objets inanimés, créer de nouveaux rythmes et de nouveaux motifs, exige de l'imagination.

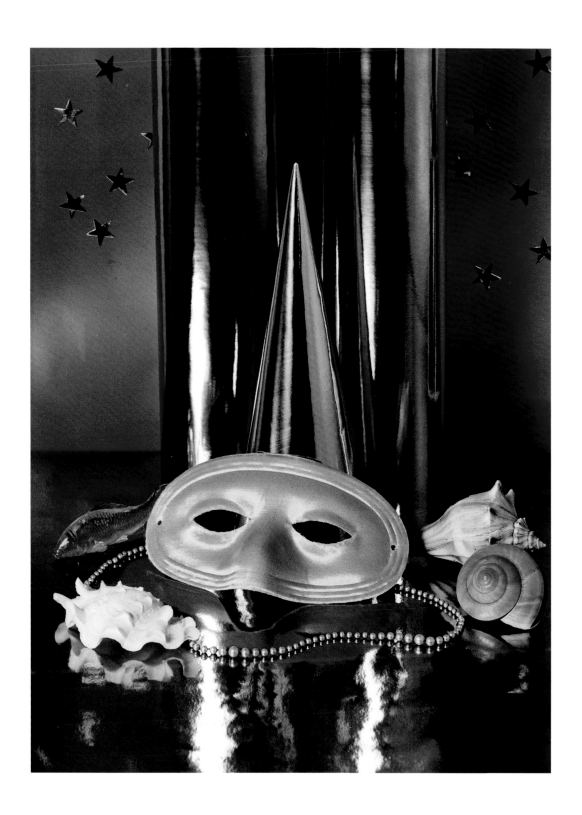

Party Mask with Shells | Partymaske mit Muscheln | Masque de fête et coquillages
1936

Toilet Paper Advertisement | Werbung für Toilettenpapier | Papier hygiénique, publicité
c. 1938

Graduation Caps and Flowers | Akademische Hüte und Blumen | Chapeaux de promotion et fleurs
c. 1937

Chair with Materials | Stuhl mit Stoffen | Chaise et tissus
1936

Favor-Horn and Shell | Horn und Muschel | Corne et coquillage
c. 1936

Kitchen Table | Küchentisch | Table de cuisine
1935

Cheese and Crackers | Käse und Cracker | Fromage et crackers
1936

Sandwiches on Tray | Belegte Brote auf einem Tablett | Sandwiches sur un plateau
c. 1938

Beach Equipment | Strandausstattung | Équipement de plage
c. 1936

Wallpaper Design | Tapetenmuster | Motifs de papiers peints
1936

The underlying element of all fine art is form, and composition
is the organization of forms.

*Das Grundprinzip aller bildenden Kunst ist die Form, und die Komposition
ordnet Formen.*

L'élément sous-tendant tout art digne de ce nom est la forme, et la composition
est l'organisation des formes.

Table Place Setting | Tischgedeck | Couvert
c. 1937

Christmas Gifts | Weihnachtsgeschenke | Cadeaux de Noël
1936

Silverware | Silberzeug | Argenterie
1937

Silver Service on Table | Silberservice auf einem Tisch | Service en argent sur un guéridon
c. 1938

Commonplace articles need to appear commonplace when imagination is used in arranging them for illustration purposes.

Auch wenn Alltagsgegenstände fantasievoll zu Illustrationszwecken zusammengestellt werden, müssen sie nach Alltag aussehen.

Des objets ordinaires doivent apparaître comme ordinaires quand on fait appel à l'imagination pour les disposer en vue d'en faire une illustration.

Riding-Boot with Feather | Reitstiefel mit Feder | Bottes d'équitation et plumes
c. 1936

Child on Suitcases | Kind auf Koffern | Enfant sur des valises
1937

Baby with Lamb | Baby mit Lamm | Bébé et agneau
1938

Father and Son in Kitchen | Vater und Sohn in der Küche | Père et fils dans la cuisine
1941

Test Shot for 4 Roses Advertisement | Probeaufnahme für Werbung für 4-Roses-Bourbon |
Essai pour la publicité du Bourbon 4 Roses
c. 1938

Eight O'Clock Coffee
c. 1938

Coffee Advertisement | Kaffeewerbung | Publicité pour du café
1940

Desk with Blueprint | Schreibtisch mit Blaupause | Bureau avec photocalque
1938

Circus Bar | Zirkusbar | Bar cirque
1937

Bedroom | Schlafzimmer | Chambre à coucher
c. 1940

Bedroom | Schlafzimmer | Chambre à coucher
c. 1937

Christmas Tree with Gifts | Weihnachtsbaum mit Geschenken | Sapin de Noël avec cadeaux
1937

Antique Display | Antiquitätenauslage | Déballage d'antiquités
1938

What makes a still life good instead of mediocre is the quality of vision and imagination employed by the photographer, and especially his reaction to his subject material.

Der Unterschied zwischen einem guten und einem mittelmäßigen Stilleben liegt in der Qualität der Vision und der Fantasie, die der Fotograf einsetzt, und insbesondere in seiner Reaktion auf sein Bildmaterial.

Ce qui fait qu'une nature morte est bonne plutôt que médiocre, c'est la qualité de la vision et de l'imagination du photographe, et plus particulièrement sa réaction au sujet observé.

Food Display, with Brand Names Removed | Lebensmittelauslage mit entfernten Firmennamen | Étalage de nourriture démarquée
1937

Autumn Still Life | Herbststillleben | Nature morte automnale
1937

Corn Stalk | Maiskolben | Épi de maïs
c. 1936

Dinner Service with Produce | Tafelservice mit Obst und Gemüse | Service de table avec fruits et légumes
1936

Terrace | Terrasse | La terrasse
c. 1938

Kitchen Scene | Küchenszene | Scène de cuisine
c. 1937

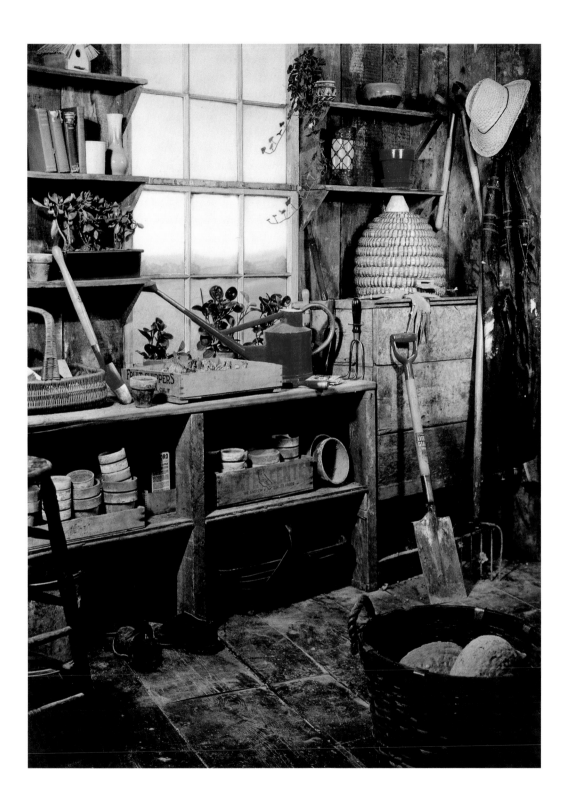

The Potting Shed | Das Gewächshaus | L'abri de jardin
1936

Portraiture in painting is already more or less a lost art. Without doubt most of
the portraits of the future will be photographic, but not as we know photography today.

Die Porträtmalerei ist schon jetzt eine mehr oder minder ausgestorbene Kunst.
Ohne Frage werden die meisten Bildnisse der Zukunft fotografischer Natur
sein, allerdings nicht so, wie wir die Fotografie heute kennen.

Le portrait en peinture est déjà, plus ou moins, un art qui se perd. Je suis sûr
qu' à l'avenir, la plupart des portraits seront photographiques, mais ce sera une
autre photographie que celle que nous connaissons aujourd'hui.

Waiting for Eve | Warten auf Eva | En attendant Ève
c. 1938

Geranium Pots | Geranientöpfe | Pots de géranium
1936

Nasturtiums | Kapuzinerkresse | Capucines
c. 1937

Fallen House | Eingestürztes Haus | Maison écroulée
1938

Tools with Blueprint | Handwerkszeug mit Blaupause | Outils et photocalque
c. 1938

Window with Plants | Fenster mit Pflanzen | Fenêtre et plantes
c. 1937

First Robin of Spring | Erstes Rotkehlchen im Frühling | Premier rouge-gorge au printemps
c. 1938

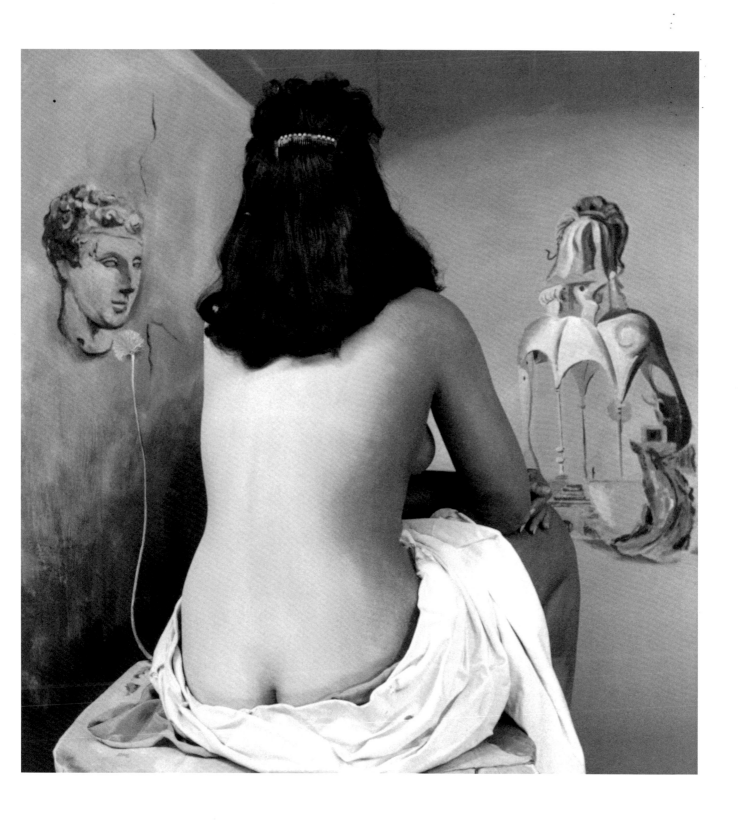

Untitled
c. 1938

Biography | Biografie | Biographie
Paul Outerbridge
1896-1958

Paul Outerbridge at the age of seven with his two sisters
Paul Outerbridge im Alter von sieben Jahren
Paul Outerbridge à l'âge de sept ans

Paul Outerbridge at the age of 13
Paul Outerbridge im Alter von 13 Jahren
Paul Outerbridge à l'âge de treize ans

 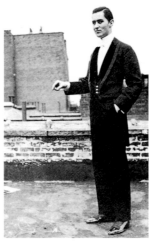

Paul Outerbridge as a pilot, c. 1919
Paul Outerbridge als Pilot, ca. 1919
Paul Outerbridge comme pilote, vers 1919

Paul Outerbridge, 1921

1896
Born Paul Everard Outerbridge, Junior, August 15th in New York City.

1906
Attends elementary school in New York; later the Hill School, Pottstown, Pennsylvania.

1914
Graduates from the Cutler School, New York City.

1915
Studies anatomy and aesthetics at the Art Students' League, New York; designes posters for the Wintergarden Revue.

1916
Works with Rollo Peters on stage design; produces his own revue in Bermuda; takes up residence in Greenwich Village.

1917
Joins the Royal Flying Corps and later the U.S. Army.

1918
Travels to Hollywood and returns to New York City.

1921
Marries Paula Smith; takes up photography; enters Clarence H. White School of Photography.

1922
Photograph published by *Vanity Fair*, Kitchen Table [July 1921]; in November the advertising photograph Ide Collar is also published in *Vanity Fair*.

1923
Talks with Alfred Stieglitz; studies with Alexander Archipenko; has solo exhibition at the Art Center, New York.

1924
During the following three years, becomes a highly successful advertising photographer with many commercial accounts, among them *Vogue*, *Vanity Fair*, and *Harper's Bazaar*.

1925
Leaves for Europe; works for Paris *Vogue*; meets Man Ray, Constantin Brancusi, Pablo Picasso, George Hoyningen-Huene, Marcel Duchamp, Igor Stravinsky, Salvador Dalí, and Georges Braque.

Paul Everard Outerbridge, Jr. wird am 15. August in New York City geboren.

Besuch der Grundschule in New York, später Besuch der Hill School, Pottstown, Pennsylvania.

Abschluß der Cutler School, New York.

Studium der Anatomie und Ästhetik an der Arts Students' League, New York. Entwurf von Postern für die Wintergarden Revue.

Arbeit als Bühnenbildner mit Rollo Peters. Selbstständige Produktion einer Revue in Bermuda. Umzug nach Greenwich Village.

Eintritt in das Royal Flying Corps, später in die U.S. Armee.

Reise nach Hollywood und Rückkehr nach New York.

Heirat mit Paula Smith. Beginn der Fotografenkarriere und Studien an der Clarence H. White School of Photography.

Veröffentlichung der Fotografie „Kitchen Table" (Juli 1921) in *Vanity Fair*; im November Veröffentlichung der Werbefotografie „Ide Collar", ebenfalls in *Vanity Fair*.

Gespräche mit Alfred Stieglitz und Studien bei Alexander Archipenko. Einzelausstellung im Art Center, New York.

In den folgenden drei Jahren wird Outerbridge zu einem äußerst erfolgreichen Werbefotografen mit vielen kommerziellen Stammkunden wie z. B. *Vogue*, *Vanity Fair* und *Harper's Bazaar*.

Abreise nach Europa und Beginn der Arbeit für die Pariser *Vogue*. Er lernt Man Ray, Constantin Brancusi, Pablo Picasso, George Hoyningen-Huene, Marcel Duchamp, Igor Strawinsky, Salvador Dalí und Georges Braque kennen.

Naissance de Paul Everard Outerbridge, fils, le 15 août à New York.

Fréquente l'école primaire de New York puis la Hill School de Pottstown, en Pennsylvanie.

Diplômé de la Cutler School, à New York.

Étudie l'anatomie et l'esthétique à la Art Students' League, New York; crée des affiches pour le spectacle de Wintergarden.

Conçoit des décors de théâtre avec Rollo Peters; produit son propre spectacle aux Bermudes; élit domicile à Greenwich Village.

S'enrôle dans le Royal Flying Corps, puis dans l'armée américaine.

Se rend à Hollywood puis retourne à New York.

Épouse Paula Smith; se met à la photographie et entre à l'école de photo Clarence H. White School of Photography.

Publication par *Vanity Fair* de sa photographie «Table de cuisine» [juillet 1921]; en novembre le spot publicitaire «Ide Collar» paraît également dans *Vanity Fair*.

Entretiens avec Alfred Stieglitz; étudie avec Alexander Archipenko; exposition personnelle à l'Art Center, à New York.

Pendant les trois années suivantes, devient un photographe publicitaire à succès avec des clients importants comme *Vogue*, *Vanity Fair* et *Harper's Bazaar*.

Départ pour l'Europe; travaille pour *Vogue* à Paris; fait la connaissance de Man Ray, Constantin Brancusi, Pablo Picasso, George Hoyningen-Huene, Marcel Duchamp, Igor Stravinsky, Salvador Dalí et Georges Braque.

*Paul Outerbridge at the farewell dinner
for Edward Steichen in the Algonquin
Club,* 1939
*[Last row, 5th pers. from left: Edward Steichen;
in the middle (with moustache): Paul Outerbridge]*
Paul Outerbridge beim Abschiedsessen
für Edward Steichen im Algonquin Club
[Letzte Reihe, 5. von links: Edward Steichen;
Mitte (mit Schnurrbart): Paul Outerbridge]
Paul Outerbidge à la fête d'adieux
d'Edward Steichen au Algonquin Club
[Dernière rangée, 5ᵉᵐᵉ à partir de la gauche:
Edward Steichen ;mau milieu (avec moustache):
Paul Outerbridge]

*Paul Outerbridge at the
Laguna Beach Art Fair,
c.* 1951
Paul Outerbridge auf
der Kunstmesse in
Laguna Beach, ca. 1951
Paul Outerbridge à la
foire de l'art à Laguna
Beach, vers 1951

*"Here's a print knocked out by some photo-
finisher in which most of my face needs
burning in, but it will serve to show a few
things [...]
The single egg in the rays of a spotlight
was the last advertising picture I did in
the East—for National Dairies through
N. W. Ayer for, as I recall, either 300 or
400 Dollar. It was a black and white. This
information is for the purpose of acquaint-
ing you with some of the other material that
I feel someone should take in hand and do a
selling job on."*

„Anbei ein stümperhafter Abzug irgendeines
Fotolaboranten, worin der größte Teil mei-
nes Gesichts retuschiert werden müsste, aber
zumindest sind einige meiner Fotos darauf
zu sehen [...]
Das Ei im Scheinwerferlicht war das letzte
Werbefoto, das ich an der Ostküste gemacht
habe – über N. W. Ayer für die Groß-
molkerei National Dairies, für 300 oder
400 Dollar. Es war ein Schwarzweißfoto.
Mit dieser Information möchte ich Sie auch
auf das andere Material aufmerksam ma-
chen, das sich, wie ich glaube, zum Verkauf
anbietet."

« Ci-joint l'épreuve bâclée d'un laborantin
quelconque. Si la majeure partie de mon
visage a dû être retouchée, on peut du moins
y voir quelques-unes de mes photos [...]
L'œuf éclairé par un projecteur a été la
dernière photo publicitaire que j'ai réalisée
sur la côte est – par le biais de N. W. Ayer
pour les laiteries National Dairies, pour
le prix de 300 ou 400 dollars. C'était une
photo en noir et blanc.
Avec cette information, je voudrais
également attirer votre attention sur l'autre
matériel qui, comme je le crois, est en vente. »

PAUL OUTERBRIDGE, C. 1952

1927
Establishes a large, expensively equipped studio in Paris financed by Outerbridge and the mannequin manufacturer Mason Siegel, but the project is short-lived; separates from his wife, Paula.

1928
Works in motion pictures in Berlin; later in London for Ewald André Dupont.

1929
Takes part in the Werkbund [Crafts Association] exhibition, *Film und Foto*, Stuttgart; returns to New York.

1930
Experiments with Carbro color; sets up country studio outside New York; exhibition at the American Designers Gallery in New York.

1931
Exhibits at the Albright Knox Museum in Buffalo, Third Annual Exhibition of Contemporary Photography, The Ayer Galleries, Philadelphia, Eleventh Annual Exhibition of Advertising Art, Art Center, New York.

1936
Highly successful commercial color photographer.

1940
Random House, New York, publishes his book, *Photographing in Color*.

1943
Moves to Hollywood, and then to Laguna Beach to set up a small portrait studio.

1945
Marries Lois Weir; in partnership with her founds women's fashion company Lois-Paul Originals.

1947
Travels to make picture stories for magazines.

1950
Travels to South America.

1954
Writes columns for U.S. *Camera* magazine.

1958
Dies of cancer on October 17.

1927
Er richtet in Paris ein großes Atelier mit teurer Ausstattung ein, das er gemeinsam mit Mason Siegel, einem Hersteller von Schaufensterpuppen, finanziert. Das Projekt ist nur von kurzer Dauer. Trennung von seiner Frau Paula.

1928
Arbeit an Filmen in Berlin, später mit Ewald André Dupont in London.

1929
Teilnahme an der Werkbund-ausstellung *Film und Foto*, Stuttgart. Rückkehr nach New York.

1930
Experimente mit dem Carbro-Verfahren. Einrichtung eines Ateliers auf dem Land außerhalb von New York. Ausstellung in der American Designers Gallery in New York.

1931
Ausstellungen im Albright Knox Museum in Buffalo, New York, bei der Third Annual Exhibition of Contemporary Photography, The Ayer Galleries, Philadelphia, Pennsylvania, und der Eleventh Annual Exhibition of Advertising Art, Art Center, New York.

1936
Großer Erfolg als kommerzieller Farbfotograf.

1940
Sein Buch *Photographing in Color* erscheint bei Random House, New York.

1943
Umzug nach Hollywood, später nach Laguna Beach; dort Einrichtung eines kleinen Porträtstudios.

1945
Heirat mit Lois Weir. Gründung der Bekleidungsfirma Lois-Paul Originals.

1947
Fotoreisereportagen im Auftrag verschiedener Zeitschriften.

1950
Reisen nach Südamerika.

1954
Er schreibt Kolumnen für die Zeitschrift U.S. *Camera*.

1958
Paul Outerbridge stirbt am 17. Oktober an Krebs.

1927
Ouvre à Paris un grand studio équipé d'un matériel coûteux et financé par Outerbridge et par le fabricant de mannequins Mason Siegel, mais le projet a la vie courte ; il se sépare de sa femme Paula.

1928
Travaille pour le cinéma à Berlin ; puis à Londres avec Ewald André Dupont.

1929
Participe à l'exposition Werkbund-ausstellung, *Film und Foto*, à Stuttgart ; retourne à New York.

1930
Expérimente le procédé Carbro-couleur ; installe un studio à la campagne, à l'extérieur de New York ; exposition à l'American Designers Gallery de New York.

1931
Expose à l'Albright Knox Museum de Buffalo, New York, Third Annual Exhibition of Contemporary Photography, The Ayer Galleries, Philadelphie, Eleventh Annual Exhibition of Advertising Art, Art Center, New York.

1936
Photographe commercial couleurs couronné de succès.

1940
Publication de son livre *Photographing in Color* par Random House, New York.

1943
S'installe à Hollywood, puis à Laguna Beach où il crée un petit studio de portrait.

1945
Épouse Lois Weir ; conclut un partenariat dans la mode féminine et crée Lois-Paul Originals.

1947
Voyage pour réaliser des reportages photos destinés à divers magazines.

1950
Voyages en Amérique du Sud.

1954
Rédige des chroniques pour le magazine U.S. *Camera*.

1958
Meurt d'un cancer le 17 octobre.

Selected Bibliography

Ausgewählte Bibliografie | Bibliographie

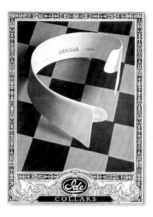

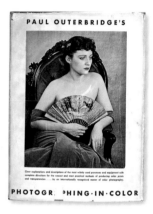

Books and other publications by Paul Outerbridge
Bücher und andere Publikationen von Paul Outerbridge
Livres et publications de Paul Outerbridge

1922
Paul Outerbridge, Jr., "Visualizing Design in the Common Place," in: *Arts and Decoration*, New York, vol. 17, no. 5, Sept., pp. 320ff. [article with ill.].

1923
Paul Outerbridge, Jr., "Seeing Familiar Objects as Pure Form: The Pleasures of Observation are Unlimited for those with Eyes that See" in: *Arts and Decoration*, New York, May, pp. 23ff. [article with 6 ill.].
 Paul Outerbridge, Jr., "Familiar Objects Made Interesting through Photographic Skill," in: *Advertising Fortnightly*, New York, June 20.

1932
Paul Outerbridge, Jr., "How Long O Lord" in: *Worlds Work*, New York, vol. 61, no.1, Jan., p. 51 [full page photographic study].

1933
Paul Outerbridge, Jr., "What is Feminine Beauty," in: *Physical Culture*, New York, Jan., pp. 36-39 [photos included].

1939
U.S. *Camera Magazine*, New York, vol. 1, no. 2, Jan./Feb., p. 49 [1 photo]; p. 85 [back cover]; no. 3, Mar./Apr., pp. 5ff. ["Color" column]; no. 4, June, pp. 8-11, and no. 6, Oct., pp. 6-8 ["Color" column]; facing p. 11 [full page ad for *Photographing in Color*; excerpt from *Photographing in Color* with 2 photos].

1940
Paul Outerbridge, Jr., "Color Chart," in: U.S. *Camera Magazine*, New York, vol. 1, no. 9, Apr./May, pp. 38-39 [excerpt from *Photographing in Color* with 7 photos; "Color" column].
 Paul Outerbridge, Jr., *Photographing in Color*, New York [Random House, 204 pp. including 14 colored plates tipped in].
 Paul Outerbridge, Jr., "A Note on Color Photography" [with 2 photos], in: San Francisco. Golden Gate International Exhibition 1939-1940, A *Pageant of Color Photography*, San Francisco [Crocker-Union], pp. 42-43.

1942-43
The Complete Photographer: A Complete Guide to Amateur & Professional Photography, New York [National Educational Alliance], 10 vols.:

vol. 3, Paul Outerbridge, Jr., "Color Esthetics," pp. 872-83; p. 833 [photo]; p. 840 [photo].
Vol. 6, Paul Outerbridge, Jr., "Lighting and Studio Technique for Color Advertisements," pp. 2260-62 [with 3 photos].
Vol. 7 Paul Outerbridge, Jr., "Nude Photography in Black and White and Color," pp. 2704-15 [with photos].

1952
Paul Outerbridge, Jr., "Clarence John Laughlin and His *Many Mansions*: a Portfolio," Outerbridge Archive, Special Collections, The Getty Center, Los Angeles [unpublished typescript, dated 12/5/52].

1953
Paul Outerbridge, Jr., "The Seeing Eye," in: *American Photography*, New York, Febr., vol. 47, no. 2, pp. 34-45 [with article about William Current with photos of Current].

1954-57
Paul Outerbridge, Jr., "About Color," in: U.S. *Camera*, New York, vol. 17, no. 7, July, 1954 and vol. 20, no. 12, Dec. 1957 [monthly column].

**Photographs by Paul Outerbridge;
Books and Articles on his Work
Fotos von Paul Outerbridge;
Bücher und Artikel über sein Werk
Photos de Paul Outerbridge;
Livres et articles sur son œuvre**

1922
Vanity Fair, New York, vol. 18,
no. 5, July, p. 8 [photographic study
of The Kitchen Table]; Nov., p.5
[photo of the the Ide Collar].
 New York Evening Post, November 4,
pt. 4, p.[4] [photograph of the Ide
Collar].

1923
Good Housekeeping, New York, vol. 76,
no. 6, June [Colman's Mustard
advertisement].

1924
Camera Pictures, published by Clarence
White, New York, p. 12 [photo].
 New York Times, March 16, p. 10
[review of the exhibition at the Art
Center, New York].
 Good Housekeeping, New York, vols.
78-79, March, p. 133; no. 10, Oct.,
p. 285; no. 12, Dec., p. 143.
 Advertising Fortnightly, New York,
vol. 2, no. 11, March 26, p. 20
[Pyrex advertisement].

1925
Vogue, New York, vol. 66, no. 10, Nov.
15, pp. 66-68 [5 photos with
anonymous article "The Perfume
of the Couture"].

1926
Das Kunstblatt, Potsdam, no. 11, Nov.,
p. 447 [2 ill. with anonymous article
"Photographie in Amerika"].
 Harper's Bazaar, New York, vol. 60,
Dec., pp. 66-75 [23 photos with
anonymous article "The Thrill of
Christmas Giving"].
 Pictorial Photographers in America,
New York, no. 80 [photo of Bracelets].

1928
Die Dame, no. 21, July, Berlin,
pp. 8-11 [7 photographs with
anonymous article "Die Kamera
entdeckt ein Neues Reich"].
 Herbert Wauthier, "Photographers
and Photographers," in: *Artwork*,
no. 16, winter, London, pp. 244-49
[article with 7 photos]

1929
Harper's Bazaar, New York, vol. 63,

Dec. [anonymous article "Gifts for
Everyone" with 12 photos].

1930
The Royal Gazette and Colonist Daily,
Bermuda, Jan. 24.

1931
*Photographie [Arts et metiers
graphiques]*, Paris, pp. 35, 43, 125.
 Vanity Fair, New York, vol. 35, no. 5,
Jan., pp. 56-57 ["Music" photo study
with a short article on Outerbridge.
Photograph of Eggs].
 M. F. Agha, "Paul Outerbridge, Jr.,"
in: *Advertising Arts*, New York, May,
pp. 42-45 [article with 5 photos].
 Fortune, New York, vol. 3, no. 5,
May p. 7 [McCann-Erikson
Advertising advertisement, 1 photo].
 McCall's Magazine, New York, July,
p. 32; Oct., p. 32; Nov., p. 132.
 Harper's Bazaar, New York, vol. 65,
no. 6, June, p. 113 [Coty
advertisement with 2 photos].
 Printer's Ink, New York, vol. 157, no.
10, Dec. 3, pp. 49-52 ["Modern
Photography in Advertising, No. 10."
International Paper Co. Advertising
with 4 photos].

1932
Advertising Arts, New York, May,
p. 21 [Apples photo from 11th Annual
Exhibition of Advertising Art, New
York. Medal to Outerbridge
for photo for McCann-Erikson], cf.
Fortune, 1931.
 Maurice Burcel, "Paul Outerbridge,
Jr.," in: *Creative Arts*, New York,
vol. 12, no. 2, Febr., pp. 108-15
[9 photos including cover photo and
pencil portrait by Rollo Peters].

1936
House Beautiful, New York, vol. 78,
no. 10, Oct., p. 46 [1 photo]; Nov.,
p. 32 [1 photo]; Dec., p. 38 [1 photo],
p. 55 [1 photo].
 PM: *An Intimate Journal for Production
Managers...*, New York, no. 27, Nov.
[cover photo].
 Rehearsal, New York, Sept. 24,
pp. 33-36 [Dummy prototype for *Life*].
 U.S. *Camera*, Annual, New York,
p. 103, p. 168 [2 photos].

1937
House Beautiful, New York, vol. 79,
no. 2-12, Febr.-Dec. [cover photos].
 Mademoiselle, Paris, Nov. [cover
photo plus 2 photos in issue:
"Shower"; cover photo repeated in

Helena Rubenstein advertisement].
 Gary Strider, "This Man
Outerbridge," in: *Popular Photography*,
New York, vol. 1, no. 8, Dec.
[color insert on heavy paper:
"The Gilded Venus"].
 U.S. *Camera*, New York, Annual,
p. 30 [1 photo].

1938
House Beautiful, New York, Jan.-July,
Sept.-Dec. [covers].
 Modern Photography, New York,
Annual, pp. 38-39.

1939
"American Aces. Paul Outerbridge, Jr.
– Young Man Goes East and Comes
Back Again," in: U.S. *Camera*, New
York, vol. 1, no. 2, Jan.-Febr.,
pp. 54ff. [anonymous article with
12 photos].
 Better Photography, New York, Dec.
[cover photo].
 Herbert Thayer Bruce, "Hard to
Find – Grand to Know," in:
Commercial Photographer, New York,
vol. 14, Sept., pp. 489-94 [with 5
photos including shots of his studio].
 U.S. *Camera*, New York, Annual
1939, p. 108 [1 photo].

1940
Robert W. Marks, "Portrait of Paul
Outerbridge," in: *Coronet*, New York,
March, pp. 18-29 [with 7 photos].
 U.S. *Camera* Magazine, New York,
vol. 1, no. 10, June/July, pp. 11-13,
"Photo Guide Section" [1 photo];
pp. 75-76 ["Color" column].
 U.S. *Camera* Magazine, New York,
Annual 1940, p. 72, 232 [2 photos].

1942-43
*The Complete Photographer: A Complete
Guide to Amateur & Professional
Photography*, New York [National
Educational Alliance], 10 vols.: vol. 2,
p. 622 [Outerbridge cited];
vol. 4, pp. 1209, 1210 [2 photos].

1943
Commercial Photography, New York,
Dec., p. 87.
 Time, New York, vol. 41, no. 15,
April [National Dairy Products Corp.
advertisement with Eggs photo].

1951
American Photography, New York,
vol. 45, no. 8, Aug., p. 477
[1 photo: "Monterey Coastline"].

1952
Holiday, New York, March, pp. 104-12 ["Buenos Aires," 3 photos].

1958
New York Times, Oct. 26, p. 88, col. 8 [obituary].

1959
U.S. *Camera*, New York, vol. 22, no.1, Jan., p. 46 ["About Color" column].

1960
U.S. *Camera*, Annual, p. 334, "Paul Outerbridge," by Tom Maloney [obituary with 2 photos].

1976
Graham Howe, "Paul Outerbridge, Jr. 1896-1959 [sic]," in: *Exposure*, New York, vol. 14, no. 4, Dec., pp. 2-7 [7 photos].

vol. 4, March 1980, pp. 36-47 [article with 6 photos].
 Graham Howe, G. Ray Hawkins, Jacqueline Markham, *Paul Outerbridge, Jr.: Photographs*, New York [Rizzoli], 159 pages.
 Constance Sullivan, *Nude Photographs*, *1850-1980*, New York [Harper & Row], pp. 63-64, 66 [3 photos].

1981
Joe Novak, "Paul Outerbridge, Jr.: Photographs," in: *Camera 35*, New York, vol. 26, no. 7, July, pp. 22-24 [review of Rizzoli book with 3 photos].

1993
Jeannine Fiedler, *Paul Outerbridge Jr., Photographien*, Munich [Schirmer/ Mosel].

Exhibition and Collection Catalogs
Ausstellungs- und Sammlungskataloge
Catalogues d'exposition et de collections

1937
Photography 1839-1937, The Museum of Modern Art, New York [exh. cat.; introduction by Beaumont Newhall; 5 photos by Outerbridge].

1969
"Photographs in the Metropolitan," The Metropolitan Museum of Art, New York, Bulletin, vol. 27, no. 7., March, p. 357.

1976
Paul Outerbridge Jr., The Los Angeles Center for Photographic Study, 40 pages [exh. cat.; project director: Robert Glenn Ketchum].

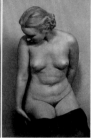

1978
Diana Edkins, "Pioneers of Commercial Colors: Burial, Kipper, Murray, Outerbridge, Steichen" [Gravure portfolio, Great Images # 18], in: *Modern Photography*, New York, vol. 42, no. 9, Sept., pp. 104-09 [3 photos].

1978-79
G. Ray Hawkins Gallery, Los Angeles, *Photo Bulletin*, vol. 1, no. 9, Dec. 1978/Jan. 1979.
 Hilton Kramer, "A Cubist Photographer," in: *New York Times*, Oct. 21, 1979, Sept. II, pp. 37-38 [1 photo].

1980
Owen Edwards, "The Gentlemen Photographer," in: *Horizon*, New York, vol. 23, no. 6, June 1980, pp. 48-53.
 Vicki Goldberg, "Paul Outerbridge," in: *American Photographer*, New York,

1999
Manfred Heiting, *Paul Outerbridge 1896–1958*, essay by Elaine Dines-Cox with Carol McCusker, personal portrait by M. F. Agha, Cologne [TASCHEN].

2009
Phillip Prodger, Graham Howe, William A. Ewing, *Paul Outerbridge: New Color Photographs from Mexico and California 1948–1955*, Pasadena [Nazraeli Press].

David Travis, *Photographs from Julian Levy Collection, Starting with Atget*, Art Institute, Chicago, pp. 59ff. [exh. cat.].

1979
Detroit Institute of Arts, *Bulletin*, vol. 58, no. 4, 1979/80 [Cover].
 David Travis, *Photography Rediscovered. American Photographs*, *1900-1930*, New York, Whitney Museum of American Art, New York [exh. cat.].

1981
Elaine Dines, *Paul Outerbridge. A Singular Aesthetic*, Laguna Beach Museum of Art, Laguna Beach, 240 pages. [exh. cat.]

1982
Manfred Heiting, *Photography 1922–1982, Photokina – World Fair of Photography*, Cologne, pp. 89-104 [exh. cat.].

1986
The J. Paul Getty Museum Journal, Malibu, vol. 14, p. 282.

1988
The J. Paul Getty Museum Journal, Malibu, vol. 16, p. 190.

1991
Jill Quascha, *The Quillan Collection of Nineteenth and Twentieth Century Photography*, New York [Quillan Company Limited], pl. 11.

Carl E. Rourk, Paula Ann Stewart, and Mary Kennedy McCabe, *Catalogue of the Amon Carter Museum Photography Collection*, Fort Worth, p. 439.

1996
Tom E. Hinson, *Catalogue of Photography*, The Cleveland Museum of Art, Cleveland, pp. 264-65.

2000
John Elderfield, *Modern Starts: People Places Things*, The Museum of Modern Art, New York [exh. cat.].

Cornelia H. Butler, Lee Weng Choy, and Francis Pond, *Flight Patterns*, The Museum of Contemporary Art, Los Angeles [exh. cat.].

2001
Peter Weiermair, *The Nature of Still Life: From Fox Talbot to the Present Day*, Milan [Electa] [exhib. cat.].

2003
Jeffrey Fraenkel and Frish Brandt, *The Eye Club*, Fraenkel Gallery, San Francisco [exh. cat.].

2004
Thomas Seelig and Urs Stahel, *The Ecstasy of Things: From the Functional Object to the Fetish in 20th Century Photographs*, Fotostiftung Schweiz, Fotomuseum Winterthur, Göttingen [Steidl] [exh. cat.].

2008
Masterpiece Photographs from the Minneapolis Institute of Arts: The Curatorial Legacy of Carroll T. Hartwell, Christian A Peterson, Minneapolis [Minneapolis Institute of Arts] [exh. cat.].

2009
Paul Martineau, *Paul Outerbridge. Command Performance*, The J. Paul Getty Museum, Los Angeles [exh. cat.].

2013
Esther Adler and Kathy Curry, *American Modern: Hopper to O'Keeffe*, The Museum of Modern Art, New York [exh. cat.].

Katherine A. Bussard and Lisa Hostetler, *Color Rush. American Color Photography from Stieglitz to Sherman*, New York [Aperture]/Milwaukee [The Milwaukee Art Museum] [exh. cat.].

Photohistorical Books
Fotografiegeschichte
Histoire de la Photographie

1949
Beaumont Newhall, *The History of Photography from 1839 to the Present Day*, The Museum of Modern Art, New York [Simon & Schuster], p. 166.

1977
Hans Jürgen Syberg, *Fotografie der 30er Jahre*, Munich [Schirmer/Mosel], p. 107 [1 photo].

1980
"Separate Worlds of Neglected Masters," in: *Time-Life Books, Photography Year*, New York, pp. 204-14 [12 photos].

1982
Bruce Bernard, *Photodiscovery. Masterworks of Photographs, 1840-1940*, New York [Abrams], p. 210.

Beaumont Newhall: *The History of Photography*, The Museum of Modern Art, New York, pp. 182, 277.

1985
Lucina Barnes, *A Collective Vision: Clarence H. White and His Students*, University Art Museum, California State University, Long Beach [exh. cat.].

Michèle Auer and Michel Auer, *Photographer's Encyclopaedia International 1839 to the Present*, Hermance, Geneva [Editions Camera Obscura].

1994
Michel Frizot, *History of Photography*, Paris [Bordas S. A.], pp. 478, 480, 556, 563.

1997
B. Martin Pederson, "Nudes 2," in: *Graphics International*, New York [cover].

2001
Gabriel Bauret, *Color Photography: Portrait, Nature Morte, Nu, Paysage...*, Paris [Assouline].

2005
Brooks Johnson, *Photography Speaks: 150 Photographers on Their Art*, New York [Aperture].

Peter Stepan, *Icons of Photography: the 20th Century*, Munich, London [Prestel].

2007
Pamela Roberts, *A Century of Colour Photography*, London, [André Deutsch].

2014
Marie Cordié Lévy, *L'autoportrait photographique américain: 1839–1939*, Paris [Mare & Martin].

EACH AND EVERY TASCHEN BOOK PLANTS A SEED!
TASCHEN is a carbon neutral publisher.
Each year, we offset our annual carbon emissions with carbon
credits at the Instituto Terra, a reforestation program in Minas
Gerais, Brazil, founded by Lélia and Sebastião Salgado.
To find out more about this ecological partnership, please
check: www.taschen.com/zerocarbon
Inspiration: unlimited. Carbon footprint: zero.

To stay informed about taschen and our upcoming
titles, please subscribe to our free magazine at
www.taschen.com/magazine, follow us on Twitter,
Instagram, and Facebook, or e-mail your questions
to contact@taschen.com.

© 2017 TASCHEN GmbH
Hohenzollernring 53
D-50672 Köln
www.taschen.com

Original edition:
1999 © Benedikt Taschen Verlag GmbH

EDITOR
Manfred Heiting, Malibu

EDITORIAL COORDINATION
Simone Philippi and Inka Lohrmann,
Cologne

DESIGN
Birgit Eichwede and
Tanja da Silva, Cologne

PRODUCTION
Horst Neuzner, Cologne

TRANSLATION
German translation by Katrin Velder, New York;
Carbro text by Wolfgang Himmelberg, Düsseldorf
and G.-I. Koshofer, Bergisch Gladbach
French translation by Joëlle Ribas, Munich;
Carbro text by Frédéric Maurin, Paris

Paul Outerbridge, Jr.
© 2017 G. Ray Hawkins Gallery, Beverly Hills, CA

© Text: Elaine Dines-Cox, San Francisco
 with Carol McCusker, Albuquerque

© Text by M. F. Agha: Estate of M. F. Agha, New York

Printed in Italy
ISBN 978-3-8365-6456-4